Art and...

Contemporary art can be difficult. Reading about it doesn't need to be.
Books in the *Art and...* series do two things

Firstly, they connect art back to the real stuff of life – from those
perennial issues like sex and death that trouble generation after
generation to those that concern today's world: the proliferation
of obscene imagery in the digital age; our daily bombardment by
advertising; dubious and disturbing scientific advances.

Secondly, *Art and...* provides accesible theme-based surveys which
energetically explore the best of contemporary art. *Art and...* avoids
rarefied discourse. In its place, it offers intelligent overviews of art –
and the subjects of art – that really matter.

Art and... Series List
Art and Advertising
Art and Death
Art and Laughter
Art and Obscenity
Art and Science
Art and Sex

'This intelligent and stimulating book is an excellent contribution to the literature in the field of art and science, and provides a perspective that reaches far beyond the usual approaches to the relationship between, and the intersection of, art and science.'

– Ingeborg Reichie, *Nature*

Art and Science

Siân Ede

I.B. TAURIS
LONDON · NEW YORK

Reprinted in 2008 by I.B.Tauris & Co Ltd
6 Salem Road, London W2 4BU
175 Fifth Avenue, New York NY 10010
www.ibtauris.com

In the United States of America and in Canada distributed by
Palgrave Macmillan, a division of St Martin's Press
175 Fifth Avenue, New York NY 10010

First Published in 2005 by I.B.Tauris & Co Ltd

ISBN 1 85043 583 9 hardback
EAN 978 1 85043 583 9 hardback

ISBN 1 85043 584 7 paperback
EAN 978 1 85043 584 6 paperback

A full CIP record for this book is available from the British Library
A full CIP record for this book is available from the Library of Congress

Library of Congress catalog card: available

Typeset in Agfa Rotis by Steve Tribe, Andover
Printed and bound in Great Britain by TJ International Ltd, Padstow, Cornwall

Contents

For my father, Eddie Nicholls,
who taught me how to read maps,
and my mother, Peggy Nicholls,
who managed very well without them

Acknowledgements

I must warmly thank Mikhael Essayan, Paula Ridley and all my colleagues at the Gulbenkian Foundation who, in the Foundation's long tradition of risk-taking and pioneering, have allowed me to pursue my interests in the name of work, especially through its grants programme *The Arts and Science,* though I should stress that this book reflects my own views and not those of the Foundation. I am extremely grateful to many scientists and artists who have patiently explained things and encouraged me further. Some of these are named where appropriate in the endnotes but significant ones include Ken Arnold, Frances Ashcroft, Aosaf Afzal, Paul Bonaventura, A S Byatt, Christine Darby, Richard Deacon, Jayne Anne Eustace, Richard Gregory, Christine Kenyon Jones, Janna Levin, Felicity Luard, Mark Lythgoe, Richard Mankiewicz, Mark Miodownik, Steven Rose, Nicola Triscott and Richard Wentworth. I must particularly thank my editor, Susan Lawson, Steve Tribe and all those who have read earlier drafts and tactfully pointed out fallacies and indiscretions. If I have failed to heed their suggestions the fault is my own. I am especially indebted to my daughters, Kate and Alice Quine, for putting up with my obsessions on a daily basis.

... semiotics and ergonomics
lasers and caesuras
retro-rockets and peripeteia
sapphics and turquoise
sines and sememes
hubris and helium
Eliot and entropy
enjambment and switchgear
quasars and hapax legomena
thermodynamics and macrostylistics
anti-hero and anti-matter
bubble chambers and E.K. Chambers
H2O and 8vo
genres and genera...

Edwin Morgan, *Pleasures of a Technological University*[1]

Introduction

Ambiguities
and Singularities

Contemporary scientists often talk about 'beauty' and 'elegance'; artists hardly ever do. Scientists weave incredible stories, invent extraordinary hypotheses and ask difficult questions about the meaning of life. They have insights into the workings of our bodies and minds which challenge the way we construct our identities and selves. They create visual images, models and scenarios that are gruesome, baffling and beguiling. They say and do things that are ethically and politically challenging and shocking. Is science the new art?

Contrary to the claims of some in the science community, the public is better informed about contemporary science than it is about contemporary art. Scarcely a news bulletin passes which does not contain the words 'scientists have discovered that...' followed up with accessible explanations. All schoolchildren in the West (unless they live in Creationist Kansas) must compulsorily learn the basics of genetics, chemistry and physics. Our television and movie fictions glamorise medicine and forensic science; we relish and revere the slick clinical jargon of *ER* and *Casualty* and their crash crises, instant diagnoses and gorily authentic-looking body parts. Even small children can

be knowledgeable about the appearance and function of a gerbil's kidneys and the gynaecology and obstetrics of cows, thanks to *Animal Hospital* and the prime-time viewing of vet documentaries. 'Nature' programmes attract huge viewing figures. General practitioners regularly encounter patients who come to the surgery with self-made diagnoses, full of technical information acquired from the Internet. Moreover, we subscribe to the purity and implicit justice of the scientific method, with its emphasis on the primacy of impartial evidence, which has become so much a part of the police detective and forensic science fiction and films we seem obsessed with. Logical argument and rational expression, together with a Gradgrindian respect for 'facts', are paramount in public and political discourse and the arts constituency itself must justify its existence through a semblance of order which involves the continual making of strategies, audits and statistical surveys, even to the extent of identifying rules and conditions which govern the nature of that hallowed term 'creativity'. And, while scientific ideas are intelligently aired every day, art is not explained or discussed on its own terms except as an end-of-the-news item where it is likely to be derided for its apparently infantile sensationalism or its knee-jerk irony, or vaguely revered for its decorativeness, or its hints at some kind of inaccessible sanctity. We are much more likely to be seriously persuaded, moved, worried or enchanted by science.

One of my objectives in this book is to show that in our clever, curious and materialist world 'art' is as vital to our existence as 'science'. Visualising, abstracting, imagining, inventing, pretending, storytelling, re-presenting and ceaselessly reinterpreting things are as important as indications of human achievement and communication as rational discourse and the presentation of empirical evidence. We may be afraid of the uncertainty and chaos that this implies, but we should be able to acknowledge our susceptibility to seeing things from a range of viewpoints and be confident in the value of such approaches. We have probably survived as a species as a consequence. Indeed, our brains easily and simultaneously incorporate many systems of knowledge. We possess the capacity to test out the evidence of our sensations and to make reasoned conjectures, but also to fantasise, guess and imagine. Real scientific progress could not happen without daydreaming: intellectual research and logical planning are essential for the making of art. We can take interest and pleasure in understanding how the brain processes the visual and emotional signals that present themselves to us in an artwork, in discovering the historical and cultural basis for its composition, and in actually experiencing

the sensations it stimulates and letting them conjure up uniquely personal associations. Different though such approaches are, they don't have to be mutually exclusive and they add to the richness of knowledge and experience. And, at a time when scientific 'progress' is in the ascendant, its discoveries and pronouncements need to be placed in contexts where things can be seen quite differently, where ideas can be expressed with a poetic or abstract succinctness and always in a questioning and compassionate spirit.

If scientists don't always 'get it' when it comes to contemporary art, an increasing number of artists are beginning to 'get' science and there are many examples of excellent works which have been inspired by it. But while 'Sci-Art' sometimes seems to be all the rage, not all of it is interesting *as* art. Indeed, I do not believe that art can *directly* be 'about' science – lectures, books or discussions are more successful at presenting explanations or stimulating debate. If art is 'about' anything, it is a reflection of human experience in complexity and it emanates from an inventive individual with an unusual and sideways view on things, communicating with vigorous visual acuity and daring, its intellectual content, like that of poetry, conveyed through hints and ambiguities. Artists don't 'do' prettification, product or propaganda for the public understanding of science. But they can engage with it and create images which suggest alternative ways of seeing.

There is much in contemporary science that can stimulate art's flexible, intuitive and visceral response to the world and in this book four important aspects become evident. The first of these concerns new scientific explanations for the structures and processes of the human mind and body and the subsequent implications for revisions in what we think of as 'human nature'. Secondly, there are science's startling new technologies; thirdly, its ethical controversies. And, fourthly, I believe it is important to examine how far the pendulum is swinging away from the cultural and linguistic relativism that has for almost a century predominated in the theoretical discourse underpinning approaches to the arts and humanities, and how far it is moving towards a universalist belief system and approach, as promoted by the new sciences, especially those concerned with the evolution of the mind.

'The single human voice telling its own story can seem the only authentic way of rendering consciousness,' writes the novelist and critic David Lodge.[1] Scientists may be to able to explain how the brain works in terms of mapping the cortex or understanding synaptic connection-making or the function of neurotransmitters, but they cannot convey how experience feels the way it

does to us as individuals. Nevertheless, current endeavours to understand the actual matter of mind and consciousness increasingly show it to be depersonalised. How far can we claim to possess a unique sense of self, of individuality, or identity, if so many of our mental processes are innate or automatic? Over the coming years we will be able, mechanically and electronically, to extend the capabilities of our brains as well as our bodies. Imaginative leaps forward will require artists to engage with and invent new paradigms for the body/mind continuum.

Scientific images of human cells or brain scans in artworks were remarkable the first time they were used. Helen Chadwick's squelchy internal organs intertwined with flowers, fur or hair, her human embryos set like jewels, presented images which demanded radical questions about the nature of self, of 'beauty' and 'femininity'. Marc Quinn's 2001 Genomic Portrait of Nobel Prizewinning geneticist Sir John Sulston features colonies grown from bacterial cells from his subject's sperm containing segments of his DNA – he *is* his DNA – but you can't make this witty gesture twice, or a visit to the National Portrait Gallery, where this portrait can be found, would soon become dreary. X-rays, brain scans, the double helix have become commonplace icons in advertising and popular journalism – artists need to be more inventive. And claims from the science community that their swirling, colour-clashing representations of cells or chaotic systems are aesthetically rich seem to miss the artistic point. Biologist Stephen Jay Gould has called science images 'loci for modes of thought' and for artists the 'thought' will relate to the quest for multiple ways of interpreting what it feels like to be human rather than the search for a harmonious picture or an indication of absolute meaning.

From the beginning of the twentieth century, art became increasingly associated with political protest but, as the world has become more disparate and apparently more liberalised, its defiant gestures have seemed increasingly frivolous. Recently, however, there has been a reinvigoration. In the influential international German art show Documenta 2002, curated by the American-Nigerian artist/curator Okwui Enwezor, all 116 artists uncompromisingly addressed the theme Globalization with 'a mighty denunciation of violence, poverty and social dissolution', as *The Art Newspaper* reported. It remains to be seen how successfully provocative artists can be when their impact is so closely tethered to the art market. But science is bedevilled by market forces too and it would be no bad thing if artists were to engage with those scientists who are themselves extremely concerned about ethical issues – when genetic

research rushes ahead, for example, or about the power of vested interests in choosing where research funds are prioritised, or about the ways in which new discoveries are increasingly being patented for profit. Such collaboration may present a particular challenge to artists who don't want to make work that is simply 'issue-based' and to scientists who may be afraid that important arguments might be devalued by lightweight irony. But in the best work such doubts can be resolved, and particularly with a view to our deep concerns about our imperilled environment and with questions of ownership and the global economy, they must increasingly be.

And lastly there are the philosophical differences. We know from our experience of the science labs and the art rooms of our secondary schools how the theoretical and practical stances of art and science contrast. We are also familiar with the delineating distinctions set forth by scientist and novelist C. P. Snow in his provocative 1959 essay *The Two Cultures*, and of the irritable response by Cambridge literary critic F. R. Leavis. Their radically conflicting approaches largely still hold true, although in retrospect we can also see how they reflect the snobberies of the time: science the product of naively over-optimistic gung-ho chaps, literature the legacy of the morally superior – and rich. (A stereotypical class divide may still linger: art – mysteriously omniscient and fashionably louche; science – boffinish and unsubtly earnest.)

The rift goes deeper, however, and derives from radical differences in two epistemological traditions concerned with the nature of knowledge itself. On one hand is the view that there is an implicit reality out there waiting to be discovered, independent of the observer's mental state, as very many scientists maintain. On the other hand is the idea that reality is all or at least partly a construction of the human mind, phenomenologically and linguistically determined and therefore unfixed, and whether we are aware of it or not, viewed in accordance with the prevailing values and beliefs of particular times and places. How far can we say that objects possess an intrinsic meaning beyond that derived from the way we utilise them or have beliefs about them? Is knowledge dispassionate and absolute, or forever ambiguously dependent on the slippery meanings we give to words? The postmodernist writer Roland Barthes encapsulates this in a piece of literary criticism: 'the systems of meaning...take over this absolutely plural text, but their number is never closed, based as it is on the infinity of language.'[2]

In 1996, the physicist Alan Sokal published a paper in the American cultural studies journal *Social Text*. Called 'Transgressing the Boundaries:

Towards a Transformative Hermeneutics of Quantum Gravity', it presented a thesis which questioned the concept of an external world with properties independent of human life and thought. Sokal went on to assert that physical 'reality' was essentially a social and linguistic construct. For evidence he drew on the notions of indeterminacy and relativity in quantum theory, and to give his arguments intellectual gravitas he cited postmodernist critics such as Derrida, Irigaray and Lyotard. And then, as soon as his thesis came out in print, he confessed. The paper was a hoax, produced to demonstrate that postmodernist, socially constructed analyses of science were based on ignorance, prejudice and hilariously muddled thinking. Peppered with scientific errors, the paper had been accepted without question because it supported the prevailing political and cultural orthodoxy of the journal and its constituency. It was difficult for even the most rigorous cultural theorist to come up with a defence that had any clear credibility in the science world.[3] For, to some extent, Sokal and many in science and beyond felt justified in expressing a weariness for the obfuscation, self-reference and self-reverence evident in the worst excesses of postmodernist discourse, which, while apparently refusing to make absolute judgements, often unquestioningly accepts an underlying political agenda, with its origins in questionably outdated theories influenced by Freud, Marx and Foucault. 'Prime numbers would be there regardless of whether we had evolved sufficiently to recognise them,' says mathematician Marcus du Sautoy in a recent book (which reflects a Platonist view typical of many mathematicians). 'One can imagine a different chemistry or biology on the other side of the universe, but prime numbers will remain prime whichever galaxy you are counting in.'[4]

While many in the arts and humanities can see that this is the case, they are suspicious of any constituency that claims to be wholly right in finding the route to Truth and particularly can't agree to assess all human behaviour, perceptions and products outside any political and cultural context. We must always assert the right to ask who makes the judgement and why. The evolutionary psychologists' view is that human nature is universally the same because it has evolved everywhere by natural selection and is driven overwhelmingly by imperatives to survive and breed. Few in the arts and humanities would disagree that human behaviours, products and artefacts reflect or express certain fundamental drives, but our interpretation of them has to be multilayered, not regarded simply as the consequence of life on the prehistoric Savannah or of universal 'rules' governing perception and

cognition, or those related to notions of symmetry and asymmetry. We can never know how someone in twelfth-century Italy or Tang Dynasty China would read the works of Picasso. The plays of Shakespeare with their stories of divided kingdoms, family conflicts and forbidden love are understood all over the world, but every time they are played they are reinterpreted in different contexts by different audiences. Who decides which science to apply to determine whether Hamlet is mad or the only one sane? A Navaho sand-painting ritual for a sick child is a mystery – we literally cannot read the signs nor subscribe to the belief, let alone the science, that she can be made better this way. Are we then to dismiss this cultural practice? This is shaky political ground and what appears to be dogged cultural relativism can infuriate scientists. Unfortunately, their own track record isn't too persuasive. Who can say what is 'natural' behaviour for women at the beginning of the twenty-first century, when many scientific experts got it so wrong at the beginning of the twentieth? Even when we greatly respect their methodologies, it is always important to take cultural context into account.

For there are fashions in thought and even in science. As the philosopher Thomas Kuhn pointed out in the 1970s, scientific discovery moves forward through radical change or 'paradigm shifts'.[5] New discoveries that fundamentally challenge and then go on to replace existing theories can sometimes stimulate a complete revision of ideas for the way we regard our existence. Outstanding examples are Galileo's endorsement of the Copernican view that the earth revolves around the sun, and not vice versa, and Darwin's heretical *Origin of Species*, which demonstrated that human beings were not privileged through creation by an omnipotent God but had evolved through random biological accidents. It is particularly interesting that these significant breakthroughs occurred in politically heated contexts – Galileo in post-Reformation Europe, Darwin at a time of increasing materialism and religious doubt.

Such questions challenge the legacy of the traditional Enlightenment belief in impartiality, justice and freedom from superstition or political subversion. They also cast doubt on the primacy of 'the scientific method', as defined by the philosopher Karl Popper in the 1950s. The scientific method aims to prove a hypothesis through a series of empirical tests to distinguish its 'falsifiability' (rather than its verifiability). And it is a precious commodity because it offers an agreed and impartial methodology for pursuing an understanding of phenomena or behaviour, providing evidence which can be open to public scrutiny and rationally assessed, even where it can never be definitively agreed

on. Scientists are expected to play by the rules which are there to ensure an almost superhuman objectivity. Can this ever be possible? No, claims the philosopher Paul Feyerabend: 'all methodologies have their limitations and the only "rule" that survives is "anything goes".'[6]

Surely, in order to form a rounded view of any phenomena, we need to take into account both perspectives – the rational, well-evidenced hypotheses of science along with an awareness of the social and political contexts in which such hypotheses are framed, tested and reported. Both extremes can accommodate the idea that our view of things doesn't stay fixed forever. 'Nature' may be ultimately constrained by the parameters set by the four forces of physics but this still allows for a great deal of flexibility, as the history of evolution demonstrates.

As an anthropologist, Steven Mithen traces the way in which the human mind has evolved in an ongoing active engagement with the natural environment, developing technical, natural history, social and linguistic intelligences which continually interact, questing, imagining and suggesting new constructs to explain and predict structure and behaviour. As an art historian, the Leonardo da Vinci scholar Martin Kemp proposes that we all possess to some degree a 'structural intuition' in which we make internal models of the world that are both innate and 'ceaselessly reconfigured...to resonate with external systems'. I would add that we also have a capacity to socialise and use language to discuss and remake definitions to suit an evolving view of our environment, a 'social and linguistic intuition' equivalent. Moreover, new neuroscientific research indicates that our encounters with the world shape the very architecture of our brains in a two-way process. The brain-cells which form our individual experience, our memories, our selves, and, collectively, our cultures, develop or die according to the ways they respond – or not – to outside stimuli. In turn, we predicate our view of the world according to the experience we have acquired. Perhaps artists are especially agile in thinking flexibly but so too are many scientists working at the boundaries of their practice. We have insights into reality, we continually reshape them, putting oppositions together, arguing, reconciling on different systems of knowledge simultaneously – art and science, science and art. Not the same, never likely to form any kind of universal epistemology, but equally important modes of enquiry.

How do we interpret and reinterpret the world – through quantum mechanics or through post-structuralist theory? Both are pretty incomprehensible;

both are profound forms of knowledge. How do we learn to look at pattern – through an fMRI scan of the brain or through gazing at Vija Celmins' detailed pencil-dot skyscapes? Which is more ingenious – the Mir Space Station or the cranky utopia of Emilia and Ilya Kabakov's installation, *The Palace of Projects*? Which is more encoded – the sequencing of a piece of human DNA or Velàsquez's *Les Meninas*, as explained in Foucault's famous 1966 essay? Which is more frightening – the idea of rogue self-replicating nanotechnology machines which feed on organic materials and spread like pollen, or the Chapman Brothers' holocaust reconstruction *Hell*? Which is sillier – a psychology survey to find the fundamental rules governing sexual attraction entirely based on questionnaires filled in by university students, or Turner Prize winner Martin Creed's *Lights Going off and on in an Empty Room*? The world and our view of it comprises multiple perspectives. Where would evolution be without flexibility?

The comparison between the Mir Space Station and the Kabakovs' installation *The Palace of Projects* is an interesting one. The small and self-contained unit designed to be suspended in space may be regarded straightforwardly as a piece of brilliant engineering produced for serious and practicable scientific investigation. The Kabakovs' artwork is a winding snail-shape installation containing sixty-five Heath Robinsonian projects, in homage to improvisation created by fictional Soviet citizens and presented in the form of models with quasi-serious explanatory texts, like science proposals or engineering blueprints. By donning a pair of angel's wings, goes one proposal, one might behave better; by imagining a system to diminish the earth's gravitational field we could inhabit the air above us and enjoy more space. Each of the Kabakovs' projects addresses three basic questions – how to make the world better, how to make yourself better and how to stimulate creativity – and each presents bizarre solutions. They emanate from the experience of having to survive, practically and emotionally, within a drab and often dangerous Soviet regime. The artwork is both funny and tragic and becomes a parable for our brief struggle on Earth and our desire to understand it and improve our lot. Mir and *The Palace of Projects* derive from the same kind of inventiveness and even the same kind of impetus, and if we have seen the one we will think differently of the other and then also of our lives and what they mean.

Though in this introduction I have listed four aspects in which art can engage with science, in the book itself I do not examine them in neat

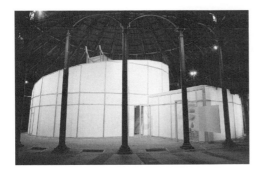

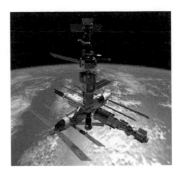

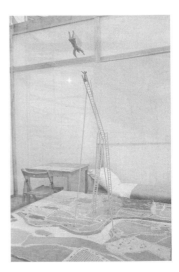

1. (above left) Emilia and Ilya
Kabakov, *The Palace of Projects*
(1998). Photograph © Stephen
White. Courtesy Artangel.
2. (above right) The Mir Space
S-tation.
3. (right) Emilia and Ilya Kabakov,
The Palace of Projects (1998),
detail. Photograph © Stephen
White. Courtesy Artangel.

categories under these headings, because while science tries to understand
the world through identifying patterns and grouping them to form taxonomic
categories, art deliberately does not. Good artwork is always more than the
sum of its parts and operates like poetry, making suggestions, hinting at
associations, teasing emotionally, challenging intellectually and expecting the
viewer to play a part in making new meanings from it. I think of Cornelia
Parker's *Cold Dark Matter* in its dimly lit room at Tate Modern – fragments
of stuff swaying on suspended piano wire grouped in a square and casting
shadows around a single light bulb. I know the bits and pieces are the remains
of a collection of arbitrary domestic clutter piled into a garden shed and then
blown up by the Army, and that the title of the work provokes the viewer
to consider indeterminate astrophysical states – the explosion/implosion of

Big Bang or black hole, matter and anti-matter, particle and wave, time and space. I find it gorgeous, funny, worrying, wry, outrageous, clever and moving but I will never be able to explain it once and for all.

So the vast range of the subject matter in this book – contemporary art and science – has presented me with a mapping challenge: how to forge a clear route through the territory without over-prescribing a new set of categorical approaches. In general I have pursued my own curiosities and made my own links in the hope that readers will use them as starting points for their own enquiries, connections and sometimes, too, contradictions. In some sections, mostly in the first half of the book, I provide introductions to some aspects of contemporary science. In others, mostly in the second half, I look at ways in which contemporary art can be understood differently if one is informed by some scientific knowledge, and I also examine works in which artists have deliberately engaged with science.

In the first section, I address 'The Problem with Beauty', which I take as a route to explore some of the essential differences in the cultural attitudes of the constituencies of science and art. I go at a somewhat rapid gallop through a history of science's quest for a unified vision of the world (Chapter 1, 'Everything is Connected in Life'), against which can be compared a breakdown in art's world-view (Chapter 2, 'Disconnections and Asymmetries'). I posit my own thesis which relates to the fact that while science aims as far as possible to be dispassionate and objective, art is always related to the way we experience life, especially to the reluctant realisation that each of us is mortal.

The next section, 'Evolutionary Perspectives', takes readers back in time and in its three chapters – Chapter 3, 'From the Future to the Past'; Chapter 4, 'New Mythologies'; and Chapter 5, 'Universal Studios' – I turn to scientists' views on the evolution of the human mind and explore the validity of some of the more interesting ideas concerned with discovering universal characteristics in human behaviour, going on to investigate some scientific hypotheses (not all of them sensible) for why art is made and what makes it appealing.

In the next section, 'Mind and Body, Body and Mind', I look at ways in which artists are making new work to reflect contemporary constructs, images and technologies concerned with the nature of consciousness and of biomedical research. The title of the first of these – Chapter 6, 'Sculpted by the World' – is taken from an observation by the former neurologist and artist Warren Neidich who explains how our encounters with the world shape the way our innate perceptual apparatuses adapt to it. Chapter 7, 'New Bodies for Old', shows how

traditional attitudes to the body as God's marvellous machine have altered as the world has become secularised. It also looks at the somewhat squeamish work being produced by artists relishing in new gene technologies.

In the final section, 'The Fragile Environment and the Future', Chapter 8 addresses what might well become the most crucial matter for the future concerns of both artists and scientists. Although life on the planet has faced a number of severe natural threats to its existence in the geological past, human activities and interventions seem greatly to be contributing to its incipient devastation. 'It's All Over, Johnny: Art and the Fragile Environment' features the work of artists who express regret about this but also a fierce determination that action should be taken.

The final chapter (Chapter 9, 'Reconnections') looks at the potential for future art-making in response to science but challenges the desire of some scientists for a single unified form of human knowledge.

I hope that this book will inform artists about scientific ideas, both at large and in their minute particulars, with a view to encouraging them to make more challenging and complicated works of art. I also hope that scientists may read it and gain a better understanding of art for its own sake and recognise that though art doesn't address anything literally, its abstract think-ing, visualisations and narratives play an unusual and essential part in creating vivid and changing constructs of the world and the way we live in it. Finally, I hope the general reader will find the book a useful and even provocative starting point for further investigations into both science and art in order to ponder on the ingenious diversity of the human imagination.

Chapter 1

Everything Is Connected in Life

Beautiful Things in Science

When I first became interested in science and found myself in the company of scientists, I was regularly struck by their frequent use of a word that is scarcely ever heard in the arts. That word is 'beauty'. In spite of the sheer effort required by the scientific enterprise – the fiddling with high-tech instruments, the sifting of vast amounts of data, the anxiety about grant applications, the bruising competitiveness that surrounds publication – when they talk about their work, scientists often verge on the rhapsodic. In his book *Unweaving the Rainbow*, Richard Dawkins challenges the view expressed in Romantic poetry that the desire to analyse the workings of the world through examining its smallest components is merely to make a 'dull catalogue of common things'.[1] On the contrary, he says, 'The wonder of the universe and our place in it is revealed through science in ways otherwise impossible to appreciate or imagine.' Physiologist Francis Ashcroft, whose research investigates the function of ion channels in the beta cells of the pancreas, says, 'I am piecing together the puzzle. My aim is to see the interconnectedness of it all – how all the bits fit together to produce something gloriously new.'

4. Gillian Wearing, *Signs That Say...* (1992-1993). C-type prints, 40 x 30 cm. Courtesy the artist and Maureen Paley/ Interim Art.

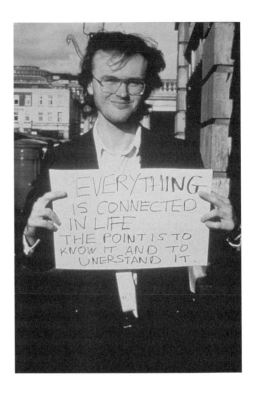

In the world of science the idea that there is some kind of universal jigsaw where all the bits fit together seems to prevail. Marcus du Sautoy is working in an area of mathematics called group theory which tries to understand symmetry. He describes finding consistent mathematical patterns which form palindromes, reading the same from left to right as from right to left. 'Knowing that a zeta function has palindromic symmetry would not be so amazing as a result in itself,' he writes:

> It's more that it is evidence of some deep and subtle structure at the heart of my subject which I don't yet understand. And it is showing a small bit of its beautiful head by manifesting itself in this functional equation. If I can understand this palindromic symmetry I am convinced it will go hand in hand with revealing a huge vista of structure that we are currently too blind to see.[2]

In the introduction to the book *It Must be Beautiful: An Anthology of the Great Equations of Modern Science*,[3] its editor, the physicist and science writer Graham Farmelo, tells how the physicist Paul Dirac, asked in a seminar in Moscow in 1955 to summarise his philosophy, wrote on the blackboard in capital letters, 'PHYSICAL LAWS SHOULD HAVE MATHEMATICAL BEAUTY.' Farmelo writes:

> Much like a work of art, a beautiful equation has among its attributes much more than attractiveness – it will have universality, simplicity, inevitability and an elemental power.

It is hard to believe that Farmelo and his fellow scientists inhabit the same planet as contemporary artists and the theorists whose discourse underpins their practice. Because for them the idea of simple, beautiful equations is barely conceivable. The artist's experience of life is uncoordinated, dislocated, contingent, incomplete. 'Art does not belong to the order of revelation,' wrote the phenomenologist Emmanuel Levinas. It is 'the very event of observing, a descent of night, an invasion of shadow.'[4] 'Art is magic delivered from the lie of being truth,' declared Theodor Adorno. Knowledge itself may do little more than reflect our capacity for persistent self-delusion, Foucault claimed. Such capriciousness extends to everything we try to take account of, including science. Reality shifts, it is always conditional. A postmodernist theorist might well invert Farmelo's axiom:

> Much like a work of science, a work of art represents both more and less than a simulacrum of pleasure – it is foregrounded by the values relative to the value-maker, attests to multiple layers of possible meaning, is inevitable only in that it privileges the mores of a particular culture at a particular time in history and, within its shifting temporary context, it is ripe for continual reinterpretation and validation.

The dramatic contrast between these two visions of reality makes manifest the extreme differences in the epistemological traditions which have under-pinned and separated the two cultures of science and the arts and humanities through much of the twentieth century. Fundamentally, these concern whether distinctions can be made between the act of perceiving and the

object perceived. On the one side is the school of neo-realism, which posits that objects and phenomena exist in themselves and can be studied rationally and empirically, independent of one's mental state.[5] There is an immaculate universe 'out there'. On the other side is the phenomenalist contention that one cannot distinguish between objects of knowledge and objects as one perceives them. Linguistic philosophy examines how basic epistemological words such as 'knowledge' and 'perception' are used.[6] Everything is provisional. There is no room for the absolute here, let alone an absolute beauty.

There are some artists and critics who dare to use the word 'beauty' unenclosed by the heavy quotation marks of irony. In her 2001 book *The Trouble with Beauty*,[7] Wendy Steiner sees beauty as a higher principle outside the boundaries of time and place, achieved through a striving for love, compassion and, especially, through the female spirit of empathy. Beauty is expressed through decorum and finesse, harmony and balance, gorgeousness, even glamour. She deplores the ugly (mostly male) expressions of squalor, outrage, abstraction, formlessness and misogyny endemic in modernist and contemporary art.

Steiner may be recognising a hitherto suppressed feminine aesthetic but even to dare to speak of beauty seriously is to lay herself open to accusations of naivety, self-deception and a lack of humour. And, also, of course, of gross political incorrectness. For was not the experience of Beauty largely reconstructed in the eighteenth century as an affirmation of bourgeois capitalist identity, as the Marxist critic Herbert Marcuse has proposed? Rich and powerful men desire to possess it as a sign of their wealth and power – their lovely architectures and landscaped vistas, their art and clothes, their beautiful women and children, indicative of their superior position, health and happiness. In the grumbling skirmishes between the feminists and the Marxists, is Steiner not complicit with this state of affairs? Worse, the evolutionary psychologists have reconstructed much the same thing and, as we shall see in Chapter 4, some theorists and social scientists believe they may even have a political agenda.

But while they may scorn such relativist discussions, scientists are not talking about the domestication of Beauty. For them real Beauty is altogether a more profound entity and is aligned with Truth, the truth of a unified Reality waiting to be revealed. Of course there is a paradox at the heart of this belief. Scientists are examining the *material* world of real things working in particular ways. But even if they start out simply making observations, whether

of stars, fishes or brain cells, they cannot resist looking for patterns, which leads to the positing of empirically or logically provable hypotheses. If these start out on the level of 'just supposing', in the most rigorous practice the Popperian system is brought into play, attempting by replicable experiment to disprove them until there is sufficient evidence remaining which cannot be disproved, and which, therefore, may point to the right answer for the time being. Scientists know that while breakthroughs are hailed, paradigms shift. And yet, even if their task is to observe change itself, as in dynamic systems or as a consequence of entropy or environmental breakdown; moreover, even while many will claim to have no religious affiliations and to be robustly atheist or agnostic, the majority express a faith in the notion of an absolute knowledge which demands a high order of visionary thinking.

Scientists may be motivated simply by curiosity – how does it work, rather than why. Nevertheless, a quest for completeness recurs throughout the history of science and it is interesting to learn that this vision originally had more to do with mysticism than with clear reason operating in harmony with empirical investigation. It has ancient roots and connects with unified world-views which can be traced back as far as the emergence of the religious cosmologies of the early hunter-gatherers. The teachings of Pythagoras were bound up with a mystical belief that there existed a primordial substance present in everything, with man as a microcosm of the macroscopic universe and united to it by a divine, eternal spirit, a World-Soul. 'It is perhaps fitting that Pythagoras was a near contemporary of Buddha, Confucius, Mahavira, Laozi and probably Zoroaster,' the historian of mathematics Richard Mankiewicz points out.[8] Followers of Pythagoras acknowledged that nature was in a perpetual state of flux, change or metamorphosis, but this in itself was manifest of a kind of eternal constancy. Mathematics was the one true source of knowledge, geometric proofs existed beyond the boundaries of human life and numbers were mystical entities which had both philosophical and revelatory roles. That there were numerical relations in music was only evidence that the earth was at the centre of a harmonious universe, around which orbited the music of the planetary spheres. The quest to explain nature in simple terms was a preoccupation of other pre-Socratic philosophers, some of them possessing intuitions which foresaw modern scientific theory. Anaxagoras believed that all heavenly bodies contained the same constituents as Earth and that nature was built from an infinite number of minute particles, which he called 'seeds', entities which Democritus went on to call 'atoms'.[9]

The twin pillars that support western thought, and consequently science, derive from two of the greatest philosophers in the epistemological tradition. Both Plato and Aristotle were concerned with the nature of knowledge itself – the relationship between the wide external world 'out there' and our internal perceptions and experience of it. Plato was influenced by Pythagoras' view that the existence of mathematical constants is a clear indication of the existence of a reality which is eternal and immutable, if only partly accessible to human perception. Plato's 'forms' or 'ideas' exist as abstract entities, providing a universal template for every object in existence, and the material world presents to us mere imitations or shadows of the real thing.[10] The route to this higher state is reason, a means of posing questions and answers to tease out inner truths, and it can also operate through the deductive logic implicit in mathematics. Euclidean geometry's ideal forms are the circles, triangles and rectangles, the cones, cubes and pyramids used in hypothetical problem-solving and while some of these concepts relate to everyday measurements, they also exist in an imaginary space where 'a point is that which has no part' and 'a line is a breadthless length', where lines run parallel to infinity, and infinitesimals diminish as far as the imagination will stretch.[11] Aristotle, however, disagreed with the notion of a Platonic ideal and believed the forms to be simply characteristics of concepts we had arrived at through actual experience. Although we might subscribe to the vision of underlying coherence in nature, we can only trust the evidence of our own perceptions in investigating it. Aristotle was the first biologist, examining plants and animals to discover their nature step by step, then going on to classify them by their basic functions.

Platonic reason and Aristotelian empiricism shadow and illuminate each other in 'natural philosophy' onwards and through to the Enlightenment. Even today, we can broadly see Platonic tendencies in the thinking that underpins mathematics and physics while Aristotle's emphasis on the primacy of observational and empirical methodologies motivates the biological sciences. When the divine influence of a single Creator was brought into the picture in the post-Classical era, broadly speaking, Aristotelian principles went on to influence Islamic science, while Plato's ideas were routed into early Christian and Judaic – Neoplatonist – ideologies, informing them with a pantheistic vision in which God and nature were as one. Descartes' *cogito ergo sum* – 'I think, therefore I am' – gives priority to independent rational thought over empirical or sensual investigation. And, as a dualist, Descartes regarded mind

and matter as separate manifestations of God's will. Spinoza, on the other hand, rejected Descartes' dualism and posited the existence of a single infinite reality or Substance of which God was the immanent cause. Eternity could be glimpsed through mathematical deduction which demonstrated that nature was ultimately governed by coherent universal laws.[12] Newton was to discover the basis of such universal laws – the laws of motion, of gravitation and the science of mechanics – and went on to lead the way for examining phenomena such as the nature of light, colour, heat, acoustics and fluids.[13] And in positing that the force acting on a falling body and the force acting on the planets in orbit were one and the same, Newton's genius was to recognise that the same natural laws operate on earth and in the heavens.

The Enlightenment is generally regarded as the impetus for the origins of modern science in eighteenth-century Europe, uniting thinkers through a belief in the supremacy of reason, particularly in the face of superstition, religious intolerance and injustice. Aristotelian empiricism was a major influence on materialist thinkers such as Hobbes, Locke and Hume who denied the existence of innate ideas, claiming instead that all knowledge is derived from sense-experience. 'Beauty is no quality in things themselves. It exists merely in the mind which contemplates them,' wrote the Scottish philosopher David Hume.[14] The Platonic vision of reality deduced through innate reason and Aristotelian empiricism in actually encountering it, were brought together in the epistemology of the founder of German Idealism, Immanuel Kant. Kant both agreed with and countered Hume's scepticism by arguing that the human mind can neither confirm, deny nor scientifically demonstrate the ultimate nature of reality. He also recognised that through the very process of perceiving and acquiring knowledge, we partly invent the world by our means of measuring it – in space and time and by the 'orders' he categorised as quantity, quality, reason and modality. Reality and our encounters with it are therefore set in ceaseless interplay with each other.

Kant's deliberate ambivalence seems to mark a dividing point for art and science. The consequence for science was that reality came to be regarded as something 'out there', to be explored as a thing in itself, and increasingly through physics rather than metaphysics. Even if the world had no ultimate purpose, its phenomena could be observed and classified to discover whether there was an inherent order in nature. The Swedish botanist Carolus Linnaeus, in his *Systema Naturae* of 1735, created a regularised method of the classification of plants according to their sexual characteristics, informed by a

belief that there was an ultimately hierarchical system which encompassed the whole of life. Although Linnaeus recognised that natural history must predate the Bible's chronology, Nature was the consequence of a God-given harmony. Linnaeus' contemporary, the French naturalist the Compte de Buffon, however, took the view that all classification systems were artificially contrived devices. And in philosophy Hegel and his followers were to promote the notion that we invent the world we perceive, going on to deny the existence of a self-contained reality and eventually claiming that history, time and religion were all human constructs, ideas which were greatly to influence arts theorists in the twentieth century (see box, page 22).

By the nineteenth century, many influential intellectuals including, of course, Karl Marx, were openly expressing uncertainty about the existence of God.[15] Among such doubters was Darwin himself, although even with a family history of vigorous liberal thinking, he held traditional Christian beliefs. His idea that all life, including all human life, had evolved in response to the wayward demands of natural selection and not by the intervention of a benign creator, was extremely heretical and he delayed the publication of *The Origin of Species by Means of Natural Selection* until 1859. Purposeless, random and even faintly ridiculous though the theory of evolution appeared, however, it was taken up by the intellectual community. Some natural philosophers incorporated it into a system of thinking that accommodated their vision of a God-given harmony. The German scientist Ernst Haeckel, for example, appropriated natural selection as a kind of divine agent for transforming simple structures into more complex ones, from molecules to cells to human brains, and so on, all the way to the universe itself, as though it were all part of a wholly conceived plan. Haeckel's fabulously illustrated book *Art Forms in Nature* still resonates with delight at the marvels of creation[16] – but so too does Darwin's wonderful *Voyage of the Beagle*, with its busy personal account of random collection and imaginative speculation.

In the nineteenth century, geometry was redefined, although this didn't yet challenge the vision of an ultimate all-encompassing unity. The German nineteenth-century mathematician Bernhard Riemann defined geometry as the study of manifolds which account for space itself with no external frame of reference, bounded or unbounded spaces being made up of any number of dimensions. Using planes to map spheres, Riemann's was a geometry that could be applied to the topology of the universe itself. And when Einstein added a fourth dimension – time – to the three dimensions of space, there formed a

single continuum – space-time.[17] Einstein's Special Theory of Relativity (1905) showed that time and space and our positions within them are relative to each other, their locations depending on the observer's viewpoint and velocity. They could therefore no longer be measured by traditional means, so Einstein brought another term of reference into the calculation, the one constant determinate – the speed of light.[18] If any object approaches the speed of light, Einstein posited, time expands, the length of the object contracts and its mass increases. Energy is therefore equal to mass times the speed of light squared, or $E = mc^2$, as the world's most famous and elegant equation puts it. Einstein felt a deep sense of awe for nature's coherence and he felt privileged to be able to use his powers of reasoning to participate in its exploration. 'We followers of Spinoza see our God in the wonderful order and lawfulness of all that exists,' he declared. 'The individual feels the futility of human desires and aims and the sublimity and marvellous order that reveal themselves both in nature and in the world of thought.'[19]

The 1953 discovery by Crick and Watson at Cambridge, together with Maurice Wilkins and Rosalind Franklin at King's College London, of the structure of the DNA molecule has led to a transformation of Darwin's theory. Genetics and the decoding of genomes, the complex genetic sequences that make up individual organisms, including our own, have resulted in the creation of whole new systems of classification which have massively refined our understanding of the underlying patterns in plant and animal life, in human heredity, archaeology, anthropology, physiology, molecular biology and medicine. Assuredly within the next few decades there will be new breakthroughs in neuroscience which will lead to greater agreement about the nature of consciousness itself – the very domain where the matter of the world out there may be more closely reconciled with our mental experience of it. But in other areas of science there have been dramatic paradigm shifts that have challenged the notion of the coherent universe, bringing back into play metaphysical speculations on the nature of human intervention and interpretation. 'We have been pushed aside by the products of our own reasoning!' as Neils Bohr exclaims to Werner Heisenberg in Michael Frayn's play *Copenhagen*.[20]

The very terminology of quantum theory is indicative not just of its counter-intuitive nature but of the way in which it evades conventional scientific scrutiny. The Uncertainty Principle states that it is impossible to know both the position and the momentum of a particle simultaneously. Light can behave as both particle and wave. The scientific observer has to make a

Contemporary artists find particular empathy with the notion that we ceaselessly recreate our own classification systems. The presentation of randomised collections – often in the style of the wunderkammer, the cabinets of curiosity displayed by the early natural philosophers – is a favoured way of reflecting a delight in nature and in human existence, tinged with more than a little irony to suggest the foolhardiness of any belief in fixed hierarchies and taxonomies and also to imply an underlying grief about the routeless nature of existence. In the summer of 1999, the American artist Mark Dion worked with teams of community volunteers to scour the foreshores of the Thames between Tate Britain and Tate Modern, picking up natural objects and human artefacts, which included oyster shells, bits of pottery and strands of nylon rope. The finds were cleaned and arranged randomly according to type of object (discarded shoe soles, shards of china ranked by colour, string, and so on) and deliberately left unlabelled, undated and certainly given no status according to 'value' of any kind. As with the undated shards, bones, stones and scraps laid out on site at an archaeological dig, the collection's only sure meaning is defined by the context in which its constituent pieces have been found – 'objects found on the riverside in the year 1999'. The collection is displayed in a forbidding mahogany specimen cupboard, modelled on the ones in the Pitt Rivers Museum, Oxford, which ironically bestows on it the authority of a rationally organised science museum display. Viewers are free to make their own associations, just as they unwittingly do when they contemplate 'genuine' science collections, their eyes moving arbitrarily from one piece to the next involuntarily investing their own layers of meaning onto the official version and taking evident private delight from doing so, as they rediscover for themselves a childlike pleasure in finding, sorting and rearranging 'treasure'.[21]

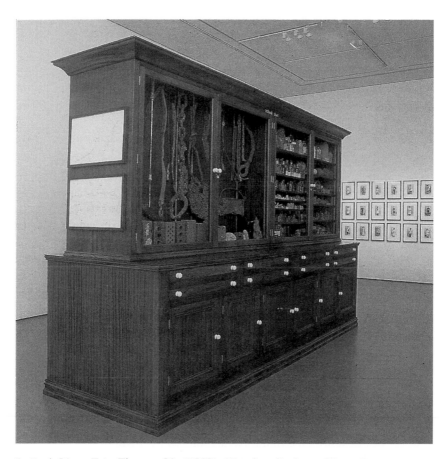

5. Mark Dion, *Tate Thames Dig* (1999). Wooden display cabinet containing cardboard boxes, polythene bags, plastic crates and found objects, 2660 x 3700 x 1260 cm. Courtesy Tanya Bonakdar Gallery.

decision which to observe, playing an unwilling subjective role in determining the definition. The term 'super-position' refers to the fact that an electron can be in two places at the same time, the concept of 'entanglement', that, once entangled, two particles are forever connected and able to affect each other's behaviour, even if they travel to opposite ends of the universe. Essentially the behaviour of phenomena at the quantum scale becomes a matter of Probability. Contemporary physics, far from being a bedrock of implacable laws and measurable function, seems to be dealing with unpredictable events

that sound as if they verge on the magical. Indeed, as physicists will sometimes wearily attest, more than a normal share of oddball mystics beat a path to their doors, hoping to find evidence at last that the universe itself is not only paranormal but psychic. Perversely, however, physicists can find coherent patterns of behaviour even where they don't quite understand the reasons for them. Experiment agrees with theory in all but a few parts per hundred million, and quantum mechanics is, moreover, used in a number of working applications.[22] And although quantum theory, which operates within the micro world, cannot be 'reconciled' to Newton's laws, which operate in the macro world, or to Einstein's General Theory of Relativity, physicists blame themselves for not yet arriving at an understanding of the process, rather than believing that reality itself could be inherently inconsistent. There is, as the physicist David Bohm has proposed, an 'implicate order' to be discovered, inaccessible as yet to empirical observation but underlying the organisation of the entire physical world.[23] We can only glimpse at it, perhaps not in the normal sense but in multiple dimensions we can scarcely imagine. Rather than drawing on the metaphor of a 'jigsaw' which will slot into other pieces of explanation about the nature of the universe, Bohm's view suggests that each small piece may contain a microcosm of the whole – 'some deep and subtle structure at the heart of my subject that we are currently too blind to see,' to reiterate Marcus du Sautoy's view of his own mathematical area of study.

Certainly, mathematics no longer seems to reflect the idea that there is a simple logic to the universe. Long before the mathematical world would take his ideas seriously, the Russian mathematician Ludwig Phillip Cantor (1845–1918) demonstrated that there are an infinite number of numbers just between 0 and 1 and more than one kind of infinity – the countable and the uncountable: infinity equals infinity equals infinity and independent of dimension, as the mind-defying proposition goes.[24] In 1931, the Czech-born mathematician Kurt Gödel posited his first Incompleteness Theorem, which states that within any contained axiomatic system, even one as basic as the arithmetic of whole numbers, there would always be some propositions which could not be proved to be either true or false. The second Theorem states that a consistent formal system cannot actually prove its own consistency. Attempts could be made to prove every conceivable statement by going outside the system in order to arrive at new rules and axioms, but this would create more problems, for this larger system would itself contain unprovable statements, and so on, ad infinitum.

That sentence is false. Or is it? The sentence that that sentence is false may be false itself. And so might this one – which might explain something about the practice of mathematics where the truth-values of basic propositions may be beyond proof. In what appear to be ever-decreasing circles of logic, mathematicians have begun to focus on how the truth of mathematical propositions can be decided. Alan Turing showed that even if a super-computer were to be put to work on sorting out the truth or falsehood of all mathematical propositions, there could never exist an algorithm which could determine whether a given formula was true or not. This hasn't rendered mathematics functionless, of course, and it can be utilised for ever more complex purposes. Cantor's 'transfinite arithmetic' enables cosmologists to posit calculations which can apply to the shape and extent of the whole universe. Boole assigned to the symbols 1 and 0 specific meanings, 1 being the 'Universe', 0 being 'Nothing', ideas which were used to underpin a form of algebraic logic and also went on to form the basis of the world's digital computing revolution. Gödel's focus on algorithms has led to the development of sophisticated computer software which can be effectively applied to a new mathematical physics. Computational mathematics address the dynamics involved in the stability of the Solar System, biological systems and the complex dynamics of life itself. Even so, Gödel's Theorem can be applied to demonstrate that because a computer's 'knowledge' is limited by a fixed set of axioms, unlike the human mind it can never stumble upon an unexpected proposition. And perhaps needless to say, this idea has informed modern linguistic theories about the capacity of language continually to re-form new ideas.

'We can't even predict the next drip from a dripping tap when it gets irregular,' exclaims Valentine in Tom Stoppard's play *Arcadia*. 'Each drip sets up the conditions for the next, the smallest variation blows prediction apart, and the weather is unpredictable the same way, will always be unpredictable.'[25] The principle that any dynamic system can be measured lies at the heart of Chaos Theory, a term which sounds at first like the ultimate oxymoron. The behaviours of random systems such as waves in the sea, cloud formations and even human systems like traffic jams and the stock market, are only 'chaotic' because they seem to defy human prediction. In science, the terms 'random' and 'chaotic' are not synonymous. If we had detailed information about all the variables involved, wild randomness could be tamed with calculations and this is what chaos theorists try to do. Behaviours of the most random events will appear orderly if they fulfil the predictions we make for them,

although if there are errors in the making of measurements, particularly in the initial stages of a system, predictions can be wrong. The 'butterfly effect' charmingly demonstrates this – an unnoticed flutter of a butterfly's wing in one part of the globe may escalate into a hurricane at the other. 'Chaos theory may appear to give a fairly depressing view of the universe as a place of instability destined to dissipate under the relentless tyranny of the second law of thermodynamics,' writes Richard Mankiewicz, but he goes on to point out how the universe is full of structures, 'from the metronomic beat of pulsars to the exquisite convolutions in a DNA molecule.'[26] Order exists, then, even if, in another oxymoron, it is disordered and complex.

Complexity Theory includes study into chaotic systems, artificial intelligence, emergent systems and artificial life, all of which can be examined if they are transformed into non-linear equations and algorithms and observed as computer graphics and simulations. In 1970 the Cambridge mathematician John Conway created a computerised miniature universe on a two dimensional grid containing evolving cells, and called it the 'game of life'. The cells survive or die according to the number of neighbour cells. John Von Neumann has even shown such cellular automata capable of self-replication, as in real life, and his analysis of the mathematics of self-production is so accurate that it can be applied to the structure of DNA itself. Cellular automata, as they are called, have been described as new life-forms, what makes them especially interesting is that some exist in a state somewhere between order and chaos. Stephen Wolfram has pointed out the similarities in their behaviour patterns to those in non-linear dynamics and has begun the job of classifying their complexity.[27] The system starts with an array of cells in one or more dimensions, each with a colour code to their state of being, according to a rule of dependence based on the cells' existing state and those of their neighbours, and the complex interaction becomes visibly manifest in repeating shapes or patterns. Some patterns are so complex that they can, in principle, simulate a Turing machine, a universal computer, which can compute equations for any structure or process in the universe. Simpler mechanisms can show how the emergence of the diverse morphologies of plants and animals – the geometries of flowers, the fractal branching patterning of trees and lungs and the Fibonacci spiralling of shells – can arise from simple rules.

The observation that nature produces reiterating patterns seems deeply reassuring and that these patterns often manifest a symmetry, more profound

still. Symmetry underlies the classification of fundamental particles and the forces through which they interact and is intrinsic to mathematical calculations in set theory and group theory, areas of research which try to find repeatable patterns and predictable sequences. Asymmetry is measured against an ideal norm of symmetry and is thus seen to be merely broken symmetry, that which is *not*, not that which *is*. A wide range of symmetries exist in nature, from snowflakes to minute carbon molecules, from starfish to the aperiodic geometrical shapes known as Penrose tilings (after the mathematician Roger Penrose), which though they never repeat in pattern fit together smoothly to make a coherent form.

All this shows that although the structure and function of many natural phenomena still appear to be indeterminate, unfixed and dependent on countless variables – not least the observer's perspective on them – scientists haven't given up on a vision of coherence. Indeed they seem to desire it fervently. Despite the fact that the Second Law of Thermodynamics demonstrates that the universe loses heat that it can never regain, with order always tumbling into disorder, despite the random twists and turns of evolution, extinctions in geological time and the suggestion that the speed of light itself might not be constant2 – the idea prevails that if we look hard enough for consistent patterns of structure and behaviour all might be turned into theorems and equations. The lengths we go to in order to perceive, measure and even predict 'reality' reflects a deep desire to master and control all nature, even while we marvel at it. In the 19th century James Clerk Maxwell unified the electric and magnetic forces into a single electro-magnetic force and there are now theories which unite to it the weak and strong nuclear forces. If gravity can be combined with Quantum Mechanics (and although this is proving difficult, proponents of string theory can see that progress ahead) a Grand Unified Theory will emerge. Given the fact that these four fundamental forces present ultimate parameters to growth and form in both organic and inorganic systems, and that complex dynamic and behavioural systems are governed by Complexity Theory, some scientists think there's a good chance they will be able to declare a Grand Unified Theory of Everything in the World, the Solar System, the Universe, and – surely not? – the Mind of God, or at least our construction of it – all the way from the evolution of the trilobite through to the death of stars in distant galaxies, from the rules governing the emergence of 'human nature' to the origins and purpose of art. Nature may be inherently symmetrical,

ordered and ultimately very simple after all.

This is a stupendous vision of one-ness and perhaps it is no surprise that scientists leap out of bed in the morning and rush to their workplaces to find another piece in the jigsaw, fractal in the Mandelbrot set or even a glimpse at David Bohm's implicate universe:

> To see a World in a Grain of Sand,
> And a Heaven in a Wild Flower,
> Hold Infinity in the palm of your hand
> And Eternity in an hour.

as William Blake envisaged in his distinctly non-scientific view of the universe.[29] Rejoicing in the beauty of computer images which show symmetries in structure and system, glorious with evolving colour patterns and multi-dimensional topologies, sinuous with order verging on chaos and snaking back to order again, scientists can sound ecstatic. This isn't simply an image. It is literally the Meaning of Life. And it is beautiful. Who needs art?

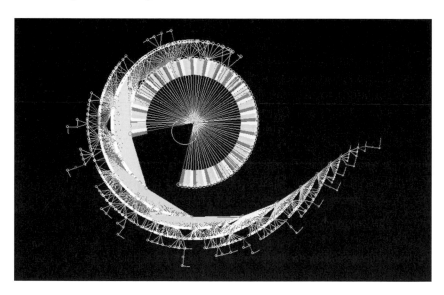

6. Andy Wuensche, created with DDLab (www.ddlab.com), *ORDER: basin of attraction (point attractor)* (2000). n=15, K3 rule 250,32767 nodes, G-density = 0.859. Courtesy Andy Wuensche and DDLab.

Chapter 2

Disconnections and Asymmetries

The Less than Beautiful in Art

O Attic shape! Fair attitude! with brede
of marble men and maidens overwrought,
With forest branches and the trodden weed;
Thou, silent form, dost tease us out of thought
As doth eternity: Cold Pastoral!
When old age shall this generation waste,
Thou shalt remain, in midst of other woe
Than ours, a friend to man, to whom thou say'st,
'Beauty is truth, truth beauty,' – that is all
Ye know on earth, and all ye need to know.

John Keats, *Ode 'On a Grecian Urn'* (1820)

Art was once regarded as the instrument of beauty. It was Kant's view that works of art are sufficient unto themselves, they have a 'purposeiveness without a purpose'. They are made purposely towards some end but that end is the work itself and the inherent pleasure to be derived from it. This is not simple pleasure. The best work demonstrates 'genius', it is original and, because it makes demands on the imagination, the understanding and a kind

of intuitive reasoning beyond the reach of material knowledge, it conveys a sense of deep and timeless completeness. But does it?

Keats' famous lines are well known and often quoted as a self-fulfilling mantra:

'Beauty is truth, truth beauty,' – that is all
Ye know on earth, and all ye need to know.

Taken out of context, they are usually interpreted at face value. But there has been much discussion about their meaning and they may not be what they seem.

In the Ode, the poet addresses a work of art, a Grecian urn, one of many of which he would have seen on his frequent visits to the British Museum where he was an admirer of the newly acquired Elgin Marbles. In art, he seems to suggest, life is arrested and forever on the brink between anticipation and fulfilment:

Bold Lover, never, never canst thou kiss,
Though winning near the goal – yet, do not grieve;
She cannot fade, though thou hast not thy bliss,
For ever wilt thou love, and she be fair!

It is the artist's ancient role to communicate between a timeless other world and the physical world of the here and now, capturing the moment in order to evoke a response which derives from imagining the living scene and understanding its essential, eternal significance. Art halts time and defies death. Here forever is human life in all its vigour:

What mad pursuit? What struggle to escape?
What pipes and timbrels? What wild ecstasy? ...
For ever warm and still to be enjoy'd,
For ever panting, and for ever young

Both urn and poem use devices – the urn's skilful carving of 'marble men and maidens overwrought,/with forest branches and the trodden weed', the poem's jewelled language, rhetorical exclamations and syncopated rhythms – to move and stir the emotions. Art may even be an improvement on life, the poem seems to suggest:

> Ah, happy, happy boughs! that cannot shed
> Your leaves, nor ever bid the Spring adieu

But in the final verse the mood changes and it now reverberates with words betokening grief – 'silent', 'tease', 'Cold Pastoral!', 'old age', 'waste' and 'woe'. In retrospect, we begin to realise, the poem's rapture is not a careless one but forced and frenzied. The last verse ends with the urn asserting (in quotation marks), "Beauty is truth, truth beauty," to which the poet replies

> – that is all
> Ye know on earth, and all ye need to know.

And we begin to see that the quotation and the poem may not actually be about the transcendent nature of beauty in art and its relationship with eternal truth at all.

Keats wrote the poem at the age of twenty-three, having recently nursed his consumptive brother Tom to his death in December 1818. His mother had also died and Keats, formerly trained in medicine, knew what his own fate was to be. His love for Fanny Brawne was hopeless, he was in financial difficulties and his work had been cruelly criticised. Over a very brief period he wrote what came to be regarded as his greatest works, the Ode 'On a Grecian Urn' included, published in a volume in 1820. But Keats was not to live to hear himself described 'among the English poets'. He died in Rome in February 1821 at the age of twenty-six. The poem was written by a young man facing the certainty of death.

When we return to the poem with this knowledge in mind, its whole mood appears different. The emotional tone is hectic, by turns feverishly flushed and despairingly cold. And the famous couplet now rings hollow: "Beauty is truth, truth beauty," it tells him and he replies,

> – that is all
> Ye know on earth, and all ye need to know.

Keats' response to the urn is an expression of bitter irony.

In what is now recognised as the Romantic period, from around 1780 to 1830, artists and poets saw it as their role to move the emotions in order to rouse the viewer to deeper contemplation. But the idea that passionate arousal was not only necessary but a healthy form of self-expression is relatively recent. Right up until the nineteenth century, the predominant view

in western art derived from classical times was that a form of beauty that provoked the emotions too much should be tempered with cool reason and the decorum of form. Plato banished tragic drama from his ideal state. It could foment passion that led to rebellion or, alternatively, despair. Plato was sceptical about the value of art and artefacts which were, after all, only mere imitations of objects in life, themselves only feeble mimics of the ideal. Beauty might exist in essence in the forms at the back of his shadowy cave but it was unattainable on earth. Aristotle acknowledged that art was imitation but justified tragic passion on the grounds that its capacity to arouse pity and fear from its audiences might be all to the good. When they witnessed the consequence of defiant heroic action on stage they would be moved to terror at the gods' indifference and feel pity for the fallen heroes. Such synthetic passion would purge them of any dangerous emotions lurking in their spirits and they could go about their lives as sanitised citizens.

From late classical times through to the Renaissance, and even up to the mid nineteenth century, artists subscribed to the Platonic pursuit for universal forms, on the grounds that individual objects such as trees, animals or men, were only imperfect copies of the eternal patterns. Artists sustained a reverence for the art of high Classicism, works which most closely achieved an approximation to an ideal form, so instead of seeking beauty direct in nature, they sought perfection from existing templates. They learned to perfect their copying according to rules established to define beauty, such as simple geometric relationships, which included the Golden Section whose measurable ratio was supposed in classical times to express inherent aesthetic values. The Neoplatonists, who in early Christian philosophical and religious systems around the third century combined Platonic thought with oriental mysticism, claimed that certain painters and sculptors must possess exceptional God-bestowed gifts for perceiving the eternal patterns underlying objects, refining the coarse matter of living things until they best represented their real counterparts in heaven.

The exquisite flowering of Renaissance art embodies what many regard as the epitome of beauty, though it is a beauty often charged with a devotional significance and an understanding of classical mythology that few of its modern viewers can share. It must not be forgotten either, that a great deal of Renaissance art was commissioned and acquired by rich patrons out of a desire to flaunt their material wealth. Even so, there can be found many good reasons to support judgements about the beautiful, evidence of an individual

artist's exceptional inventiveness in pushing the boundaries of existing conventions, so that his work has an immediacy and freshness and a kind of bravado, an ingenuity in composition, an adulation of the human form whether through a vivid depiction of the flesh tones in nudes or bedecked with voluptuous folds of fabric, a fluidity of movement, a dramatic play with darkness and light, a confidence with drawing or with brush-stroke, an intense feel for colour. There never was however, in art or life, a universal intrinsic beauty uninformed by cultural preference and rules. 'The pattern that painters found in the visible world was not the one laid up in heaven but the remembered shapes they had learned in their youth,' the art historian Ernst Gombrich points out.

> Would not a Chinese call that orchid 'perfect' which corresponds
> most closely to the rules he had absorbed? Do we not tend to judge
> human bodies by their resemblance to those Greek statues that have
> become traditionally identified with the canon of beauty?[1]

This canon of beauty was reasserted during the Enlightenment at a time when privileged men were exploring the world and bringing back objects and artefacts, both natural and antique. Some of these were displayed simply to demonstrate the wonder and variety of the world, as encyclopaediae or cabinets of curiosity containing objects loosely grouped by subject. But others were classified according to systems of hierarchical status based on deterministic theories which addressed the idea that some civilisations had through their art achieved the apotheosis of perfection. The influential Dutch scholar Johann Joachim Winkelmann (1717–1768) regarded ancient art as a reflection of the history of the human spirit and civilisation, and located its greatest achievements in Periclean Athens. By imitating the Greeks we could discover our own best selves. Roman art was inferior as it merely copied Greek style and that of the Egyptians and Etruscans came lower down in his esteem. 'From its earliest days the British Museum adopted the attitude that privileged Greek art over all other art,' writes the historian Ian Jenkins, and its influence was widespread, bestowing on the art of all other cultures the stigma of inferiority.[2]

While such beliefs still lingered in art even up to the middle of the twentieth century, the Romantic spirit of the nineteenth century discharged the quest for classical rules. Beauty was now to be found in the particular

and not the universal, to be experienced uniquely by the individual, not the general. Kant's view that we can never have certain knowledge meant that questions of faith were a matter for each individual. That individual was free to engage with reality as he wished through a kind of dutiful yearning and, according to later thinkers in the Romantic tradition, a degree of wholesome self-torment. Although a formal engagement with nature was evident in the Pastoral Tradition from classical culture onwards, Romantic artists engaged with it in person and with passion. And nature not mere artifice was to be regarded as the purest route to truth and beauty.

Edmund Burke had introduced the idea of the Sublime in 1757, distinguishing it from the Beautiful.[3] The Sublime confronted man with the boundless infinity of the universe, arousing intense feelings of astonishment, terror and vastness, all culminating in a kind of cathartic pain. The Beautiful, by contrast, was a rather gentle domesticated thing to be encountered in smallness, smoothness, gradual variation and delicacy, bringing with it a consoling pleasure. Kant's subsequent analysis of the Sublime was to disassociate it from sensations of fear of the unknown and attribute to it exhilarating experiences of splendour, evidence of a wondrous and divine spirit in nature which stimulated the alert and receptive mind. Cloud-tumbled skies, stormy seas, arctic barrenness, deep forests, wildernesses hitherto regarded as uncivilised wastes became proper subjects for deeper feeling and contemplation, and provided rich material for art and poetry. Kant explained that through a free-play between intuitive imagination and conceptual understanding, especially if mediated by feeling, we can be moved by the beauty of a work of art and come closer to the essence of nature.[4] This vision of the Sublime can be discerned in many of Turner's paintings and in the astonishing vistas of wild American territory in the Hudson River School paintings of Thomas Cole and Frederic Edwin Church, although there is an element to the latter which suggests that they express not simply wonder at the overwhelming beauty of the landscape but a desire to control and own it, indicative of the confident expansion of the New World, and, indeed, of other parts of the world, in the nineteenth century.

There was an unresolved tension between a reverence for wild nature and the desire to colonise it. This led to a lyrical nostalgia for an untainted countryside and a revulsion at its increasing industrialisation, to the view that rural people possessed a natural nobility and to a moral conscience about those in the new cities whose labours were necessary to keep the

profitable new industries flourishing. The painter, critic and art theorist John Ruskin (1819–1900) had a remarkable influence on public opinion and his views on beauty still have a residual hold. Defender of the Pre-Raphaelites, he was revolted by the ugliness of mass production that was the inevitable consequence of the Industrial Revolution and he was fervently romantic in his views on art and the ordinary working man. His beauty was to be encountered as much in the small details of nature as in its sublime vistas and his belief was that artists were to engage with it as if they had emerged seeing the world afresh, as with an 'innocent eye'. This was not to plead for originality. For Ruskin, too, art was a reflection of the Divine where a Platonic beauty is virtually interchangeable with truth:

> By the term Beauty...properly are signified two things. First, that external quality of bodies...which, whether it occur in a stone, flower, beast, or in man, is absolutely identical; which...may be shown to be in some sort typical of the Divine attributes, and which therefore I...call Typical Beauty: and secondarily, the appearance of a felicitous fulfilment of function in living things, more especially of the joyful and right exertion of perfect life in man; and this kind of beauty I...call Vital beauty.[5]

Ruskin was not simply concerned with an other-worldly truth. As the cultural critic Raymond Williams comments, Ruskin implies that the artist was 'an instrument of revelation in conflict with a corrupt society'.[6] The 'function' of art was to provide a beauty to demonstrate Man's inherent perfectibility and was a goal to strive for. But, although Ruskin is regarded as one of the forerunners of socialism, Williams observes, his is 'all in all generally a conservative criticism of a laissez-faire society, especially where he talks of "function" which supported an authoritarian idea which included a very emphatic hierarchy of class.' By Ruskin's time, huge quantities of 'great art' were being wrenched from original sites all over the world, to be owned, collected and admired by the very rich, or displayed in the new museums which had sprung up in every town, supported by philanthropists dedicated to opening the hallowed doors to the masses for their better edification. Beauty in art was beginning to replace beauty in collective religion and was seen to have a similar function – moral improvement through a sense of the ineffable, and political acquiescence to those in charge.

Adjusting a Red to a Blue

Neither science nor art can be seen outside the context of their political and social histories, and in attempting to trace the ways in which beauty has been upheld as a sacred relic, a thing pure and untainted by human ambition and greed, I have not much taken history into account. One does not have to be an unreconstructed Marxist or Foucauldian to ask the simple question – who has the power? And if beauty was something that was only ever in the eye of the beholder, it has often been exclusively in the hands of a particular holder or a few holders. The rich and powerful can own art and corral off nature but nothing is beautiful if you are starving, oppressed or dying, except the hope for life itself and then only poignantly so.

There has always been turmoil on a world scale, but in the twentieth century we became universally aware of it. It is one thing to point out that the iconography of art happens amazingly to reflect the breakdown of perceived order in science in the same period, that Picasso may have been influenced by the zeitgeist of new theories of Relativity, or that modernist art unwittingly reflects quantum theory. Far more immediate to the constituencies of both art and science was the First World War and, if any imagery predominates for me, it is that of the jagged lines, the upheaval of mud and the dismembered bodies of the trenches, visual evidence of a world-view in dislocated shards. Many of science's greatest advances have taken place as a consequence of the demands for better ways of killing or defending people. Many scientists have been victims of war and have had to flee their homelands to be coerced away from openly pursuing ideas out of simple curiosity towards applying them for secretive purposes. No one in the West was unaffected by the two world wars and the interesting coincidence may be that the advances in contemporary science that show a breaking of symmetries, a displacement of time and an upheaval of old laws and orders all happened against a backdrop of split and rupture on the world's battlefields and a radical breakdown in any consistent moral and spiritual tradition. If scientists were able to hold on to their vision of a coherent reality it was because their methodologies demanded objectivity outside any worldly boundary.

But those in the arts could not escape in this way. For although they may have referred to and revered their forebears, they evidently live in the world and if the world no longer presents itself as safe and protected then art can no longer exist in a preserve kept secure for an idealised beauty to reside in. Each new stage in the twentieth century's 'avant garde' has broken old orders

and shocked the viewer's complacency. The notion of beauty has continued to exist but it has been subject to a continual evolution in style. Some artists pursued a quest for an expression of what Kandinsky, a former theosophist, called 'the ordered development of the spirit'.[7] Kandinsky, Hans Arp, Joan Miro, Constantin Brancusi, Paul Klee, Piet Mondrian and Naum Gabo, among others, subscribed to the idea that there was a hidden order beyond all things which they strove to discover through continuously refining their work, often undertaking intellectual, and indeed scientific and mathematical research, to explain their methodologies or spiritual revelations. Each pioneered an individual form and style through abstraction, beneath or through which one can perceive glimpses – a sense of vitality or energy, flashes of light, luminescent colour, or a finer simplification of pattern or scale – betokening a vision of some profound omnificent spirit at the core of the universe. Their works have attracted a number of scientists wishing to apply the rules of mathematics or Complexity Theory to look for that hidden order. That we may perceive beauty in the work, however, may be due less to the fact that we share the artists' attempts to see into the heart of things and more that our visual systems have become accustomed to their various styles and iconographies, their familiarity breeding content and even eventual glorification.

In *Exploring the Invisible: Art, Science and the Spiritual*, the art historian Lynn Gamwell has traced ways in which art has engaged with scientific versions of nature out of a spirit of curiosity, consciously or subliminally absorbing new advances and letting scientific ideas and images affect both content and form. As a former philosopher she is interested in the ways in which both artists and scientists have sustained a belief in whole world-views at a time of systemic breakdown in both scientific theory and societal experience. In the middle of the twentieth century came catastrophic events which were to shatter a coherent vision of unity for ever. After Auschwitz, the philosopher Theodor Adorno remarked, there ought nevermore to be lyric poetry. And on 6 August 1945, towards the end of a war which had already split and appalled the whole world with its cruelties, the USA dropped the first nuclear fission bomb on Hiroshima and, three days later, another one on Nagasaki, with a combined force of 35,000 tons of TNT. Japan surrendered and the Second World War ended. Gamwell writes:

Barnett Newman, Mark Rothko and Jackson Pollock, the abstract expressionists, heard about the discovery of nuclear fission along

with everybody else, and within a few years, driven by themes associated with nuclear energy, they moved into total abstraction and achieved their mature styles: Newton's *Zip* paintings (beginning 1948), Rothko's floating rectangles of colour (from 1947), and Pollock's poured paintings (from 1947).

Newman referred to his work as sublime but, as Gamwell points out, while 'the Romantics had felt humbled in the presence of their immense and majestic deity, Mother Nature,...the Abstract Expressionists felt dread and anxiety at the knowledge that such powers were in mortal hands.'[8] The work of the abstract expressionists became more introverted and abstracted. Newman's Zip, the vertical line that divides the intensely saturated colour field on his canvases is a thin crack, perhaps a last chance of catching a glimmer of infinity. Rothko's deep opaque colour fields lure viewers towards a vast meditative spacelessness. But there is something uneasy about these works. Of Newman's paintings the art historian Robert Hughes writes, 'Their simple, assertive fields of colour hit the eye with a curiously anaesthetic shock. They do not seem sensuous: sensuality is all relationships. Rather, they appear abolitionist, fierce and mute.' Of the group of Rothko paintings in the Rothko Chapel (commissioned by the de Menil family in Houston in 1964–1967), Hughes remarks on their:

> astonishing degree of self-banishment. All the world has drained out of them, leaving only a void. Whether it is The Void, as glimpsed by mystics, or simply an impressively theatrical emptiness, is not easily determined...In effect, the Rothko Chapel is the last silence of Romanticism.[9]

After the explosion of the nuclear bomb where could art go? Philip Guston's artistic style went through markedly different periods, an earlier abstract expressionism mutating towards the ironic shrug implicit in his clumsy cartoonish cityscapes, the tragic-comedy of his squat pink man surrounded by incipient violence – clenched fists, hooded faces, piles of boots – or an untidy indifference – wonky alarm clocks, bottles, trash cans. 'When the middle 60s came along,' Guston said, 'I was feeling split, schizophrenic. The war, what was happening in America, the brutality of the world....What kind of man am I...going into frustrated fury about everything – and then going into my studio *to adjust a red to a blue?*'

Other artists such as Frank Stella, Carl André and Donald Judd, pared their work into pure form, 'the simple expression of a complex thought', as Judd described it, which encapsulated their personal musings on philosophy, architecture, design and politics; yet others used the found materials of the commerce-stifled cities, with nothing to sanctify but throwaway packaging and comic strips, and then only with mischievous irony. The honed-down minimalism of the former does possess a severe beauty, as do the gloriously synthetic colour arrangements of the Pop artists, but it is up to the viewer to confer his or her own spiritual meaning on such works and most of the world regarded them as outrageously secular. (The idea of Carl André's bricks still induces a shudder of disbelief in some areas of the British press.)

Surveying the contemporary picture, Robert Hughes expresses a regretful view that we have reached 'a sense of stagnancy which fosters doubts about the role, the necessity, and even the survival of art.' While paying respect to a core of artists whose work displays consistent and serious-minded originality (he admires Sean Scully, Robert Moskowitz, Susan Rotherberg, in America and the School of London painters Howard Hodgkin, Frank Auerbach, Leon Kossoff, Lucian Freud and David Hockney), Hughes laments the poverty of imagination and the effects of a de-skilled art education evident in most of the art he sees at the end of the twentieth century. He lays particular blame on the inflated New York art market during the Reagan era. For the flourish of new millionaires 'art was the only commodity that you could spend limitless amounts of money on without looking coarse and ostentatious.'[10]

In Britain in the 1980s and 1990s, this situation was exploited with a jokey derision by what became known as the Young British Artists, led by Damien Hirst at Goldsmiths College and bankrolled by the advertising millionaire Charles Saatchi. As they get older and develop a body of work, Hirst and his contemporaries have become significant artists but for many people they represent all that is flashy, childishly provocative and calculatingly commercial. Rigorous criticism does emerge from the better art critics but, from the outside, the art world appears to be smug and knowing, refusing to engage in a discriminating exchange of views, lest too much analysis should devalue the product. Though bestowed some intellectual gravitas in catalogue essays, a substantial body of contemporary art seems derivative, harking back, almost regretfully, to more repressive times when art really did have the power to shock. Such work seems to demonstrate little more than an existential malaise, compounding a stasis of the imagination with a weary

exhibitionism. An artist, naked and wrapped in cling-film, hanging upside down from a meat-hook, a row of lipstick-stained fag-ends stuck in a line on a gallery wall, an artist painstakingly reproducing every single name from the Bournemouth telephone directory beginning with A and Z seems to embody nothing so much as the conversation in Beckett's *Waiting for Godot*:

Vladimir	That helped to pass the time.
Estragon	It would have passed in any case.
Vladimir	Yes, but not so rapidly.[11]

Art has embraced cynicism and irony wholesale. And the spirit of Marcel Duchamp whose work, along with that of fellow Dadaists, was genuinely provocative, iconoclastic and daring when it burst upon the scene around the time of the First World War, lives on, often in limp imitation. 'Duchamp witnessed the death of the Absolute and he led a generation of American artists in a dance on its grave,' Gamwell writes. Towards the end of her book, she makes an interesting observation in which she goes back to her philosophical roots. The spiritual quest which had underlain abstract art went into decline with the sure knowledge of our capacity for total self-destruction. Instead, all that was left to express was a sceptical shrug or an unbounded existential despair. Art therefore went in one of two directions: profound cynicism, or the pursuit of an absolute negation of the self, along a path to the heart of nothingness, the *via negativa*.[12]

God has died for many people in the West and so has the idea that any political regime can provide a reliably just, all-encompassing moral authority. And the humanist concept of the individual possessed with an autonomous will is also in decline. On the one hand, there is the cult of the personal – the quest of the Me generations for an all-embracing self-gratification; on the other, perhaps as a logical consequence of neo-Darwinism, there is the gradual disappearing of the concept of the individual altogether. Who are we? Nothing but genes, chemistry and electrical charges, responding involuntarily to an environment reduced to four physical forces. And with the breakdown of traditional self-contained communities, we are thrown into the bitty decentred postmodern world. We certainly no longer share universal agreement on anything profound.

A current of mockery runs like a thread through twentieth- and twenty-

first-century art: the Dadaists, the absurdists and the craziness that is manifest in the works of Lewis Carroll through to *The Goon Show*, Spike Milligan and Monty Python. *The Simpsons* must surely represent satirical absurdity at its most affectionate, while *South Park*'s perky kids resign themselves to an insane world. For Hirst, the Chapman Brothers, Tracey Emin, Gavin Turk and a host of others, life's a bitch, and then you die. A lot of performance art presents the world as an irrational and indifferent place where pathos is met with bathos – Brian Catling, Bobby Baker, Gary Stevens or the performance groups whose very names indicate where they stand – Ridiculusmus, Improbable Theatre, Frantic Assembly, Forced Entertainment. Such work is often brilliant, funny, caustic, astute, poignant – but beautifully true?

7. Bobby Baker, *Box Story* (2001). Performance artist Bobby Baker carrying the box containing her life stories, a one-woman show devised for a church performance and subsequent tour. Commissioned by LIFT in association with Warwick Arts Centre and an Artsadmin project, 2001. Courtesy Bobby Baker and Artsadmin. Photograph by Andrew Whittuck.

Distinctions between 'good' and 'bad', too, have become taboo. Postmodernist thinking which brings loosely together the discourses of post-structuralism, psychoanalysis, Marxist philosophy, post-colonialism, historicism and many other strands of thought which oppose the idea of absolute truth-claims, encourages cultural critics to 'deconstruct' the many potential

meanings that are latent in all cultural artefacts, especially where imposed value judgements have disguised the evidence of hidden power relations and impositions. Critical theory, which can occupy up to a third of a visual art student's course in Britain (true, too, in literature, performance and film studies), refuses any attempt to make plain clear statements about the nature of experience and of artistic creation in response to it. 'Theory offers not a set of solutions but the prospect for further thought,' writes the literary critic Jonathan Culler. 'Theory is endless – an unbounded corpus of challenging and fascinating writings.' The viewer brings to an artwork a plurality of insights or intuitive concepts which ceaselessly interplay. The experience is phenomenal – imaginary, sensuous, physical, guessed, dreamed, remembered, desired – and beyond the limits of explanatory thought, linguistic expression itself being provisional, flexible, slippery. Compared with the cool rationalism of science with its material belief in wholeness, the theories employed by thinkers in the arts and humanities seem part of a playful circular game in which the truth is never to be privileged in one direction or another and is always out of reach. It goes without saying that The Truth is not deemed to exist at all and quite few are disenchanted by science, which is often viewed as socially constructed, absurdly self-important and probably sinister.

In observing how critical theory looks ceaselessly for nuances of meaning that resist ultimate closure,[13] Gamwell is reminded of the concept of the *via negativa* which originated with the fifth-century AD Eastern Orthodox monk and mystic who wrote under the pseudonym of Dionysius. Dionysius reacted against the Platonic notion of the heavenly idealised forms which had been absorbed into Christian Neoplatonism. As Gamwell explains:

> Dionysius vigorously denied any possibility of human knowledge of
> the Absolute. The Cosmos can...only be characterised by its lacks
> – it is incomprehensible, indescribable, and ultimately unknowable.
> Knowledge can be attained only by an inner journey – a *via negativa*
> in which the seeker cleanses the mind of all preconceptions. Only
> then will the sacred truth of nature reveal itself.

One has only to witness Muslims going on the Hajj, Catholics taking a pilgrimage to a holy site, Jews or Hindus or Anglicans undertaking regular worship, to recognise that the world religions still offer, through personal faith and collective ritual, a route to a simple serenity for countless people,

some of whom, of course, will be artists. But the arts community as a whole appears to be secular, at most humanist. Expected to offer personal insight into human existence in a resolutely individual fashion, artists must seek their inspiration from within, escaping the dysfunctional world with its confounding profusion of meanings to search for a silence at the heart of things. Some reach a kind of meditative calm through the actual making of their work, though not all would see this as a spiritual quest. Some subscribe to the meditative techniques and self-abnegation of eastern religions – Bill Viola, Anthony Gormley and Anish Kapoor are interested in Buddhism, for example. Others take journeys into quiet places where they may abandon the rush and mess of the world and seek some silent solace from what is left in nature – artists such as Richard Long, Andy Goldsworthy and James Turrell (we share their contemplative isolation through photographs of their work). They possess a common aesthetic – a cleanness and purity with a fondness for natural materials and rhythms, linking them to the very ancient relationships between artist and nature. But they also live in the world, and while their work is often described as beautiful – certainly more so than the work of the Cynics – such beauty contains a profound sadness at its heart. That poignancy comes, I think, from the certain knowledge that we die. The most searingly beautiful art seems to embody that knowledge as is most plainly evident in Keats' Ode.

Art tries to defy time by making a permanent record of life, but it is an ironic record. This irony is not the bitter irony of the Cynics, but the deep irony of resignation. A great deal of contemporary art, a great deal of beautiful art, is 'time-based' and plays with repetition, making loops, slowing down, speeding up, showing multiple screens and soundtracks. Shirin Neshat's glowingly lovely film installations resonate to darkly spiritual eastern music. Lost people stride the desert landscape of her native Iran in some kind of restless search, which betokens simultaneously a contemporary political urgency and a very ancient yearning which is never fulfilled. As a homage to transience, Andy Goldsworthy makes neat arrangements of leaves or pebbles or snow and Gustav Metzger pours acid on materials that will quickly decompose and disappear, leaving tiny residual traces. Such work is all the more poignant when it addresses the fragility of the world's environment. Life is beautiful. And it ends.

Science is beautiful – and it endures. Science seeks to understand and even challenge death. The periwigged anatomists of the Enlightenment smile out

confidently as they stand round the pale dissected corpse in the paintings of the Dutch Anatomy School.

8. Cornelis Troost, *The Anatomy Lesson of Professor William Röell* (1728). Oil on canvas, 198 x 310. Amsterdams Historisch Museum.

If we understand death, they seem to imply, we may one day be able to master it. A contemporary equivalent is the image made with a state-of-the-art digital deconvolution microscope by Dr Paul Andrews, biologist at the University of Dundee, which was among the winners of the 2002 Nikon International Small World Competition. It shows a luminous abstract shape, its purple shades contrasting with the jellyfish green of the fluorescent protein GFP and it is a cancer cell caught in the act of division. 'The division of cancer cells in my entry is a snapshot of what is happening in real life to a body affected by the disease,' Dr Andrews has said. 'I want people to see what beautiful images science can produce.' The idea that cancer cells can be taken out of any human context and seen as beautiful strikes a note of eerie chill. He does not speak with irony. For many artists there is nothing to marvel at in the dispassionate natural world. Our whole experience of life is dis-unified, decentred, dislocated, cruel. We must love one another, or die.[14] Actually, we must love one another, *and* die.

Gamwell's thesis – that art in the face of disunity and death is either cynically conceptual or mindlessly abstract – is not meant as a final analysis. I can't myself subscribe to its simplicity. Many works are more complicated, funny and life-affirming; some are simultaneously both abstract and cerebral and make our minds work hard to accommodate ambiguities, feelings and intellectual ideas, including, of course, musings on scientific discovery.

But first we need to step right back in time.

Chapter 3

From the Future to the Past

The Evolution of the (Artist's) Mind

I know her touch. Though she could easily snap
My wrist, she is gentle in my dream.
She probes my face, scans my arm,
She touches my hand to know me.
Her eyes are grey in the dream, and bright.

Little mother, forgive me.
I wake you for answers in the night
Like any infant. Tell me about touch.
What necessities designed your hands and mine?
Did you kill, carve, gesture to god or gods?
Did the caress shape your hand or your hand the caress?

Michael Donaghy, 'Touch' (1988)[1]

Astonishing advances into the manipulation of human reproduction are currently compounding with breakthroughs in understanding the ageing process, so that more and more it is possible to believe that birth can be programmed and death postponed. We seem poised on the brink of taking

control of our nature as never before. Moreover, a revolutionary understanding of genetics, new insights into the body/mind continuum, together with speculations about ways in which our psychology has evolved, is stimulating fervent discussion about the very essence of what 'human nature' means. Self-consciously in touch with it through engagements with art, we believe we have first-hand understanding. But do we? This chapter will go back in time and examine some current scientific presumptions about the possible origins of human nature and the next two will look at contemporary scientific views on theories concerning the evolution and function of art.

The Early Mind Evolves - A Theory

We must never forget that scientific theories begin as speculations, some of which go on to hold true, others completely disappearing from view in time. Science books from the past – even the recent past – often contain quaint assertions, accompanied by arcane diagrams, but very many of them end up as history. This is particularly so in the case of theories concerned with human nature and psychology, and may even be the fate of those theories constructed nowadays when hard science is in the ascendant. Experimental psychologists and neuroscientists, archaeologists and anthropologists are increasingly trying to prove their hypotheses through measurable scientific methodologies but while science has undoubtedly helped us better understand the past through radical techniques such as carbon dating, high-tech scanning and genetic testing, there is still much that is unknown. It is tempting to apply contemporary theories, both scientific and unwittingly socio-political, to the human mind to make definitive explanations as to how the brain evolved and operates, but in perhaps fifty years time we may see it all differently again. I say this as a reminder to myself not to get too carried away with pleasing analyses such as the examples that follow, which I find convincing because they somehow ring true for me instinctively. But at the end of the day they are *models*. The brain is not arranged this way, it may have evolved differently, but for the time being it is plausible and helpful to consider it so metaphorically.

The archaeologist Steven Mithen traces the evolution of the mind in early humans over a period of six million years from the Common Ancestor (common to humans, apes and other simians) through to the appearance of *Homo Sapiens Sapiens*, our own forebear, 100,000 years ago.[2] Over that time, the architecture of the brain evolved to adapt to new functions and behaviours in

response to increasingly complex encounters with the external environment. In turn, the mind formed an internalised model of this environment, establishing a never-ceasing interplay between the boundaries of 'real' outside and proto-real inside, between the physical and metaphysical, between nature and culture. And the capacity for envisaging the world and the social individual's part in it from within led to a facility to alter it externally.

Mithen's speculations are based on the scant evidence of the archaeological record but are informed by insights into the workings of the modern mind, and his approach is illuminating. He identifies in the early human brain four distinct kinds of intelligence, which functioned discretely: a natural history intelligence; a technical capacity; a social intelligence; and the ability to acquire language. A natural history intelligence reflected an intimate acquaintance with the landscape – with the weather, the seasons, with plants and animal behaviour. Technical intelligence, which didn't alter much for millennia, enabled early humans to make tools, forming within their minds as they knapped away at a piece of stone, a mental template of what they were aiming at. Social intelligence was a very early inheritance, evolved over six million years ago as part of a natural function of the social creatures humans were, like their simian cousins. Over this time the brain grew significantly larger, particularly as the result of increasingly complex group interactions, which stimulated an ability to imagine the minds of others in order to predict their behaviour. And this led to humans' unique facility to communicate through spoken language and hence through symbols. Language seems to have appeared at around 250,000 years ago, becoming more sophisticated in its vocabularies and syntax as time went on. Competence in these four intelligences ensured the survival of individuals operating in groups and they became 'hard-wired' in the brain.

Such intelligences may have originally operated only as a kind of intuition, felt ephemerally, not properly conscious. Indeed, more than we recognise, our minds still function at this level. We learn to 'feel' the sky darkening before we arrive at a conscious awareness that it is going to rain; even in cities we negotiate our way around the landscape half-consciously creating our private taxi-drivers' Knowledge. We are born with an intuitive understanding of some elementary physics, of gravity for example, so we know a ball will roll downhill and don't need to engage in any lumbering deductive reasoning. If we wanted to improvise a table we would take this for granted as we adjusted it in construction, honing our materials through an interaction of mental

concept and hand-eye coordination, almost without thought. And we are attuned to other people's states of mind, unconsciously picking up smell, the subtle tones in voices, noticing shifting alterations in body language, reading facial expressions, even when they are deliberately blanked. We can even subconsciously project ourselves into other people's minds and try to predict their behaviour. Only later, if at all, does such awareness make itself known to our conscious thoughts or, through language, to others. Humans use language in distinctively different ways from the alarm calls used by animals because they have syntax – they arrange words grammatically, embedding qualifying clauses in sentences, to demonstrate a complex understanding of connections, relationships, time and causation. Most neuroscientists subscribe to Chomsky's hypothesis that the ability to use language is innate in us all, with local variations acquired according to up-bringing.

The Cognitive Explosion

Up until a critical time in our prehistory, Mithen explains, the four specialised cognitive domains were self-contained and there was very little interaction between them. The mind possessed a central general intelligence within which had evolved a suite of general-purpose learning and decision-making rules, conditioning behaviour at the interfaces of each domain. The use of tools for hunting reflects a combined technical and natural intelligence; the getting and preparing of food added to this reflects a social intelligence. Until around 60–70,000 years ago, there seems to have been incomplete cognitive fluidity. Why, when and how the mind altered so significantly seems difficult to attribute to any one source, though it may simply have been an inevitable accumulation of internal intelligences reaching a critical mass over a continuum of time, leading to an escalating surge towards the emergence of a modern consciousness. The evolutionary psychologist Nicholas Humphrey proposes that the significant factor – notably in *self*-consciousness – was the development of a capability to see into the minds of others, a consequence of advanced social intelligence. This internalised the communication processes which had taken place between individuals in a social group in the outside world and self-reflexively enabled the different domains in the individual's private mind to 'talk to' each other. An increasing facility with language may have been the critical factor: social intelligence beginning to be invaded by non-social information, thereby making the non-social world available for consciousness to explore, with a consequently rich expansion of connective

ideas.[3] At any rate, it is certain that some kind of internal mind-process took place because the archaeological record shows that after millennia of cumulatively slow progress in tool-making and brain growth, humans began to produce something exceptionally complex – art.

Art-making seems to have occurred around 60,000 years ago, though archaeologists have not been able to pinpoint when precisely. Recent findings have shown earlier evidence of art among human remains in South Africa – pieces of red ochre inscribed with criss-cross patterns, dated over 70,000 years ago – and according to the anthropologist Juan Luis Arsuaga, who has investigated sites in Spain, the presence of bone jewellery amongst human remains indicates a fondness for decoration and even self-awareness at a very much earlier stage among Neanderthal humans. All the same, it seems clear that while for millions of years humans had exclusively used stone for tool-making, somewhere along a briefer continuum they started using bone and shells which they began to fashion into ornaments. These may have served as signs of social status or sexual adornment and it may be hard to make clear distinctions as to how far this differed from the kind of behaviour that animals display in territorial or courtship rituals, the bowerbird being a striking example. However, as far as current evidence shows, some 60–30,000 years ago there also began to appear, at different sites across the world, cave paintings and ornamental sculptures. These paintings are not crude outlines but evidence of extraordinary figurative skill in depicting three-dimensional animals and objects, alive with movement and clearly created with a distinctive individual style.

Most contemporary archaeologists believe that early visual art is far more than representational and informative. Some paintings may have presented useful literal information about the habits of various animals but they are also potentially encoded with a wealth of symbolic meaning. The ability to make a number of inferences from signs might have come from animal tracking – to an experienced eye a deer's footprint can provide clues about its size, its sex, age, the time of day or the weather, even its likely whereabouts, motivations and intentions. 'The same cognitive processes which are used to attribute meaning to marks unintentionally made by animals would be equally effective at attributing meaning to marks intentionally created by humans,' Mithen writes.[4] These marks, then, were signs and symbols fraught with layers of meaning and significance.

Mithen links the making of art to the four forms of basic intelligence: it involves planning and execution to a preconceived mental template (although

there is always room for flexibility and improvisation which may extend the original conception); it refers to an event or object outside the confines of normal time and place, demonstrating the ability to imagine natural worlds; it manifests intentional communication to others; and, like language, it attributes meaning to a visual image that is not literally associated with its referent. He proposes five main properties for a definition of art in prehistory: it contains symbols which are arbitrary in relation to their referents – like language; it is created with the intention of communication; it operates outside the confines of the here and now of space and time; the meanings of symbols can be variable between individuals and cultures, or may carry multiple meanings; and the same symbols may vary as a result of individual mark making.[5] Art, then, appears to have been a medium which was intended to communicate meaning at an intense level. This links it with another important phenomenon which occurred during the same critical period – the appearance of religious ideology (see box, page 54).

Envisaging Another World

Art seems to have been a medium of communication which linked the natural and metaphysical worlds. It is both anthropomorphic and totemistic. Anthropomorphism confers on animals human attributes and thinking processes; totemism gives humans a role in the wider natural world and links their ancestry to animals. If survival is reliant on the successful hunting of animals, then being able to imagine how they feel and what they might do, based on a long experience of real animal behaviour and of predicting human behaviour, would be of great practical benefit. But such projections also support the ability imaginatively to create other entities: animal gods, human super-beings and perpetually coexisting ancestors. There are vigorous cave-painting depictions of different creatures and many are part human-part animal – gods, perhaps, or supernatural beings of some kind.

The social anthropologist Pascal Boyer defines religion as a belief in non-physical beings which possess the ability to survive death.[6] Supernatural beings violate the laws of natural history – they can fly through stone or exist outside the boundaries of time and, crucially, they are immortal; they do not die. They can communicate with earthly beings and usually choose to do so via a special agent, someone privileged with the means of finding a route to the supernatural world and able to send and interpret messages. Such messages, it is hoped, may result in recognisable changes in the present

natural world and, in order to increase this possibility, the ancestors or gods must be appeased through ritual. The holistic vision encompasses the human and the natural world in a seamless continuum

If art-makers were in any way special – and they may simply have possessed excellent technical draughtsmanship or bone-carving skills to start with – then their apparent mediation between the real and the imagined other world seems to have resulted in their acquiring shamanistic status, instrumental in devising ritualistic depiction and ceremonies, which became more elaborate and codified as time went on. Art seems to have reached an apotheosis around sites connected with death. Many of the most elaborate artefacts that remain from the Upper Palaeolithic period and beyond into the Holocene, 10,000 years ago (a period of gradual transition as hunter-gathering groups settled into farming communities), have been found around burial sites. Some archaeologists believe that there is a material explanation for this because the presence of a richly endowed burial chamber on a piece of land marked a territory and was a token of possession, a sign to others to Keep Out. But in a spiritual sense the complex rituals surrounding death show that it was regarded not as a mortal finality but as a passing on to an other-world inhabited by the ancestors.

An Acquaintance with Death

We do not know when feelings such as love and grief became more complex than the simple intuitions of animals compelled by an overriding drive to survive and breed, opportunistically fondling their mates, nurturing their young or nuzzling their superiors, briefly grieving when they go. There are indications in the archaeology that Neanderthals kept alive some of their sick and injured fellows beyond their usefulness to the group, perhaps, we'd like to think, out of sheer affection or loyalty. Certainly, over the critical period from at least 70,000 years ago, burial ceremonies appear to have become increasingly formal and tender. There is a poignancy when archaeologists unearth infant skeletons buried with their mothers, surrounded by tokens of swansdown, shells or beads. Perhaps over millennia the transition of once simply functional emotions into self-conscious feelings flowered when language evolved and these emotions could be acknowledged both internally to oneself and described to others. If love and grief began to be felt and acknowledged as a result of a cognitively fluid emerging consciousness, then a conscious awareness of death would have been truly abhorrent, for the loss of loved ones, let alone

one's self, might be intolerable, as later humans certainly knew – and know – it to be. There exist many cultures, even now, in which the individual is submerged within the ethos of the collective group and especially where there continues to exist a belief in some kind of afterlife the sting of death is less painful. And it does seem that the coincidental emergence of a self-reflexive consciousness and of an elaborate mythology and religious ideology enabled early humans to explain the fact of their own deaths and those of their loved ones, an awareness acknowledged and relieved by participation in the rituals which connected them to their ancestors, who were literally perceived as still playing a vital part in daily life.

Hunter-gatherers started to settle about 10,000 years ago and became farmers, pursuing specialist skills and engaging in complicated social re-lationships, building towns, making boats, travelling, fighting and colonising.[7] Some were lucky enough to find themselves in places with a kind climate and good soils with a variety of natural grasses and herdable animals. This gave them a head start so they could develop metallurgy and writing systems and the guns and steel, which together with an immunity to killer viruses, assisted them in overrunning and colonising the lands of other peoples. As societies split and conquered, amassed wealth and reinvented their mythologies, so art became more elaborate and complex, developing its own conventions, although it seems always to have been instrumental in addressing the mystery of death and perhaps this is what it still does. Indeed, I believe an engagement with death underlies all but the most superficial works of art.

Then and Now

Shakespeare's *Hamlet* appears to stand at the fulcrum between the shared religious belief systems of ancient times and beliefs, prevalent in the West at least, and the autonomy of the individual. Hamlet's crisis is that:

> the dread of something after death,
> The undiscover'd country from whose bourn
> No traveller returns, puzzles the will
> And makes us rather bear those ills we have
> Than fly to others that we know not of...
> Thus conscience does make cowards of us all[9]

The art historian Martin Kemp has devised the phrase 'structural intuition' to describe how artists possess an exceptional ability to visualise, understand and reproduce deep processes in nature. They have acquired this partly through what may well be a natural disposition, an acute observational grasp, further developed through the trial and error of working with materials in the studio.[8] The roots of such a talent must lie in a combination of natural and technical intelligences. Artists who are drawn to patterns in nature are able to envisage complex internal pattern templates, executing works which require a combination of an intuitive grasp of form and a brilliant technical precision. We can see this in the work of Bridget Riley, Tess Jaray, Richard Serra or Richard Deacon, for example. But we also possess an intuition for communication, derived from the fact that we quickly tune into other people's feelings, images and ideas because we are social beings. Some artists combine exceptional natural and technical competencies with a love of language. Conceptual art reflects an obsession with words as signs and symbols, fraught with confusion and paradox – think of Damien Hirst's ambivalent titles with their arch poetry or puns: the giant toy anatomy figure of a man entitled *Hymn*, the cow sections called *Some Comfort Gained From the Acceptance of the Inherent Lies in Everything*. A great deal of contemporary art requires a facility for the making of unusual connections or unpredictable juxtapositions between disparate objects and concepts. A strong sense of paradox, of irony, of humour, or a way with manipulating the unexpected twists and turns of narrative may also be evidence of particularly flexible minds. This is not to say that art-making simply displays a set of skills or tricks. Its links with a sense of otherworldliness suggest underlying meanings beyond the merely visual or verbal. And it often contains a poignancy that seems to emanate from an awareness of time passing in

> this world, with suggestions that the only way to challenge the idea of
> death is through defiant humour or through finding a continuum between
> the material world and a hidden metaphysical one.

Hamlet's individual conscience – knowledge, *consciousness* – which had emerged within the early human mind as a connection-making state of self-awareness had removed him from the secure Eden of collective belief towards lonely introspection and self-doubt. Though it is now thought by some that Shakespeare himself was a crypto-Catholic, a dangerous persuasion in a Protestant land, so his doubts are those of an anguished man brought up to believe in hell, he is also an intellectual and a scholar and he expresses a Renaissance urge for self-determinism. In subsequent centuries, this combination of curiosity, bravery and truth-seeking was reinforced by a revival of interest in the classical quest for rational explanation and empirical proof outside the vaguely spiritual. The Enlightenment might have started out as a desire to find evidence of a wonderful, just and moral God but it was also inspired by an abhorrence of injustice and superstition, manifest in Europe in a widespread persecutory belief in witchcraft, and it led to an urge to investigate the material world intellectually and fairly. Perhaps it was inevitable that a respect for reason and empirical knowledge would lead to an erosion of belief in the metaphysical world. 'Natural philosophy' gave way to 'science' (from around 1833 when the term began to be used in its modern sense). And supernatural ideologies went on to be regarded by many as merely superstitious fantasies. So in our own times, even where some of us have particular religious faiths, the world as a whole is fragmented by innumerable beliefs and subsets of belief, by agnosticism and implacable atheism. Decentred and relativist, as some postmodernists would say, our world picture is fraught with epistemological and moral uncertainties. Even in the most secular and materialist of western communities, however, there still lingers, if only ambivalently, an expectation that artists have some sort of route to eternal truths. Romantic ideologies and literatures in the late eighteenth and nineteenth centuries revived a belief in the artist as some kind of uniquely individual divine messenger. The messengers or shamen in

prehistory had belonged to a world in which life and death were believed to be experienced along a continuum, and even now some faiths posit the same belief. 'In my Father's house are many mansions,' Christ tells his disciples, and for some indigenous people still, the dead are omnipresent in the living world. In the secularised West, however, we no longer much believe in this. We live, like Hamlet, fearing death, and art bemuses and consoles us while we live. We are not so sure that it can communicate to us from beyond the grave, except through some sense of gallows irony – 'The Physical Impossibility of Death in the Mind of Someone Living', as one of our contemporary messengers, Damien Hirst, puts it.[10]

Art and Nature

Can we still believe that artists connect to a supernatural world? Some do seem to possess exceptional 'spiritual' insight, particularly those who make work which addresses nature. This is not the objectified nature studied by science but the nature experienced intuitively as a living force of which human life is a part. Artists like Andy Goldsworthy, Richard Long and Mark Dion make work which uses natural objects – stones, leaves, trees, snow – and make patterns which are clearly man-made but still in harmony with natural rhythms and forms. Like natural objects, such artworks are often impermanent, and convey a consoling sense that time is cyclical, dust returns to dust, ashes to ashes, new life springs up again. Bill Viola uses natural rhythms, as in *The Nantes Triptych*, where three separate videos are played on a cyclical loop and portray the real-time experience of two women, one giving birth, the other dying, with existence between them portrayed as a kind of underwater struggle, in which a figure plunges repetitively, floating haplessly, the light around him a luminous monochrome cloud, to the sound of rushes of water and air, of troubled breathing interspersed with occasional lulls of anticipatory stillness. In the *Triptych*, time is sequential, shown in spatial order, the screens in a line showing birth, then a suspended life, followed by death. The three sequences end simultaneously and the viewer is plunged into darkness. When they start again we recognise that time is also cyclical, the video loop becoming an eternal loop of time. Two spiritual traditions are implicit: the western Christian sequence of nativity, life, death, and then resurrection; the eastern cycle of perpetual eternity. Both traditions are reflections of biological experience.

In a more recent work, *Going Forth By Day* (2002), Viola presents five scenarios, played simultaneously on giant screens and projected, like

Renaissance frescoes, directly onto the walls of a darkened gallery. The viewer stands in the midst, as in a darkened church, and is made to feel part of a mysterious ritual. On one screen a trail of people are making their way through a sunlit woodland, perhaps mourners at a wake because the scene evokes a sense of wistfulness which is conveyed in the manner of their walking, in the endless repetitiveness of the trail, in the early morning summer light shining through the trees. 'The constant flow of people suggests no apparent order or sequence,' Viola writes. 'As travellers on the road, they move in an intermediate space between two worlds.' On another screen, a couple wait for an old man to die in his small house high above a seashore, rendered tranquil by the winter sun. After they have departed, the old man is left on his bed behind the locked door but is then seen in the next video projection standing on the shore below, where an old woman has been patiently watching as her furniture is piled on the beach to be loaded into a boat. The couple embrace, then they and their furniture are taken away, the boat eventually disappearing among some distant islands on a peaceful horizon. On another screen, people are carrying furniture down a steep internal staircase and through the front door of a formally constructed stone house. The light has an autumnal clarity. There are passers by, some mildly curious, some minding their own business, many carrying personal possessions. Subtly everyone's movements speed up as if in anticipation of some kind of calamity. Some stop to help others but then they are running and tripping and catastrophe suddenly comes. A massive cataract of water plunges down from inside the house. It rushes down the stairs, it pours in torrents from the windows. It is at once exhilarating and terrifying. The remaining people and possessions are swept away. On another screen, people are trying to shelter at a kind of camp in torrential rain. A woman stands on the shore waiting for someone lost. There is an air of desperation, of hopeless disaster. On the fifth screen, a vague human form swims in fluid, fiery rays of light penetrating the water as the figure pulses and reaches.

The work seems to connect back to very primitive rituals and beliefs and the prevailing mood is of an inevitable resignation, with no resurrection. The scenario presents departure, disaster, chaos, bleakness and despair and it may well reflect our fears and foreboding for the future of the Earth in our own time, especially as the people displayed are clearly ordinary middle-class American citizens. Viola may well be a divine messenger of a very primitive kind, connecting intuitively with nature by effectively communicating danger

through the rituals set up by art. It would be fanciful and romantic to think of him as a shaman but his work clearly contains profoundly primitive resonances, which are intuitively attuned to concerns about the world. Though artists like Viola may draw on mythical landscapes and rituals, their messages have an immediacy that strike us in intensity, demanding compassion and solidarity in the face of dread.

Art like this, projected onto darkened walls, makes connections, I believe, with the ancient history of human kind. Its meaning is not literal or clear but it affects us emotionally. Full of vigour, of a sense of shared understanding, it realises our fears and our love for each other. It helps us experience the primitive at first hand from inside.

How different in mood is this from the bright Savannah scenarios objectively depicted by contemporary scientists, explaining where we came from and where we think we're going.

Chapter 4

New Mythologies

Reinventing the Past

I am the family face;
Flesh perishes, I live on,
Projecting trait and trace
Through time to time anon,
And leaping from place to place
Over oblivion.

The years-heired feature that can
In curve and voice and eye
Despise the human span
Of durance – that is I;
The eternal thing in man,
That heeds no call to die.

Thomas Hardy, 'Heredity',
from *Moments of Vision and Miscellaneous Verses* (1916)

The Indomitable Gene

Anyone who has held a new-born baby and gazed into its face will quickly arrive at the surprising discovery that within this tough little body is a personality ready-formed and wilfully resistant to things it doesn't want to do. A stranger

in your midst, it is somehow also a familiar one. As a yawn passes over its small features, there flickers the ghost of your grandmother; in a frown is a twitch of your brother-in-law; in a smile the identical expression of toothless puzzlement you recognise from a photograph of yourself at a similar age. We can see that children inherit a complex combination of physical features which we know is a genetic legacy: grandfather's eye colour, mother-in-law's eye-shape, father's myopia, sister's propensity to blink hard when tired, and so on. That they also inherit a confusion of personality traits is stranger, and that their unique individuality has evolved by accident and not design stranger still. We are each the consequence of a random inheritance of variations on the 30,000 individual genes in the human genome. These genes, individually or in combination with others, will be greatly significant in determining our physiology and well-being, but also our personality and behaviour. All human life and, more controversially, all human social and cultural life come down to what is essentially an information system.

Are artists born? There is some evidence that scientists may be. Cambridge Professor Simon Baron-Cohen, an expert in autism, has presented data which shows that scientists score significantly higher on a standard scoring test for autistic tendencies than either humanities scholars or social scientists. Neuroscientist Mark Lythgoe has undertaken research via questionnaires to scientists and artists and found that, by and large, scientists are 'systemisers' while artists are 'empathisers'. All the same, one can think of obsessive, uncommunicative artists, and the interesting questions may relate to how far they were born with particular 'talents' or how far they were shaped by circumstance, or whether, being so inclined, they gravitated towards the occupations they felt most comfortable with. All artists will possess the same basic brain structures and functions as the rest of the population but they may also have inherited a unique combination of dispositions. The term 'disposition' is an important one because any tendency, any potential towards one specialised talent or another, will be realised only if the environmental conditions are supportive. There is evidence, for example, that some artists may be born with exceptional hand-eye coordination, that some musicians have perfect pitch, just as we can see that some dancers are blessed with bodies that have a natural symmetry and grace, resulting from a lucky combination of critical limb proportions and a fine sense of balance. Such characteristics are physiological facts, but our encounters with the world will determine whether we use them or lose them. For the development of skills

environmental influence is crucial. Ambitious parents seeking the recipe for a little Mozart or Leonardo might in future look to genetic engineering but they will also have to provide a suitable environment – as many parents already try to, sometimes hot-housing a small child against his inclination. Mozart himself may have inherited the family disposition but he was also exposed to music from birth and encouraged by his father as soon as he could sit on a piano stool, playing the harpsichord at three and writing his own compositions at four. His siblings received the same early musical encouragement but died young, apart from his sister and, presumably because she was a girl, she was not given the same degree of exposure. And, of course, his style of composition didn't spring from nowhere. His early works sound similar to those of his Viennese contemporaries and it was only over time, with increasing confidence, persistence and adventurousness that he developed his own unique style, what has come to be called his 'genius' – not an instant visit from a Muse, or even a Gene, but a combination of disposition, imitation, self-discipline and imaginative bravado. But artists might also emerge against all expectation – writers from homes with not especially literate parents and few books, musicians from tone-deaf families, elderly people discovering a 'gift' for drawing only when they have immersed themselves in the practice much later in life. Is this the consequence of genetic determinism or just determination?

How do we define natural talent or aesthetic value anyway? Cultural definitions are often made according to cultural assumptions. Jackson Pollock's hand-eye coordination skills are irrelevant when we consider how well the work captures the agitated spirit of his time. Is perfect pitch necessary to appreciate John Cage's defiant dissonance? Can't disabled dancers move with elegance and passion? Some cultural theorists may go so far as to predicate that all our habits, actions, skills and behaviours, even including things as basic as our gender, reproductive urges, or competitiveness, reflect cultural positions or linguistic definitions imposed on us through a network of privileging cultural values.

Evolutionists would certainly not agree. Their view is that at birth we arrive with a substantial body of knowledge about the world which we share with the rest of the human race. Humans are social animals. Our cultures may look different superficially but they are essentially the same because humans are intrinsically the same and their function is to serve the biological imperative to survive and self-replicate. But yes, some individuals will possess

a combination of 'lucky' genes and display 'natural talent' and, moreover, this may be socially useful to the compulsion to survive and breed.

Culture Wars

'The willow tree at the bottom of my garden is pumping downy seeds into the air,' writes Richard Dawkins in *The Blind Watchmaker*:

> It is raining instructions out there; it's raining programs; it's raining tree-growing, fluff-spreading, algorithms. This is not a metaphor, it is the plain truth. It couldn't be any plainer if it were raining floppy disks. It is raining DNA.[1]

Neo-Darwinists believe that the gene is impelled by nothing more than an imperative to reproduce itself. It may operate in a context where other genes are bent on the same self-replicating course but genes don't think, they are goal-less and they are not knowingly cooperative. But if they are not 'kind' then neither are they 'selfish'. And Dawkins' appropriation of this blatantly anthropomorphic term encapsulates for some a suspicion that the application of the neo-Darwinian imperative to all aspects of human 'nature' is driven by a section of the science community which may have a hidden agenda. 'Selfish' is a provocative word and it sounds unnecessarily aggressive, as if the neo-Darwinists, having depicted human nature as fundamentally imperialist, wish to secure their place with the Alpha males and not with the placatory losers.

In their writings, most neo-Darwinists present convincing intellectual and free-thinking liberal credentials. Dawkins himself expresses a heartfelt belief in personal freedom, driven by a conviction that ignorance and superstition are the quickest routes to prejudice and exploitation in human society. All the same, it would be interesting to speculate whether he could have imposed a different personality on the gene. One man's selfishness might be another man's bravery. How about the Plucky Little Gene? The Gene could have been the Indomitable, the epitome of the lone hero, not selfish and imperialist but self-reliant and fearless, the kind who exists in the mythology and literature of every culture, compelled, against odds as bizarre in epic magic as they are in biology, to adapt, survive and reproduce – a Ulysses, a Rama, an Anansi or an Indiana Jones. Indeed, if anthropomorphism is a way of making science palatable to the wider public, the neo-Darwinists missed a trick in not pointing out how interesting it is that our recurrent myths and literatures reiterate the

universal truths evolved from our collective biological struggle to survive. But there is immediately a problem to my suggestion if you look at my list of heroes. They are all men. 'Of course they are!' the evolutionary psychologists would retort. 'That's nature for you.' 'Of course they are!' reply the cultural relativists. 'That's how you choose to interpret nature!' Even *Tomb Raider*'s post-feminist Lara Croft encapsulates male values.

But we should not fall into the trap of giving genes genders, personalities or quasi-political roles. And although genes may be individually self-determined, their survival depends on that of other different genes or groups of genes in their immediate vicinity, those which make up a single component, or a whole organ, in the context of a whole organism, and its relationship to the outside environment. There are debates about the extent to which genes compete or 'cooperate' – another anthropomorphic term and one which can be used to give a more positive view of nature. In reality, however, genes are just genes and an individual's make-up is determined by chance combinations of inherited genes. Personality-free, the fittest components survive collectively and we are who we are. Might our ideas, fashions and cultures also be the consequence of a process of competitive selection and adaptation?

The Memeing of Life

In the final section of *The Selfish Gene*, Richard Dawkins introduced the gene's cultural equivalent, the 'meme' and its theory, 'memetics', proposing that fashions, diets, customs, language, technology, critical theory – and art – are simply discrete information systems existing solely to be passed on. Genes have a self-replicating goal: to ensure survival of the individual via the organisms they contribute to forming, simply so they may reproduce. Memes are the same and their function too is self-replication. Like genes, memes possess variation, heredity and differential fitness and, moreover, they must also display longevity, fecundity and 'copy fidelity', the ability to replicate an idea exactly. Memes which combine to form whole systems of thought, like religions or movements in art, form 'memeplexes'.[2] Philosopher Daniel Dennett describes the idea as 'an invasion of the body snatchers' since the ultimate implication is that rather than ourselves creating our cultures, our cultures create us.[3]

The idea is amusing. Perhaps artists are not operating independently but become 'infected' by memes and reproduce them with barely a personal intervention. This may be a neat if inelegant way of explaining why many

contemporary artworks look the same, or are 'derivative', as we are more inclined to say, as in – 'he tunes into the *zeitgeist* of a *fin de siècle* urban *malaise*', or 'you fashion victim, you!' And occasionally there's a glimmer of inventiveness, perhaps the result of a random mutation to a meme, a kind of Chinese whisper, which will, in turn, be passed on as a variation, off to infect the world again.

It is interesting to note that the notion of memetics is analogous to the historicist idea that artworks are the inevitable products of a particular time and place, the artist's mind simply a conduit – a 'vehicle' or 'replicator', as the memeticists would say. Memes spell the Death of the Author, 'the modern scriptor is born simultaneously with the text...and every text is eternally written *here and now*', as the literary critic Roland Barthes wrote in 1977.[4] All the same, memetics doesn't account for the fact that some artists seem to be right outside the memeplex. William Blake's startlingly original paintings and poetry run counter to the prevailing trends of their day, even though one might be able to trace his many inspirational sources in various corners of historical culture. The striking originality that is often claimed to distinguish great art can't be explained through the reductive mechanics of memetics.

Memes are an invention, an ingenious one perhaps, but at the end of the day conceptual 'sky-hooks', as the philosopher Mary Midgley observes.[5] The philosopher Roger Scruton posits the view that the theory of the meme is

> best seen not as a truth-seeking but a power-seeking device. It enables the believer to adopt a stance of cynical disenchantment towards the human world, to look on the people whose ideas he dislikes as though they were creatures in a state of intellectual eclipse, to be first pitied as victims and then dismissed as fools.[6]

Moreover, Dawkins acknowledges the fact that originality exists:

> if you contribute to the world's culture, if you have a good idea, compose a tune, invent a sparking plug, write a poem, it may live on, intact, long after your genes have dissolved into the common pool... The meme-complexes of Socrates, Leonardo, Copernicus and Marconi are still going strong.[7]

It will be interesting to see how long the idea of memes will be going strong. So far, the construct has failed to catch on in the art world.

Evolutionary Theories

From the second half of the twentieth century, the prevailing view amongst social scientists and also arts theorists was that our behaviour and attitudes are substantially formed by culture and nurture, some believing this to be *exclusively* so. There have been sound political motives for taking such a stance, particularly where derived from a guilty post-imperialist conscience which carries the burden of a history in which dominant cultures have – often violently – imposed their values on others: male attitudes to women, heterosexual attitudes to homosexuals, imperialist values on other peoples. Even a slight glance at historical evidence from not so very long ago will find expressed, often as scientific fact, views which explain how 'naturally' inferior are women, native peoples, homosexuals. Oppressed people have had to conform to other people's stereotypes, invented for the purposes of conquering and containing them. And this idea has extended to all of us, even where we thought we were independent and free. Post-Freudians have reminded us how we are burdened by repressions resulting from our early family life, Marxists and Foucauldians by the power of the political hegemonies we labour under or subscribe to. Every aspect of our lives is the consequence of psychological, social and cultural conditioning. The critical theorist Judith Butler has gone so far as to express a conviction that even gender is a construction commodified by oppressive cultural conditioning. This is surely a position hard to sustain, in my view, especially in the light of increasing scientific evidence of differences in male and female brains – let alone bodies. But many people are circumspect about expressing a strong opinion on what it is that fundamentally constitutes 'human nature' lest it should be viewed as influenced by 'privileged' backgrounds, especially if the privilege is male or straight or rich or Eurocentric.

As art is part and parcel of culture one must be wary of where value judgments come from; they may be particularly suspect if they imply a hierarchy of supremacies. We know that when our museums, galleries and collections were established during the Enlightenment and thereafter, a preference for creating orders of status came into the ascendant over the more encyclopaedic approach of the randomised cabinets of curiosity. If nature could be organised into 'trees' with higher branches implying higher status, so too could art. Greek art was at the pinnacle of perfection, Roman inferior to it, Etruscan and Egyptian lower down the scale, and the art of other cultures held decreasing status. Within recent memory, the British Museum itself hived

off some of its ethnic collections into the Museum of Mankind while now, of course, there is a widespread urge for museums and arts organisations to reappraise the arts from different cultures and also to be socially inclusive in everything from scholarship to public access. There have been swings of opinion as to whether canons of great works should be selected for study in preference to emblems of popular culture. Which is 'better'? Shakespeare or *The Simpsons*? Keats or Bob Dylan? Classlessness, tolerance and multiculturalism are celebrated; cultural diversity, difference and otherness respected on their own terms. Declamations which privilege traditional forms of social order are suspect, especially in academia. It may be small wonder that some aspects of neo-Darwinism are treated with suspicion, considering that it is a school of thought which originates from the competitive idea of the survival of the fittest, although the idea that we are biologically universally the same surely sounds like the ultimate declaration of equality.

In his 1872 book, *The Expression of the Emotions in Man and Animals,*[8] Darwin catalogued an array of facial expressions and showed that there are universal gestures of grief, of affection, of amusement, of anger, of all the emotions which are the same the world over, irrespective of culture. Out of dramatic necessity, Shakespeare's Shylock in *The Merchant of Venice* raises the same question and from our educated perspective we are bound to agree:

> Hath not a Jew eyes? hath not a Jew hands, organs, dimensions,
> senses, affections, passions? fed with same food, hurt with the
> same weapons, subject to same diseases, healed by the same means,
> warmed and cooled by the same winter and summer, as a Christian
> is? If you prick us, do we not bleed? If you tickle us, do we not
> laugh? if you poison us, do we not die?[9]

until we are brought to an abrupt moral dilemma in considering his last question: 'and if you wrong us, shall we not revenge?'

If we all share universal physical and sensual characteristics, do we also share a universal predisposition to violence and retribution? To believe otherwise would be potentially racist and we have to remind ourselves that Shakespeare's generally vicious portrait of the Jew reflected the anti-Semitism of his time. Real human nature is embodied in Shylock's interlocutor in court, Portia, who is disguised as a lawyer, with her sense of natural justice and the quality of mercy, which 'droppeth as the gentle rain from heaven', is it not?

Yet according to the evolutionary psychologists we *do* all share a predisposition to violence. We share a vast array of similar characteristics that are common across all races and cultures. The anthropologist Donald E. Brown has compiled a list of some 373 'Human Universals', which includes things as various as an innate fear of snakes and spiders; the use of customary greetings; tabooed foods; musical repetition; tickling and nepotism.[10] The evolutionary psychologists Leda Cosmides and John Tooby propose that, far from being born with minds that are 'blank slates' to be inscribed with individual experience and the mores of different cultures, our brains share an identical range of 'hard-wired' specialist modules – they use the metaphor of a Swiss army knife – which have evolved to cope with those aspects of our environment vital to our survival as animals, social animals in particular. These are surprisingly specific and include:

> a face recognition module, a spatial relations module, a rigid
> objects mechanics module, a tool-use module, a fear module, a
> social-exchange module, a kin oriented motivations module, an
> effort allocation and recalibration module, a child care module,
> a social interference module, a friendship module, a semantic-
> inference module, a grammar acquisition module, a communication-
> pragmatics module, a theory of mind module, and so on![11]

Of course, our experience of life isn't rigidly modular but elaborately connected in a web of social motivations. And most of the single modules above are beneficial, or at least neutral characteristics and not ones anyone would want to disown. The school of evolutionary psychology focuses on the evolved or adapted psychological mechanisms that underlie human behaviour which originate from responses to the challenges faced by our hunter-gatherer ancestors in the African Savannah during the Pleistocene era, from 1.8 million to 100,000 years ago. And its declarations sound uncomfortable because they present what some see as unpalatable truths about human nature. The idea that sexual selection, the imperative to pass on our genes, is our most fundamental urge, that men are essentially hunter-gatherers and that this explains their tendencies toward violence, aggression and rape, that they prefer younger women with child-bearing hips; that women's compulsion to bear and nurture children predominates; that step-parents are much more likely to be unkind than natural parents and so on, has caused a storm of protest amongst social

scientists and many in the arts community too.[12] Taken at a glance, it sounds as if evolutionary psychology has an agenda that is mischievously sexist and imperialist. If this is our nature, is the logical conclusion, why are we bothering to forge equal professional opportunities for women if by the time they reach their thirties they begin to manifest the 'Bridget Jones syndrome', hankering after babies and complaining that men have 'a commitment aversion'? Why try vainly to say that poverty and deprivation are the causes of inner-city violence when it is clear that young men are incurably aggressive and naturally bred for warfare and pillage?

This is flagrant stuff, but most evolutionary psychologists are quick to stress that they are not making moral judgements and that when we examine human nature we should not confuse how it 'is' with how it 'ought' to be. If we understood real human nature as it was back in the Pleistocene era, we might better be able to interpret human behaviour now and take it clearly into account when making social policies. Moreover, our intricate minds have evolved to use sophisticated tools, language and complex social systems so that we may play a part in determining our fate. And the fact that we share universal characteristics must surely be reassuring. Different races and cultures are fundamentally the same, exhibiting the same levels of intelligence, skill and adaptability, uninfluenced by their sometimes devastating cultural histories, and this gives the human race a shared inheritance.

All the same, one wishes the science of evolutionary psychology were tougher. There is actually very little hard evidence about human behaviour in the Pleistocene era. Evolutionary psychology often seems to be stuck in a warp on the grassy African plains, even though we know that early humans didn't stay on the Savannah but moved from around 2 million years ago out of Africa into quite different terrains. At its most speculative, some of the 'psychological' evidence is acquired through questionnaires circulated today and it doesn't sound very plausible under scrutiny.[13] There is living evidence, however, as witnessed in the following scenario:

> Yeroen was a peace-loving and law-abiding leader in a small
> community, but perpetually challenged by Luit who was always
> starting a fight. Yeroen's women friends were in agreement about
> Luit's anti-social nature and scolded and mocked the aggressive
> younger man. But Luit had a certain charm and, in time, some of
> them began to listen to his grievances and to tolerate his company.

Of course, when Yeroen approached, Luit kept out of the way but once Yeroen was out of sight, Luit paid court to the women again and played with their children.

Luit's best friend was Nikki who was a bit of an outsider, not much liked by anyone. One day, while Luit was flirting with the women, Yeroen arrived unexpectedly and there was an argument which escalated into a full-scale fight. Yeroen's supporters among the women sprang to his defence but to their surprise they were challenged by the hitherto disregarded Nikki. After a long struggle, Luit overthrew Yeroen and saw him off and took his place as the new leader of the community, with the once spurned Nikki acting as his adjutant.

Now that he was in charge, Luit became much less provocative, and rather than being the source of conflict, he became the champion of peace and stability. When the others were quarrelling amongst themselves he would intervene and, without taking sides, would calm them down, with the threat of violence only for the most aggressive. He would always champion the weaker members of the community and rush to the rescue of anyone being unfairly attacked. He even chased away his friend Nikki when he found him attacking Amber, one of the women.

But his rule was short-lived. Behind his back, Nikki had formed an alliance with the disgruntled Yeroen and after an unexpected struggle, Luit himself was seen off and Nikki took his place, becoming supreme commander over all.

This is not one of Kipling's *Just So* stories, nor is it the plot of an undiscovered Shakespeare play. It is not from an ancient myth, a storyline for a soap or a piece of reality TV. It is an account of the behaviour of a colony of chimpanzees at the Burgers Zoo, Arnhem, observed by the biologist Franz de Waal in 1982.[14]

There are dangers in drawing too many inferences from animal behaviour models and applying them to humans but there is something obviously recognisable in this 'Machiavellian behaviour', as it has been described by ethologists (animal behaviourists), even while they are wary of the dangers of using human behaviour models to apply to animals. The notion that

communities are always ruled by competing Alpha males and that females play a subordinate role does not feel acceptable in a post-Marxist, post-feminist society. All the same, the story contains the twists and turns of power relations, the deceits, betrayals, gossip and changing loyalties that occur whenever people come together and are deeply recognisable from our literatures. We don't have to condone the morality in order to be rather impressed by the complexity of social interactions that primates engage in. The chimps' story discloses strategies which display extraordinary cunning but there is also kindness and cooperation amongst the outbreaks of 'brutality' and a prevailing vision of harmony and justice. And this is a story not of the individual but of the group in which individuals are components. It is a social group in a perpetual state of self-regulation and the power struggles and readjustments happen as part of a relentless search for an equilibrium which will best favour survival for the majority.

Of course, animal group models are particularly difficult to apply when the world is fragmented into countless communities and sub-communities. Moreover, we have come to believe in the autonomy and independence of the self-reliant individual and in our busy lives we belong to a number of small communities rather than one. Even so, many of our myths and stories play on the struggle among and between groups of individuals to find an equilibrium. Conflict and conflict resolution is the stuff of the drama workshop, informs the plots of all plays and can even be applied to an analysis of history. But it does not do to oversimplify our socio-biological nature. Human existence has become extremely complex and sophisticated – our facility with language demonstrates this and distinguishes us from animals, and we are able to construct profound metaphysical explanations for our existence in the world. And philosophers and thinkers are equally exercised by considerations of ethics and morality. If nature is amoral and favours only the survival of the fittest, how should that influence our view of ourselves? Do we shrug our shoulders and accept it? Or should we not rather point out that with our great intelligence, our potent language skills, our ability to recall, reinterpret and re-imagine, we can alter our nature? We have the capacity to create and develop philosophies, moral arguments and ideals which can undoubtedly influence the way we behave. We have only to look at the changing ideologies which inspired feminism from the late nineteenth century onwards, for example, and the way in which feminist values have taken hold, become accepted in the liberal world and hotly debated even among more conservative cultures. Such thinking *has* influenced the way we

view our nature: we choose to plan or limit our reproductive capacity, we encourage women to engage in all kinds of pursuits – physical, intellectual, social, political – which were formerly thought to be 'naturally' male, or vice versa. We don't have to be constrained by our biology.

Art has always played an important role in holding a mirror up to nature and it often reflects the debates and conflicts of its period, particularly in our own times by exaggerating, distorting, shocking, teasing and reproving. Cindy Sherman's provocative caricatures of women as sex kittens, glamour queens, fragile victims or bored housewives in the 1960s and 1970s were clearly challenging the idea that this had to continue as a reality for women – biological but culturally reinforced – and they contributed to a feminist revolution in the West which all but the most reactionary see as good for society as a whole. Jake and Dinos Chapman's 2000 work, *Hell*, consists of a room of glass cases in which hundreds of toy Nazi soldiers ingeniously molest one another against a reconstructed Holocaust landscape. The work displays an uncompromising savagery, made all the more bitter because of the way it perverts childish toys by putting them to deeply disturbing uses. But this is not ammunition for a silly debate on whether it is appropriate to allow small boys to play soldiers, nor is it an indifferent depiction of human nature. For all its gratuitous violence, in demonstrating our capacity for obscene terrorising, the piece is deeply moral in intention.

So, too, is Stanley Kubrick's 1971 film, based on Anthony Burgess's 1962 novel, *A Clockwork Orange*, an exposition of violent and anti-social behaviour amongst young men which is especially abhorrent because it is carried out for fun. Led by a thug called Alex, the outlandish gang follow a sinister clownish dress-code, speak a private language (called 'nadsat') and listen to loud recordings of Beethoven's symphonies while engaging in horrific violence. Burgess's post-war references to fascism are clear but this is a peacetime parable. After a trail of aggression and rape, Alex is eventually caught and the authorities decide that he must be cured of his violent nature. He is subjected to a course of aversion therapy, his eyes are pinned open while he is forced to witness film of Holocaust atrocities, accompanied by the high Romantic sublimities of Beethoven's Ninth Symphony, which he had played to inspire his own crimes, receiving jolts of electric shock at intervals. He ends up with a reflex terror at the very idea of violence but he is also traumatised by the sound of Beethoven's music. A senseless dummy, docile and mild, he is emasculated and dehumanised.

9. Jake and Dinos Chapman, *Hell* (2000). C-type print, 78.75 x 94.5
in (200 x 240 cm) of installation comprising glass vitrine containing
specially cast and hand-painted toy soldiers with miniaturised model-
shop landscape. Photograph courtesy Jay Jopling (London).

When it was released the film caused a furore. Kubrick himself recognised
that the first part glamorised violence to such an extent that it seemed to
be inspiring copy-cat crime too awful to contemplate, so he voluntarily
declared it banned. But the 'treatment' of Alex, the amoral criminal, sparked
almost as much controversy because it acknowledged that aggression was as
inextricably bound up in human nature as the capacity to appreciate sublime
beauty. Such artworks, charged with the capacity to entertain and shock, have
a moral purpose and make us question exactly what human nature is.

The Blank Slate Meets the Noble Savage

Along with the idea that the mind is a clean sheet to be inscribed by culture goes the Romantic hypothesis, as Steven Pinker points out in his provocative book *The Blank Slate*, that human nature is pure and free, 'natural' and good, the mind and nature possessed by Rousseau's Noble Savage.[15] The child is born innocent and untarnished, 'trailing clouds of glory', until the world makes its imprint on the unsullied spirit, conditioning it for good or ill. Romantic ideology has had a grip on notions of child development for much of the last century, and is still evident in the rhetoric of 'creativity' that prevails in arts education.

Ideological fashions come and go, and I could do worse than illustrate changes in theoretical stances experienced in my own lifetime. In my Welsh primary school in the 1950s, it was not thought appropriate for girls to do Art because it was regarded as far too messy and was properly a job for the boys. Instead, we had to endure Needlework which was seen as handily pretty and would come in very useful to our future careers as wives and mothers. Years of my life were taken up trying to perfect sample stitching (hem stitch, stem stitch, French knots and Lazy Daisy), embroidering a hot-water bottle cover and knitting a pair of ever-expanding socks. I also became acquainted with the arcane skills of drawn-thread work, appliqué, crochet and tatting. My efforts were neither pretty nor useful and the cries of 'Unpick! Unpick!' still ring in my ears. Neatness and precision were all-important but I acquired skill enough and might yet show Tracey Emin a thing or two. If subsequent child development studies have shown that it is difficult for children to acquire fine motor skills until a certain age, diagnosing those who struggle thereafter as dyslexic or dyspraxic, I can only point them to samplers cross-stitched by average six- and seven-year-olds in the past. That some of the fabric was pin-pricked with blood was thought of as suitably corrective. We were under strict instruction and the only 'creative' say we had in the matter, provided we were good, was a chance to choose our colours from a limited selection of embroidery silks or wool scraps (I can recall the sheer pleasure I took from a skein of pale mauve).

When we were not sewing, the whole class was introduced to a lot of poetry and great chunks of the Bible, much of which we learned by heart and which we had explained to us in detail. We were not encouraged to have any views of our own but, by the age of ten, we were well able to unravel the many references contained in Keats' sonnet, 'On First Looking into Chapman's

Homer'. From this brief poem we learnt about Keats, Pope, Chapman, Homer, the discovery of the Pacific, the fact that Keats was wrong to attribute this to Cortez instead of Balboa, and a recognition that the line 'when a new planet swims into his ken' referred to Herschel's discovery of Uranus in 1781. We had a selection of prints of Pre-Raphaelite paintings on the walls, all of which, we were told, were abounding in moral instruction (it would have been shameful to make any comment on their sensuousness) and we learnt about Rossetti and his sister Christina and also of Dante and Beatrice and the scolding aspects of *The Divine Comedy*. We learnt to sing and read music and had a wide repertoire of hymns, folk songs and military marching songs, with the odd chorus from an oratorio by Handel, Mozart or Mendelssohn. I was prone to daydreaming, and I can recall my head-teacher complaining to my mother, 'the trouble is, she's got too much imagination.'

Though my teachers never referred to any educational dogma in our hearing, its prescripts were clear: girls and boys had different aims in life, the quickest route to learning was 'drumming in', art meant a collection of great works which were there for moral instruction, there were scarcely any limits to a child's potential to work with hand and eye, and it was inconceivable that we should have an opinion on anything at all, let alone – heaven forbid! – express our feelings.

My school must have been in an ideological backwater because around this time educationalists were beginning to catch up with the sentiments, first attributed to Rousseau, and by way of poet and educationalist Malcolm Arnold's view that 'the pursuit of perfection, then, is the pursuit of sweetness and light',[16] into the full confluence that swept arts education along in the wake of Herbert Read's seminal book, *Education Through Art* (1943). That 'through' is very telling. It was Read's view that 'the secret of our collective ills is to be traced to the suppression of spontaneous creative ability in the individual.' The so-called Progressive Movement in education, which developed via Pestallozi, Herbert Read, Froebel and Montessori, burst the dam of education by instruction, and suddenly teachers were encouraged to provide opportunities for children to release their inner creativity. The titles of some of those early books say it all: Caldwell Cook's *Begin with the Child* (1917), Marjorie Hourd's *Education of the Poetic Spirit* (1949), Adrian Stokes's *Painting and the Inner World* (1963), Robert Witkin's *The Intelligence of Feeling* (1974) were all written with the best of intentions and, it has to be said, some genuinely productive insights. It is clear to see simply by looking

at my own constrained, not to say cruel, experience that it was time for a revolutionary reappraisal and many of these texts led the way for children to discuss their own responses to the arts and offered them a chance to pursue individual trajectories in their own art-making. But the rhetoric which appeared at the heart of the school of Self-Expression demonstrates that many educationalists cherished a view of the child both as a pure empty vessel and as a natural being who, given the right opportunity, would make connections with a well-spring of natural goodness that lay deep within. The very word 'education', we were told, meant *e duco* ('I lead *out*'), implying that there was something innate and, by implication, something innately *good* to be led out. (Actually the earliest dating of the word comes from the Latin *educare*, meaning to 'rear, bring up children', and its most common use 'to instruct or provide schooling for'.)[17] Some of the rhetoric verged on a missionary ecstasy. In a conference paper published in 1982, 'Knowing Face to Face: Towards Mature Aesthetic Encountering', the arts educationalist Malcolm Ross told his audience that through 'worshipping the world...We sense ourselves as unique, holy, sacred beings.' He went on:

> Aesthetic Education in my view seeks to sustain and enhance the direct link between the child and the phenomenal world. More particularly it seeks to bring the child in to a loving relationship with the world sensuously perceived, to provoke experiences of rapture and joy through such encounters and to build the child's self-esteem as a creative and unique human being.[18]

Teachers attending such conferences must have gone back to their classrooms feeling rather depressed. For children had a direct route to quite another source of uplifting enlightenment – their television sets. If anyone was hoping for children's art to provide an insight into the world sensuously perceived, they must have been dismayed to see drawing after drawing of warring ninja turtles or preening Barbie dolls. When asked to enact scenes in their drama classes, children of primary school age were more than likely to provide the latest storyline from *Grange Hill* or *EastEnders*, with its cod-naturalistic dialogue, and to 'compose' music in the manner of the band of their choice. What else did they know? Should their teachers not provide some different stimulus for their latent imaginations to pursue?

But worse, teachers were discouraged from intervening with the stream of

personal insight that might still emerge from under all these influences, which were to become ennobled – and politicised – by the term 'popular culture'. In the struggle to be fair, the Romantics had met up with the Politically Correct; each was equally afraid of intervention, lest the innocent mind should be corrupted with the values of the prevailing hegemony. Teachers could set a situation up, perhaps by telling a story or providing materials, but then they should withdraw. This even extended to the teaching of basic skills. Arriving each day at their nursery and infant classes in the mid 1980s to early 1990s, my daughters would sigh at the sight of tables strewn with plastic bricks, paints and cardboard, glitter, play-dough, sugar paper, fuzzy felts, empty toilet-roll tubes and other knick-knackery, out of which they were to make some kind of intuitive artwork to present me with that evening. Of course, no one ever shouted 'Unpick!' at them, so none of us had any idea whether these creations were any 'good', value judgements being much frowned upon. But children provide their own value judgements, admiringly observing those of their peers who have somehow become particularly accomplished – Good At Art. An experienced nursery nurse described how she had found a small boy on the brink of tears enviously watching his fellows cutting out paper shapes. Recognising his problem, she took the pair of scissors and showed him how to manipulate the blades, much to his delight. But she had been observed by the Early Years Inspector who was in that day. '*Never* do that again,' she was told. 'A child must always be encouraged to find things out for himself.'

One should approach a child's artwork with no expectations, I was advised by an art educationalist. One should simply say, 'Tell me about your picture'. This coy exhortation bore with it the suggestion that the child's picture might, at an intuitive level, express something innocently genuine that had sprung from some freedom-zone in the child's imagination and, moreover, that she would be able to explain it all with some kind of poetic insight. Such preciousness also implied that no one should have the right to suggest how a picture could be improved, or, indeed, that qualitative judgements were in any way relevant where the expression of personal feelings were concerned. 'The chief enemy of excellence [in art],' Iris Murdoch wrote in 1970, 'is personal fantasy: the tissue of self-aggrandizing and consoling wishes and dreams which prevents one from seeing what is there outside one.'[19] Who was there to encourage the child to look beyond herself, learn something entirely new and try to communicate her response effectively?

And what if personal fantasy should reveal something less than good

and true? What progressive arts educationalists often downplayed was the possibility that when they asked their gentle question, they would get an answer they didn't want to hear. Question: 'Tell me about your picture'. Answer: 'It's a whole lot of people killing each other.' If this response springs from the wells of human nature then it is clearly not *good* and hardly a product of rapture and joy. Indeed it is so *bad* that it must be the consequence of adverse environmental influences. Is the child exposed to violence at home? Has he been watching too much *Itchy and Scratchy*, or spending every evening playing *Tomb Raider*?

The notion that a child's spirit is unsullied is based on Romantic fantasy and certainly not on any evidence from prehistory. But debates about the 'real' nature of children could well enter vexatious territory if the more troublesome aspects of evolutionary psychology come into an ascendant. Are some individual children genetically disposed to violence, or addiction, or laziness? Extreme applications of such thinking are already happening in America, and increasingly in Britain, where the amphetamine-like drug Ritalin is prescribed to remedy what has become a newly pathologised condition, Attention Deficit Hyperactivity Disorder, apparently a consequence of a fault in the genetic make-up of disaffected boys (who happen to come from dysfunctional homes), which makes it a highly controversial and politicised strategy.[20]

People who are regularly acquainted with children are best able to see that an acknowledgement of innate characteristics, whether of 'human nature', gender or individual disposition, pleasant or otherwise, does not diminish the importance of providing a stimulating environment and incentives to change. Indeed some of the findings in contemporary neuroscience surely demonstrate how good nurturing can be transformative. A small child's brain possesses a particular plasticity, an ability to reorganise itself, which means that practice will help them establish pathways which will give them new skills they can continue to develop. In his most fascinating book *The Language Instinct*, Steven Pinker expands on the idea first introduced by Noam Chomsky that we are born with an innate understanding of syntax, grammar, word ordering, vocabulary grouping and all the building blocks common to any language.[21] Chomsky believes that language acquisition derived from a one-off mutation, and scientists at University College London have found evidence from studying a linguistically dysfunctional family that a particular gene is an important determinant; Pinker and others agree that language acquisition is innate but believe the process was much more gradual

and complex. People go on to acquire a specific language depending on what they are exposed to from an early age though the basic elements are the same. But as with many innate dispositions, if children are not exposed to any language or social interaction by a critical age, around seven or eight years, the brain cells involved die off and they will forever lose the capacity to use it, as demonstrated by tragic instances involving feral children or those found neglected in Romanian nurseries a decade or so ago.

Language is more than simple communication and represents complex thought processes, its components reflecting the way we read the world: the distinctions between 'you', 'me' and 'him', 'here' and 'there', 'now' and 'then', the subject/verb/object relationship of a sentence with embedded sub-clauses, all of which reflects an understanding of relationships, sequence and causality. The tenses of past, present and future demonstrate our grasp of time, the conditional, subjunctive and imperative 'ifs', 'coulds', 'woulds' and 'shoulds' that express the potential for wishful thinking, fear, or eventual action. Language demonstrates we understand the nature of signs and symbols, how our minds form systems of association, 'constancies' and analogies in order to read and classify elements in the world quickly and efficiently and build up a representation of the environment. And out of these we make the similes and metaphors that so richly describe our experience of things, poetry and art. Everyone should learn to recognise the importance of visual literacy and of the ability to make things with our hands, minds and the digital extensions thereof. Such ways of encountering and reinterpreting the world are as vital as language acquisition, as speaking, reading and writing.

There is much in new scientific research which should inform the way our minds develop, combining an understanding of our nature with an appreciation of how nurture may make best use of it. And, though we might all share the same basic brain structures and processes, a greater understanding of this should paradoxically foster in each of us, not similarities but differences and, perhaps especially, the quirky originality that is essential to the making of art.

Chapter 5

Universal Studios

Scientists Measure Art

'For those that like that sort of thing,' said Miss Brodie in her best Edinburgh voice, 'that is the sort of thing they like.'

Muriel Spark, *The Prime of Miss Jean Brodie* (1961)

As more is known about the mind and the way it perceives and engages with the world, as physicists and mathematicians increasingly find regular patterns and symmetries in nature, 'we may be seeing the first vestiges of what some of us hope will emerge in the future,' Peter Atkins, Oxford Professor of Chemistry, writes, 'a scientific understanding of aesthetics.'[1] A number of investigative methodologies have been brought into play and a whole variety of studies may be found in special art editions of *The Journal of Consciousness Studies* or in *Leonardo*, the journal of the International Society for the Arts, Science and Technology, and also in specialised journals in psychology, neuroscience or physics.[2] Papers describe experiments involving cognitive psychology, observations taken from lesion studies, the application of new imaging technologies, artificial intelligence modelling, mathematical analyses of the rules of symmetry and asymmetry, and statistical surveys into questions of preference and taste. Overall, however, the research field is patchworked with inconsistent and inconclusive evidence. And apart from a general subscription

to the belief that art must have emerged as a by-product of evolutionary adaptation, there is no agreed coherent theoretical base. This may well reflect the fact that there is – as yet – no overall consensus on explanations for the nature of the mind, indeed consciousness studies is a broad church containing many sectarian arguments. Moreover, intriguing though many individual scientific investigations undoubtedly are, most people working in the arts are sceptical as to whether there can ever be a universal formula to explain them. The bedrock of scientific investigation is the methodology in which a hypothesis is posited and then proved – or, more accurately, *disproved* – through replicable experiment. This might be fine where the phenomena being studied can be isolated from background noise, serving the principle of Occam's razor – that the fewest possible assumptions be made, with phenomena reduced to the smallest number of components.[3] But this means that experiments into artistic activity have to focus on a very limited number of its aspects, preferably those which can be measured against each other as axes along a graph, with the aim of producing an equation or formula. This is not to claim that scientists possess an always reductive vision. They are well aware that while they are focusing on a narrow aspect of a phenomenon, it is situated within much broader contexts, other aspects of which will need to be examined in due course. An engagement with art, however, demands a personal response and always, too, an under-acknowledged subscription to a fine mesh of cultural values with widely variable definitions. How can subjective experience be so coolly objectified and refined? Such toing and froing between introspection, cultural contextualising and objective analysis is bound to result in epistemological confusion, getting further and further away from any rule of order. And what's the point anyway?

Experiments into aesthetics can draw conclusions that sound like self-fulfilling prophesies – invent a way of finding what you're looking for and hey presto! – evidence, based on averaging results. But aren't artists supposed to be original, not average? Is good art an average preference? And, what about the wider social and cultural context? Scientific studies aren't even consistent as to what can be defined as art, some of them being founded on an old-fashioned view that art means two-dimensional pictures, and pictures mean an arrangement of marks which principally involve the brain's visual systems in their decoding. There is little acknowledgement of the fact that contemporary artists use a wide range of media which makes demands on many different mental processes – installation, performance, live art, sound

art, digital art, Internet art, film and video, and so on. It is much harder to make generalisations about the effect of such a multi-lateral assault on the senses and even harder when such works are encountered outside the clean-room conditions of the gallery – in the community, on the street, 'site-specific', or simply existing as a virtual idea in cyberspace.

Of course, the function of all art may be reduced to universal principles, if it is regarded in terms of survival and sexual selection, the view of the evolutionary psychologists. Steven Pinker writes:

> The mind is a neural computer, fitted by natural selection with combinatorial algorithms for causal and probabilistic reasoning about plants, animals, objects and people. That toolbox, however, can be used to assemble Sunday afternoon projects of dubious adaptive value.[4]

It could be argued – indeed, it is elsewhere by Pinker and other evolutionary theorists – that that adaptive value may be not 'dubious' but explicit. Anyone could hazard suggestions for the biological purposes of art – it eases social interactions, it is a mark of status and of the conspicuous display of consumption that indicates superior health and wealth. In his book *The Anxiety of Influence: A Theory of Poetry*, the literary critic Harold Bloom offers a Freudian scenario – young artists are compelled to defy the traditions they inherit and make new work that overturns the status quo. Young cubs challenge old wolves, as the ethologists might put it. One could even venture to say that artists' sensitivity and exceptional perceptiveness signify a special alertness to the world around that is beneficial to adaptation. It is as if artists were rogue mutations in the body politic, sniffing the wind, open to new ideas, makers of new constructs and constructions, sometimes derided for their lack of conformity, but ahead of their time, leading the way in adapting to new conditions and therefore supreme survivors and good company to be in.

Art is certainly an important armament in the process of sexual selection. When the neuroscientist V. S. Ramachandran describes a ninth-century erotic sculpture from Northern India as 'incredibly evocative – beautiful – capturing the *rasa* [essence] of feminine poise and grace',[5] a middle-aged woman like me is inclined to retort, 'Well, he would say that, wouldn't he?' He may be expressing a personal preference for a work which has a cultural resonance for him in particular, but he is also speaking as a robust male. Personally, I

think the woman in the sculpture, with the artist's 'clever use of abdominal creases and dimples produced by subcutaneous fat – a feminine secondary sexual characteristic' (as Ramachandran's caption informs us) looks like a brazen hussy. But I would say that, wouldn't I? The history of art presents us with emblems of sexual provocation, more often female, but sometimes homosexual, heterosexual male or with a bisexual appeal. That we apply the term 'beautiful' to idealised depictions of people who are young, healthy, unblemished by illness, injury or child-rearing, and displaying an overt sexuality is clearly more than the expression of cultural, historical or personal taste. As the Chinese writer and artist Gao Xingjian candidly admits, 'Beauty has a very sensual side and sensuality is something of substance, like the body of a woman, or a smile as subtle as the Mona Lisa's...Art and love, art and women are for a man the essence, the marvel.'[6] It's biological, in other words. When John Berger pointed out, in his 1972 book *Ways of Seeing*, that 'women are depicted in a quite different way from men – not because the feminine is different from the masculine – but because the "ideal" spectator is always assumed to be male and the image of the woman is designed to flatter him,'[7] he was highlighting the cultural reinforcement of what is essentially a biological phenomenon. Women have learned to objectify themselves, becoming both what Berger calls the *surveyor* and the *surveyed*: 'The surveyor of woman in herself is male: the surveyed female. Thus she turns herself into an object – and most particularly an object of vision: a sight.'[8] Though such thinking has contributed to a commonplace feminist deconstruction, it doesn't mean that women themselves are not complicit with this state of affairs – witness the vacuous obsession with beauty in women's magazines. Our ambivalence is reflected in Sarah Lucas' work, the statement of a modern self-determined young woman, who artfully displays the eternal triangle in an attitude that is an ironic combination of crude defiance and flirtatious come-on. One suspects that the ancient Indian model would have got the joke.

So far, so obvious. Sex happens, and the reifying and exaggeration of erotic beauty through art is part of its arsenal of tricks. *Of course* we have different cultural and age preferences, but the history of art and literature demonstrates that the evolutionists are not far from the mark. Youth and sexual beauty are pre-eminently desirable.

The beauty we find in landscapes may also have an adaptational function. According to evolutionary psychologists we are harking back to the old

10. Sarah Lucas, *Self-Portrait with Fried Eggs* (1996). © the artist. Courtesy Sadie Coles HQ, London.

Savannah in prehistoric times with our emotional systems simultaneously calmed and stimulated by a view in which open safety and pleasurable mystery combine.[9] We can relax and not waste precious energy. The Californian artist Thomas Kincade seems to have discovered this to the great benefit of his billion-dollar-a-year industry. Judging by the sales of his works, the world's favourite pictures appear to be versions of Home, Home on the Range, and feature sunsets, brooding mountains, glimmering streams, dappled groves and thatched dwellings with cosy windows lit from within.[10]

And then there's the pleasure of symmetry. In the 1920s and 1930s, the logical positivist G. D. Birkhoff applied mathematical principles to define the aesthetic measure of an object in terms of the ratio of its symmetry to its complexity and found a number of satisfying examples.[11] Experimental psychologist Richard Gregory interestingly points out that symmetry tends to be a characteristic possessed by most living things, both fauna and flora, and our tendency to seek it out is important to our survival in helping us distinguish the organic from the inanimate. Our bodies are not entirely bilateral but many biologists take the view that symmetry and a semblance

of order are pleasing in nature on the grounds that it presents evidence that the organism has not been subject to adverse mutation or parasitic infection during gestation or after. In her last major project before her untimely death in 1996, the artist Helen Chadwick undertook a residency at King's College Hospital Assisted Conception Unit, where she created a photographic series called *Unnatural Selection*, using (with proper permissions) eggs which had been fertilised *in vitro* but not eventually chosen for implantation.[12] She became closely involved in the whole process, helping embryologists select which fertilised eggs should be implanted in the mother's uterus and was interested to note that the eggs most likely to be chosen were those with the best morphology and the most rapid cellular division, those that looked most 'attractive' or healthy. Embryologist Dr Virginia Bolton pointed out that there was no scientific evidence to support this selection but it felt natural to choose eggs displaying qualities of wholeness. This is, of course, applying an aesthetic judgement to a process never meant to be viewed by the human eye but we can think of examples at normal human scale where symmetry pleases – in the human face or body, for example, psychology studies demonstrating that, at least statistically, a majority of people are attracted to evenly balanced features in sexual partners and also apply them in assessing the well-being of small babies. There are, however, many instances in the human body where asymmetry is advantageous. A great majority of people have a dominant hand, and within the brain specialised functions such as language processing and fine motor control are located asymmetrically. And in assessing human 'beauty' one can think of exceptions that prove the rule – people with attractive lop-sided smiles, hair that falls down one side of the face, oddly positioned 'beauty spots', to say nothing of the strange bodily distortions deemed desirable in different cultures (extended necks, mouth plates, tiny feet and so on). Evolutionary biologists would point out that these are characteristics that have taken to extremes perceptual rules, which become invested with emotional association so they turn into fetishes – and all ultimately to aid sexual selection.

For the new discipline he calls 'neuroaesthetics', Ramachandran (with William Hirstein) has discovered ten 'laws', or universal principles, of art, or aesthetics.[13] When we identify an unfamiliar object from background noise we are given a sensory reward. Perceptual processes link to the limbic system, the widely used shorthand term for the areas of the brain particularly associated with the emotions (the meaning implicit at the root of 'aesthetics', the 'gasp'

of satisfaction) and when a viewer's attention is alerted and his pleasure zones beguiled it is because some of the laws of perception come in to play. We don't want it to be too easy, though, and some of Ramachandran's laws demonstrate how much we enjoy decoding complicated messages, which is why artists continually try to allure and surprise us, playing up and exaggerating or, on the other hand, playing down and disguising the clues to the principles which govern basic perceptual competence. Ramachandran's laws include 'emphasis', where some characteristics in an image attract visual attention at the expense of others, the provision of information-rich regions of contrast, the presence of perceptual problems which need solving, the use of visual metaphors or puns in order to create composite associations, and so on. A significant law relates to what is known as the *peak shift effect*. When a rat is presented with a particular shape and rewarded for recognising it – discriminating a rectangular shape from a square, for example – it will be quicker to respond to that shape in future. And if the shape is exaggerated (the rectangle made longer and thinner), the rat's response will be even more pronounced because its brain has formed a 'rule' for recognising the subset of shapes within the general class 'rectangularity'. Ramachandran goes on to explain how this rule might apply to human preference so we find particular pleasure in exaggeration – he uses the Indian goddess's overemphasised erotic curves as an example. Of course, such 'rules' have long been familiar to cartoonists and designers who learn how to create a readily recognisable figure through a combination of exaggeration and economy, how to manipulate symmetry, how to create contrast, how to avoid visual confusion or boredom, how to stimulate surprise.[14] But most of us make a distinction between the simple pleasure to be found in identifying pattern and the darker purposes of art. Design can be eye-catching or pleasing, but it is ultimately functional. In art we hope to find greater profundity. As we have seen in Chapter 2, much classical art expressed a quest for a Platonic perfection where symmetry was an ideal – the Golden Section could be applied to measure it. Certain twentieth-century artists such as Mondrian, Brancusi and Klee had a vision that there was a natural harmony underlying nature and sought to provide glimpses of it in work where asymmetry paradoxically hints at ultimate symmetry. Other artworks contain a sense of imperfection in images otherwise 'beautiful', a kind of perplexity, perhaps giving us a sense that other people share our sense of poignancy, our underlying uncertainties and fears and our desire for simple eternal bliss. This may be biological too, of course. If art can console

us and unite us with others through our shared sensibilities, then it serves a useful purpose in maintaining a social equilibrium, deferring our terror of death even while it reminds us that we will not live forever. Many artworks crystallise a precious moment that in real life would pass swiftly and, in doing so, they remind us that time flies – *tempus fugit*; we should 'seize the day' – *carpe diem* – a sentiment that makes urgent the need to make the most of our existence – and go forth and multiply.

Ramachandran's Indian goddess is much more than a crudely exaggerated figure appealing to perceptual rules in order to attract male desire, just as Sarah Lucas' vulgar self-portrait is more than a tease to subvert it. Universally they may communicate both sexual desire and an underlying fear of death. But they also contain a whole lot of dense cultural and historical information. Our response therefore involves a huge web of cognitive, linguistic and emotional processing, besides simple perceptual decoding.

'The whole brain is used in the making of art,' affirms Professor John Marshall from the Radcliffe Infirmary, Oxford, an expert in the effects of brain damage on competence in the visual arts. His practice, 'lesion studies', is based on the sometimes bizarre evidence provided when people experience brain dysfunction as a consequence of injury, stroke or other illnesses, offering clues which may help us better understand normal brain function. Examining an artist patient with left-hemisphere stroke dysfunction which resulted in aphasia, or disruption of speech, Marshall noticed that while the patient had lost the ability to create the abstract or symbolic art which had hitherto been his major interest, he was still extremely skilled in making figurative representations. In another study elsewhere, however, when the Bulgarian artist Zlatio Boiyadiev suffered a severe stroke resulting in total aphasia (presumably a different kind of aphasia from Professor Marshall's case), his art manifested a shift from an accomplished social realism to a much more impressionistic style, with bold colours, inverted perspectives and heavy brush strokes. Neurologist Jason W. Brown has observed that the ability to see perspective may be linked to phonology (the sound system of language); and in the art and writing of people with lexical-semantic disorders (language processing related to vocabulary and meaning) there is increased fantasy, often of a dream-like nature.[15] Abstract and figurative art seem to involve different brain areas which connect with different aspects of language processing, and while it isn't at all clear yet what these findings mean in terms of relating language to symbol-making, there seems to be a hint of real revelation.

Feelings of greatly heightened intensity might be the consequence of disturbances in the temporal lobe, the area implicated in some types of epilepsy. The temporal lobe, specifically the amygdala, is involved when people experience states of ecstasy or profound spiritual enlightenment, or its miserable opposite, preternatural despair.[16] Both Van Gogh and Dostoevsky were epileptic and, while we can't be certain of the kind of epilepsy each suffered from, we can see that their work is certainly fraught with an exaggerated intensity which we can read directly and empathise with, even while we are not epileptic ourselves.[17] Lesion studies also show how the damaged brain finds ways of readjusting its competencies, with sometimes peculiar consequences, as the writer and neurologist Oliver Sacks has described in books such as *The Man Who Mistook His Wife For A Hat*. We all find our dreams intriguing but the idea that the brain can produce surreal but convincing scenarios in people who are wide awake and otherwise sane is absolutely compelling, especially for the light it might throw on our understanding of the imagination in making art. In my view, lesion studies are the most interesting route to understanding the processes involved in art-making because, although it is difficult to isolate the location and function of particular brain processes, especially when brain dysfunction has multiple consequences, the study is rooted in the experience of individual people who can contribute subjectively to the research, telling their clinicians how their odd experiences actually feel from the inside. I would go on to propose that it is time that someone in the neuroscientific community drew together all such research, keeping an open mind before coming up with hypotheses but making connections across the field.[18]

There is something unsettling about the fact that experience can be caught as an image on a brain scan. New brain imaging techniques offer rich opportunities for scientists to study which areas are involved in making or responding to art but the practice is still quite rudimentary, requiring a huge amount of data processing to elicit information about a single simple process. The film-maker John Tchalenko has monitored the actions of the portrait artist Humphrey Ocean, using eye-tracking equipment to analyse frame-to-frame eye movement, together with motion-sensors to measure the hand's movements in space, and functional Magnetic Resonance Imaging (fMRI) of the artist's brain to examine which areas receive increased blood flow. What this basic experiment confirms is the fact that an experienced artist needs to look at his subject less than a non-artist does.[19] And although Humphrey

Ocean is actually an artist of distinction, there is nothing yet to suggest that what he is doing is any different from an activity that might be carried out with equal expertise by anyone used to hand-eye tasks. A skilled artist quickly forms an abstract mental template of the subject – the art historian Gombrich called it a 'schema', one moreover which is both culturally 'inherited' and personally evolved[20] – which he then inventively adjusts in his version on paper. What Ocean does is not merely to make a slick record; after years of self-development as a professional artist, he looks for differences between his mental concept and the new image before his eyes and adjusts his portrait accordingly, giving himself the pleasure of making small new discoveries as he proceeds and continuing to refine his distinctive personal style through deliberate intervention – what is generally known as 'creativity'. It would be boring and mechanistic if he did not. He may be applying simple universal rules to the painting of portraits but we do not expect him to be Rembrandt, or anyone else but himself. And the real questions are ones that, so far, can only be answered subjectively – which artists have particularly influenced you? Why did you choose to elongate that line there? Is that a conscious decision or do you think it relates to some unconscious memory?

The role of memory is essential to art-making and investigations into the many areas of the brain involved in coordinating different kinds of memory feedback are becoming fascinating. An experiment I took part in myself, conducted by Sven Braeutigam and Steven Rose from the Open University, was set up to examine brain function involved in autobiographical memory.[21] Magnetoencephalography (MEG) scans were taken of the participants' brains while we made simple decisions to choose one of three food products displayed on a video screen, as if we were shopping in a supermarket. Supermarket shopping was chosen because it is an activity that a majority of us nowadays have in common (a sobering thought) and, because it is one in which we have each built up an accretion of memories connected to our individual tastes and decision-making processes, it is uniquely autobiographical. MEG scans measure the minute fluctuating magnetic fields caused by electrical activity which occurs when neurons fire in the brain, and can identify dynamic brain processes occurring on a millisecond timescale. In the sample of participants' brains, there were some differences between us – different brain areas 'lit up' – but there was robust consistency in the sequence of signals which occurred within the first second following the presentation of images. The visual cortex was first activated, followed by the left temporal regions and when we

took longer to make a decision there was also activity in Broca's area, which indicates an increased tendency to silent vocalisation, probably with regard to items previously encountered. There was also somewhat unexpected activity in the right parietal cortex which suggests that we were assessing spatial representations, perhaps comparing an item with one retrieved from memory, and concentrating on doing so. The experiment confirmed earlier research by the neuroscientist Antonio Damasio (whose ideas will be further explored in Chapter 6), showing that, rather than applying a rational process to decision-making, emotional responses came into play. Though this experiment was breaking just a small piece of the ground, one can imagine how associations of touch, smell and taste are activated and how those might set up different personal reverberations for each of us. While supermarket shopping is hardly an art, it involves memory processing, verbalisation, attention and emotion-rich awareness, which just goes to show how much more complex is that function we call 'creativity'.

Investigations into creativity have become a minor industry in both the arts and sciences. Particularly interesting are those which use a combination of boldly conceived metaphorical constructs with state-of-the-art computer modelling. Drawing on thought experiment models from artificial intelligence, the philosopher and psychologist Margaret Boden demonstrates how creativity emerges from simple cognitive rules to involve billions of coordinated neural interactions in the making of mental maps.[22] Experimental psychologist Mike Page gives an example of connectionist modelling for simple creative decision-making – he uses Gombrich's model of arranging flowers in a vase until the arrangement feels 'just right'.[23] We arrive at decisions – conscious or felt – through a process of what is called 'constraint satisfaction', after taking into account a number of simple constraints, such as the desired distance of one flower from another, their colour combinations, their respective sizes, for example. 'Connectionist theory maintains that familiar items are represented by similarly stable states of activation in the brain, towards which other less stable states are "attracted",' Page writes.[24] One specialist group of cells competes against another until a stable state is reached. Computer models can be made showing ever more complex patterns evolving dynamically until they reach a point at which the maximum number of constraints is satisfied. Artists will recognise how an artwork evolves from the first few tentative marks on a blank page, establishing constraints as it proceeds, out of which a more complex picture emerges, which then goes on to provide a narrower

number of options until the work seems to arrive at a kind of inevitability, one which may even take on a momentum of its own.

The logical consequence of such analyses is that computers can be programmed with a range of rules and constraints from which would emerge original new work. But who would decide what constituted a universal 'rule' for attractiveness or style outside any cultural context, and can this be successfully measured? In an experiment conducted in 1997–1998, the art theoretician and psychologist Vladimir Petrov took cultural context into account in studying the work of a number of European and Russian painters and composers from the mid-fifteenth to the mid-twentieth centuries. His aim was to assess the dominance of Left-brain/Right-brain creativity at any one period as he had a hunch that there might be periodic or cyclical patterns in styles of art over time.[25] The idea that the two hemispheres of the brain can so specifically correspond to opposite modes of thinking was popular up to the 1970s, but brain scientists now recognise that it isn't as simple as that. Broadly speaking, however, Petrov worked on the basis that Left-brain prevalence corresponds to rationality and the use of constructive features, Right-brain creativity with emotional and intuitive states.

In this massively complex field of study which was to take into consideration the work of artists from quite different times, places and cultures, Petrov had to narrow down the parameters of the experiment to render it scientifically manageable, and some might question both his ambition and his methodology. He worked out an index of symmetry for each painter, which he represented as an equation:

$$K = \frac{n(L) - n(R)}{n(L) + n(R)}$$

where $n(L)$ and $n(R)$ are the numbers of Left brain and Right brain scores for a painter, according to the estimates of a given expert.

To assess the qualitative aspects of each work, he devised a table of ten parameters to determine the prevalence of Right- and Left-brain activity each along a continuum of 6 stages:

Traditional work through to Originality, peculiarity:
(a) Rationality – Intuitiveness;
(b) Strict form – free form;

(c) Conciseness, asceticism of expressive means – Variety, diversity of expressive means;
(d) Graphic features – Picturesque, colourful features;
(e) Restrained static features – Expressive dynamic features;
(f) Discrete elements – Continuous transitions between elements;
(g) Use of cool part of spectrum – Use of warm part of spectrum;
(h) No colour gradations – Significant colour gradations;
(i) Smooth painting – Textured painting.

Some of these qualities clearly rely on highly subjective judgements, to say nothing of some knowledge of and 'feel' for art history, but Petrov arrived at a consensus by consulting experts (art historians, musicologists) and asking them to make ratings.

The idea that there are noticeable changes in style in art is not new to art historians. Indeed, Gombrich was influenced by his friend Karl Popper's formulation of the 'conjecture and refutation' methodologies of science, taking the view that period style in art develops through 'schemas and corrections', with artists revising and extending the schema they have inherited. Alternatively, according to Harold Bloom's scenario, they defiantly overturn the status quo.[26] Such changes might be indicative of a number of factors and it would be impossible to make a thorough investigation into the reasons for this without taking into account the historical, geographical, social and philosophical context of the art in question, let alone the degree of its adherence to prevailing genres, schools or theories predominant at any time. And this is to say nothing of the changing perspectives of hindsight. Petrov does take account of the socio-political climate of the times, drawing on research which 'compared oscillations in the style of architecture with changes in social life – revolutions, reforms, totalitarian and democratic styles in politics etc'.[27] But there is an inherent circularity about an experiment which is set up to prove a hypothesis already established – 'the selection of the period should depend on the expected evolutionary behaviour of the phenomenon under question.' And in trying to respect subjective opinion 'scientifically', Petrov creates a list of parameters that are far from comprehensive and are subjective in themselves. The colour expert, John Gage, for example, would dispute that there was a universal consensus about 'cool' and 'warm' parts of the colour spectrum.

Petrov's findings show that, 'in accordance with theoretical assumptions, periodic cycles of about fifty years of Left-or Right-brain creative dominance

were observed in various art media...during the evolution of the socio-psychological life of a society.' Moreover, the results:

> allow us to forecast changes in art in the forthcoming 40 to 50
> years...we can expect a new half-cycle of L-brain prevalence in
> the next several years, with such features as rationality and a
> predominant role for verbal elements, theoretical concepts, reflexive
> processes etc.

There is certainly a predominant trend in contemporary practice towards conceptual art, which relies on intellectual association-making and on a play with words, semantics and ideas. But such work often reaches the gut first, rather than the intelligence, it is sensuous, intuitive and irrational – think of Damien Hirst's installations and the paintings of Chris Ofili, full of witty ideas but sensuous and unsettling too. And, as we shall see in the next chapter, it is Damasio's view that all rational thought is founded upon emotion. Moreover, conceptual art coexists with other works which, though inspired by interlocking intellectual ideas, are physicalised and abstract – Richard Deacon's sculptures, Tess Jaray's paintings, the architecture of Frank Gehry or Daniel Liebeskind. The picture is infinitely more complex than such a study can allow for and the methodology of the experiment is open to challenge. Can the methodologies of scientific investigations based on a search for absolute values ever apply to making and viewing art?

In 1980, the psychologist Hans Eysenck conducted a research exercise in order to measure Visual Aesthetic Sensitivity amongst groups of young people across cultures to see if there could be any universal agreement on harmony in shape and form. He used as a measure their preference for one figure over another in forty-two pairs of drawings made by the German painter K. O. Gotz and took the form of small abstract patterns in black and white.[28] Gotz had first drawn a 'good' picture, then he had altered it to incorporate 'faults'. To ensure that the artist's own judgement of 'right' and 'wrong' should not be too influential, a group of experts, painters and graphic artists, were asked to form a consensus on which image had 'a better configuration or "gestalt"'. ('Gestalt' refers to the way the brain tends quickly to process an image as a simplified whole, the sum of its parts.)

The young participants were told to look at the forty-two pairs one at a time and choose 'the better one', the one 'without errors and faults'. They were

asked 'not to say which design you find more pleasant. Your task is to discover which of the designs is the more harmonious one.' More than a few must have been baffled by the casuistic distinction between 'pleasant' and 'harmonious'.

The test was undertaken by groups of young people from Britain, Japan, Hong Kong and Germany. Care was exercised to take into account differences in variables, such as the participants' age, their basic intelligence, their 'psychology', their artistic training and their cultural background. One would have thought that many of these variables would require a battery of further fine analyses in themselves, but they seem to have been dealt with somehow, although in reporting the results of his main study some of Eynseck's comments do not seem grounded in any precise psychological analysis. People with 'high "psychoticism" scores' (his term and quotation marks), he announced, 'tend to show poor aesthetic sensitivity', but, he went on to explain, this might have been the result of their tendency 'to be anti-establishment so they sometimes recognise which is the "better" of the two drawings, but give a judgement in the opposite direction!' Given that 111 of the British contingent were 'university students without any special artistic training', this may be entirely true and it is perhaps surprising that 'likelihood to take the Michael' was not another variable written into the study. However, the final results showed that 'the mean judgement of the non-expert group agrees with the original judgement of the expert group, irrespective of their background.' A majority of participants agreed which images were 'the best'.

Even if we try to forget that good artists aren't 'average' and that the best work strikes its viewers because it is out of the ordinary, does this mean that humans *do* possess a universal Visual Aesthetic Sensitivity? Indeed it might, when it comes to assessing the impact of a simple image, as Ramachandran's basic 'rules' show. But can an evaluation of 'good' or 'bad' squiggles, presented out of any context, provide evidence of universal quality indicators for art?

The psychologist Chris McManus, who studies 'psycho-aesthetics', is particularly interested in perceptions of symmetry, drawing on the classical notion that there are ideal and measurable symmetries in art and architecture, and on the fact that humans like dividing arrangements and compositions into sections with consistently similar ratios, with the geometry of the Golden Section embodying psychically satisfying proportions. McManus has digitally reconfigured a number of Mondrian's works by making small computational adjustments to the artist's characteristically asymmetrical arrangements of straight lines, creating 'pseudo-Mondrians' to see whether people prefer

them to the real thing.[29] Interestingly, subjects involved in his experiment have demonstrated 'significantly better than chance expectations in their preference for the Mondrian original, suggesting that the paintings may encapsulate some universal principles of compositional order which can be detected'. Of course, as McManus can't undertake a comparative study of opinions from people who pre-dated Mondrian, it might be impossible to assess how far 'Mondrian-ness' has become part of our commonplace visual iconography. But Mondrian himself, as it happens, was seeking a universal holistic vision. Originally a theosophist and much influenced by eastern spirituality, he distilled his vision of the world into straight lines and primary colours as a means of finding a greater connection to what he perceived as the deep order of the universe.

But perhaps the deep order of the universe is also apparent in the distorted topologies of cubism, as the physicist Arthur I. Miller believes, with Picasso finding synergy with Einstein's new understanding of space and time.[30] And according to physicists and computer specialists Richard P. Taylor, Adam P. Micolich and David Jonas, the patterns in Jackson Pollock's drip paintings provide 'a direct expression of the generic imagery of nature's scenery'. These are essentially fractal, a form usually made manifest in computerised images which show luridly coloured, endlessly recursive patterns – at first sight rather different from Pollock's chaotic gestures. But close measurement and modelling confirms the speculation that Pollock was the unwitting founder of a new genre, Fractal Expressionism.[31] According to the above hypotheses, then, the universal templates we are intuitively tuned into would seem simultaneously to be asymmetrical arrangements of straight lines and primary colours, the broken perspectives of relativity, and fractals. Or perhaps we are tuned into chaotic systems, or possess a profound recognition of the 128 rules of Complexity Theory, or the unfixed nature of Probability from quantum theory, or maybe Godel's Incompleteness Theorem? In a coherent universe, all might be valid simultaneously. Does art have a direct route to the deep structures in nature or is it rather that it picks up on the deep structures in current scientific discovery?

'It seems to me,' writes Martin Kemp, historian of art and science, 'that the evolution of the human brain (and, at lesser levels of complexity, animals' brains) has equipped us with the means to set the exterior structures and inner constructs in ceaseless dialogue.'[32] He is talking about the interplay between the structures of objects in the world out there and the structures

in our minds which have evolved to perceive and understand them. Kemp has posited the idea that visual artists often possess exceptional 'structural intuition', partly hard-wired but also developed from a close acquaintance with the behaviour of materials and forces through observation in nature and manipulation in the studio. It is, perhaps, an inheritance of the natural intelligence domain in the early human brain, according to Steven Mithen's model. In structural intuition 'the orders of nature respond, as it were, to our articulate scrutiny, while the mental processes of perception and deduction seem to reconfigure themselves continuously to resonate with external systems.' While our perceptions are tuned into basic structures in nature, then, we are also alert to newly discovered constructs, and in a Kantian free-play between intuitive imagination and conceptual understanding, we continually readjust our view of the world.

Kemp turns to evolutionary theory and takes the view – made popular through the work of Brian Goodwin and Stephen Jay Gould in opposition to the hardline neo-Darwinists – that the theory of natural selection and adaptation does not give the sole satisfactory explanation for the development of organisms. The standard neo-Darwinian view is that the many individual genes which form an organism mutate separately and randomly, the fittest surviving to propagate further, the randomly collective process resulting in the emergence of a whole organism, resistant to further change. But an alternative version is that particular morphologies and behaviours emerge from processes obeying certain principles of order, with organisms operating as integrated dynamic self-organising *wholes*. Life forms evolve over time in response to the constraints of the fundamental physical forces, so similar patterns of growth and form can be perceived in quite different structures and dynamic behaviours, and we are attuned to perceiving them. Some of the patterns that emerge in nature – for example, spirals or whorls or symmetrical geometries – occur also in the natural engineering and behaviour of inanimate things – whirlpools, bubbles, eroded rocks. Kemp points to the work of the Scottish biologist and classical scholar D'Arcy Wentworth Thompson whose book *On Growth and Form* shows how forms develop according to mathematical principles operating within physical constraints. Kemp writes:

I believe that the kind of insight produced by Thompsonian morphogenesis [observations on the evolutionary development of the structure of organisms] has as yet a largely unexplored potential in studies of twentieth century art, and even in the art and ideas of earlier years.[33]

A great deal of abstract art has been directly influenced by contemporary studies in mathematics and physics – Kemp cites Henry Moore, Ben Nicholson, Barbara Hepworth, Ivor Hitchens, Walter Gropius and Naum Gabo, among others. But his intention is not to look for universal hidden patterns in art, disavowing a taste for 'geometrical mysticism...not grounded on any firm sense of what actually went into the design of the works in question', but rather to acknowledge artists who have consciously looked at the structures of growth in nature and allowed an organic discipline to inform their work both intuitively and with conscious inventiveness. He quotes the sculptor Peter Randall-Page, whose work in stone includes large cone and seed shapes, 'Although my work is firmly rooted in observation,' Randall-Page writes, 'I try to achieve...rightness of form through a kinship with, rather than a facsimile of nature.'[34]

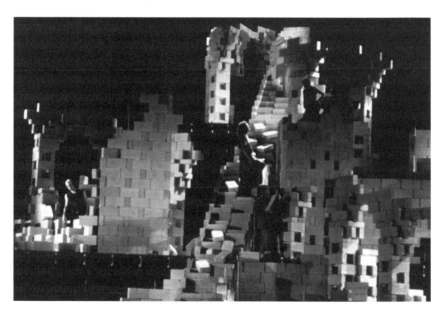

11. Station House Opera, *Salisbury Proverbs* (1997). Photograph by Bob van Danzing. Courtesy Julian Maynard Smith and Artsadmin.

The performance company Station House Opera, under the directorship of architect-trained Julian Maynard Smith, has made a series of works for European outdoor sites in which performers shift breeze blocks to create and continually reconfigure architectural structures. In the twenty-four-hour

staging of the work in 1997, in front of the west face of Salisbury Cathedral in England, the bricks were first arranged to form a high wall. Then the performers entered and began to move the bricks apparently at random, forming new constructions as they went on. Sometimes they operated individually, at other times they collaborated, all the while demolishing and rebuilding. Arches, staircases and wheel-shapes evolved, then a single brick was removed and the patterning altered, metamorphosing into new structures. The accompanying music – orchestral and choral – seemed to indicate that some kind of intense ritual was taking place. The experience was rather like watching a disturbed ants' nest where the creatures were programmed (as ants' brains are) to obey a few basic rules, with an individual performer occasionally initiating a new action. This aberration spurred others to join in, or conduct their own actions, to the point where different groups appeared to be competing. The work looked like a model of chaos, with equilibrium emerging from turmoil and back into chaos again, but was actually highly organised, the performers working to six building strategies but with one section open-ended and allowing for new enterprise and improvisation.

'I think nature is interesting enough,' writes Maynard Smith:

> Art is about human beings, which includes their response to nature.
> For an artist our response to the notions of randomness, uncertainty,
> chaos, catastrophe are more interesting than the phenomena
> themselves...These performances have more of a relationship with
> developmental biology. The organism goes through many stages
> before becoming mature, each one adapting and building on
> the structures which existed before. In the breeze-block pieces
> information is released into the building process at controlled points
> in relation to feedback from the process. The information is in the
> performers' brains. I think the thing it proves is that the higher the
> level of organisation, the more evolved and interesting the design.[35]

This was consciously programmed organisation derived from constraints but allowing for inventiveness and emerging as a unique artwork. Art-making does sometimes tune into nature's structures, symmetries and patterns but the most striking work exploits the rules to make something original.

The sculptor Richard Deacon, who works as a 'fabricator' with materials which include heavy galvanised steel, aluminium, transparent polycarbonate

and curvaceous laminated wood, makes large abstract sculptures which demonstrate a kinship with nature though an intuitive understanding of what form is capable of but are inspired by a poetic synthesis of conceptual ideas. These ideas, often intellectually conceived through reading, thinking and making connections, translate into abstract forms which have evolved in the inner mind and are realised as solid sculptures which seem to be the embodiment of thought in action, nebulous templates of the imagination, limited only by the constraints imposed by the physical forces in external reality. 'The work is always subject to gravity and place in a very definite way,' Deacon says:

> Material and its manifestation are core areas in what I do...My idea about sculpture was that it was composed of matter but wasn't subject to gravity. This is metaphorical, obviously, but I thought of sculpture as being between me and the world, rather than sitting in the world.[36]

In a new work, *Red Sea Crossing*, two large sinuous shapes twist, turn and coil away from and towards each other, a narrow gap between them. Snaking, leaning, hovering, or flying in the air, supported on a few balancing points, they weave and knot in on themselves, pushing at the boundaries of material strength, tension, torque and torsion. The title carries with it associations of the Bible story. Deacon writes, 'I've made the sea and don't know whether we are Israelites or Pharoah's army.' But the work's genesis – a good word in all senses considering this is the Exodus that follows – derives from an earlier work, never fully realised, which addressed the concept of DNA and the double helix, traces of which idea are manifest in the helical twists of the wood at the 'corners' of the new work. *Red Sea Crossing*, Deacon suggests:

> connects the Out of Africa exodus of early humankind to Brancusi's walk from Bucharest to Paris and the way in which Paris attracted and infested visitors with modernism – and other less savoury diseases. But there is also an order/disorder dialogue.[37]

Deacon is interested in scientific research – he was one of a group of European artists who made new work after visiting Europe's giant particle accelerator in CERN, Geneva in a London Institute initiative in 2000, and

12. Richard Deacon, *Red Sea Crossing (Passage de la Mer Rouge)*
(2003). One part of two-part sculpture. Oak and stainless steel. Part A
150 x 450 x 280 cm; Part B 200 x 550 x 450 cm. Courtesy Lisson Gallery.

has undertaken a residency at Oxford University looking at the structure of
cells. Inspired by the idea of reconciling objective investigations into external
reality with the preoccupations of human culture, his work does not explain
or address nature but translates intellectual thinking into form and structure,
and rather as a poet uses words to communicate layers of meaning, he uses
materials as the building blocks of form. Because of their striking physical
presence, his abstract sculptures elide mind and matter, mind and body. Their
effectiveness demonstrates Richard Gregory's belief that we always project
onto external objects the sense of our own felt physical proportion and
presence, an idea expanded, as we shall see, by the neuroscientist Antonio
Damasio, who stresses the physical and emotional basis to all our thoughts
and our internal and external maps of the world. In our physical imaginations
Deacon's structures can be stroked, embraced, their lines followed by the
fingertips, their weight felt at the pit of the stomach, their lightness and
airiness fluttering the hairs of the skin. Let loose, a child would want to crawl,
climb, peek through, rock and lie on them. The boundaries between our senses
also melt away and the works seem to embody notions of synaesthesia, the

phenomenon in which the stimulation of one sense gives rise to experience in another. Look at them and you can hear them as music.

New research in consciousness studies confirms the view that we have each inherited a suite of universal hard-wired specialist modules which have evolved to adapt to the world out there, so that we do universally share basic common perceptual rules – 'aesthetic' ones, if you wish. But we also observe, learn from and mimic each other, as the history of art demonstrates. We research and study artworks but we also intuitively tune into the wordless sensations that emanate from the most inventive and almost without thinking, find ourselves influenced by their style and spirit. We may then go on to make new work or forge new ideas which build on such inspiration. And so we 'sculpt' our own views of the world, laying down unique personal neural pathways shaped by our historical and cultural environments, which directly and indirectly influence the making and viewing of new art – and, indeed, new insights and constructs in science. Contemporary science is providing some astonishing insights into the workings of the mind, glimpses of which can help arts people understand the nature of the often unexpected connections they make, but I think most of us would resist the idea that the products of their dynamic imaginations could be reduced to a scientific formula for all people at all times. Much more interesting is the idea that we continually adjust our view of the world. This seems to strike a chord both culturally and biologically. We are nothing if not adaptable creatures and while evolutionary time is slow, our sophisticated imaginations are endlessly flexible and inventive.

Chapter 6

Sculpted by the World

Art and Some Concepts from Contemporary Consciousness Studies

She lay in the bath with the water touching
her all over, and remembered that not even
the most tender lover could do that. She wondered
if every molecule on the surface of her skin
was wet and what wet meant to such very
tiny matter.

Jo Shapcott, from 'In the Bath' (1992)[1]

In 2002, the artist Andrew Carnie worked with the developmental neurobiologist Richard Wingate to find ways of visualising the structure and growth of neurons, the minute specialised nerves cells that transmit impulses in the brain.[2] Dr Wingate works on fine-scale neural anatomy and neuronal migration in order to determine how these relate to genetic patterning and Carnie was interested in discovering how memories are laid down. The artwork that resulted was called *Magic Forest* and took the form of a walk-in installation in which the viewer trailed through a floating woodland of lacy winter trees, at once dreamlike and familiar, and suffused with the kind of poignant

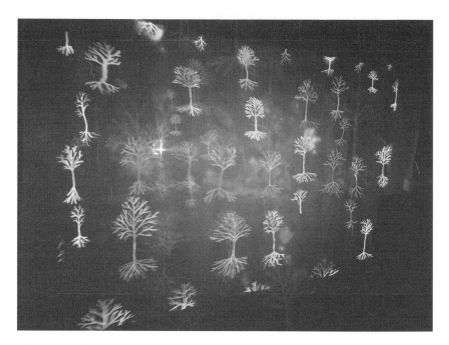

13. Andrew Carnie, *Magic Forest* (2002). Artist's photographs from installation at *Head On* exhibition at the Science Museum, London. Courtesy of the artist.

evanescence that is indicative of the artist's individual style. The 'trees' were actually images of living brain cells caught in the act of conducting signals in complex branching formations – dendrites – to form connections known as synapses. Enthused by the new science, Carnie had captured the images viewed through the latest technology – a laser-scanning confocal microscope – and drawn them with the aid of computer-imaging techniques, stained them with fluorescent dyes and projected them onto layers of fine fabric. What the images represented was intellectually intriguing but the closest the artist could come to translating them into a felt sensation of the phenomenon of memory was to hint at its mystery by offering the analogy of a forest. Dendrites *look like* trees, and a physicist might be able to explain why many natural systems take on branching formations. Forests have been locations of mystery, fear and surprise since humans were hunter-gatherers and made up stories about them, which have filtered into our individual if not our collective unconscious. The seemingly randomised way in which we access our personal

memories feels a little forest-like and certainly it's a more sensuous metaphor than the banks, filing cabinets or computer data-base analogies more often used. But all this does is demonstrate how difficult it is to explain how matter becomes mind, how a series of sparks and synapses give rise to the veracity of personal experience, indeed how the mere materials employed by artists can set up so many reverberations. The science is intriguing, the art wonderfully beguiling in its own right but they can't quite meet up.

The quest to explain the enigma of how our brains operate to form what feels like our singular experience of consciousness has become a huge preoccupation in science. This may be surprising to those of us in the arts who feel we have a unique purchase on the subjective mind, which we claim to understand from the inside, intuitively, if not so much objectively. Surely, if our working life is spent manipulating the illusions of seeing and feeling, of imagining and inventing, we must have a unique entry into the workings of that unyielding wrinkled organ. The folly of pursuing a rational explanation is hinted at in Helen Chadwick's image (see back cover), cupping the impenetrable soft grey matter between her sensitive fingers – the object felt by the subject who is none the wiser intellectually.

Intuitively artists understand how a sensuous receptiveness to the world is made manifest in the vital immediacy of experience, for it is their job to create new stimuli which can effectively convince, confuse and compel. The neurobiologist Semir Zeki uses the ingenious conceit that artists are unintentional neurologists, exercising to capacity all aspects of the visual brain, thereby demonstrating how well it works. That friendliest of polymaths, the experimental psychologist Richard Gregory, has long been alerting artists to the tricks and illusions they often unknowingly trade in.[3] And the neuroscientist Antonio Damasio stresses the fact that our mental and physical processes are inextricably linked, our emotions and feelings underpinning all our thoughts and actions – how else could one really respond to art? Meanwhile, many theoreticians in the mainstream arts are still caught up with post-Freudian ideologies. There is something perverse about the fact that this great thinker and writer who started his career with every intention of establishing a new science is now much more likely to be cited in the arts and literature, his theories having little or no credibility in the neurosciences. A disinterested observer might muse on the ways in which we continually need to invent or re-invent myths and metaphors to explain our internal processes. All language, all modelling, is essentially symbolic but scientists are

hoping to find the real thing, using hard evidence from animal studies, from observing the experience and behaviour of people who have brain damage, or from viewing the brain in the act of functioning, as revealed through high-tech brain-imaging. The arts community may consider this a rather tenuous and reductive way of analysing the richness of human experience. All the same, small new discoveries can amount to whole new ways of explaining ourselves. This chapter, therefore, will offer glimpses into some aspects of the neurosciences, in the hope that we can approach an understanding of art with a fresh awareness.

Envisaging

Looking at the world is not a passive event. It is a response to a felt physical environment. Neuroscientists believe we are born with a capacity to make out specific aspects of form, of height and depth, even of gravity, and a great deal of our visual acquisition is then derived from touching things, literally at first hand. As the infant develops he begins to establish internal maps of the world and, having experienced touch, he develops a way of imagining how that world must feel, even when he is just exercising his visual system. Seeing becomes therefore a kind of believing. Indeed, seeing need not involve vision at all. In his autobiography, *Planet of the Blind*, the American writer Stephen Kuusisto gives a breathtaking account of how he negotiated the world as a child out of a fierce determination to persuade himself and others that he was not blind:

> It's hard to explain how, as a child, or even as a grown man, I have
> been so proficient at hurtling forward without breaking my neck.
> Fast blind people have exceptional memories and superior spatial
> orientation. By the age of five I was a dynamo. Wanting to see me
> run, my mother saw me run and guessed that I must be seeing more
> than I really could. And so I landed like the bee who sees poorly but
> understands destination by motion and light and temperature.[4]

The neuroscientist Mark Lythgoe has proposed that Kuusisto might actually be able to see things more clearly when he is in 'travel motion' – a consequence of a phenomenon known as 'blindsight' in which people with damage in most parts of the visual cortex still retain the capacity to see things in motion because the specific cortical region concerned with visual

movement remains intact. The point is, however, that, like seeing people, Kuusisto had been creating an internal map of the world from the moment his tentative senses were ready to perceive. And while we may have good vision ourselves, we know what he means because we have learned to find our own routes through quickly reading clues, ignoring some, dismissing others, choosing what we need to grasp and committing the sensation to memory.

We perceive the world not simply by 'using our eyes' but exercising the whole brain to build up a 'catalogue' of objects, making connections with many other brain areas, particularly memory and also, of course, emotion. Visual images flood into our brains as light strikes the retina at the back of the eye. The retina converts this signal into a series of chemical signals which are, in turn, transmuted into electrical signals which travel down the optic nerve to the part of the outer region at the back of the brain in the visual cortex, and one of the brain's first tasks is to define outlines. There are discrete areas in the visual cortex dedicated to identifying specific aspects of vision – vertical or horizontal lines, colour or movement, for example. These elements are brought together to ensure that the total image arrives consistently in space and time. And even while our brains are swiftly adjusting to focus on the scene before us, images established in memory form feedback loops to confirm that we recognise what we have seen before, mediating prior knowledge into perception. As we acquire this personal knowledge then, we impose 'top-down' concepts on to 'bottom-up' perceptions. When we look at a cluttered scene in front of our eyes we may receive only partial information but our brains automatically fill in the gaps to make sense of things.

In art, our inclination to top-down impositioning can be exploited to great effect. Semir Zeki believes that particularly compelling are those artworks which contain only vague clues and perhaps especially those which are actually incomplete because they require the viewer to work hard, offering 'in a sense, a neurological trick, endowing the brain with greater imaginative powers'.[5] Indeed, the solving of a perceptual conundrum brings its own reward, and we experience what feels like a little stab of pleasure when we unscramble a confusing image to make sense of it, the internal top-down/bottom-up synthesis involved in visualisation making direct links to the limbic system, the brain regions concerned with physical processes, emotions and memories. The root meaning of 'aesthetic' in early Greek is 'I breathe in', 'I gasp' and it acknowledges this frisson of emotion. In an installation called *The Influence Machine*, commissioned around Halloween 2000 by Artangel, the

artist Tony Oursler projected phantasmagoric moving faces, which shifted and blurred onto the windy trees in London's Soho Square, accompanied by disembodied voices and sinister music. There is a specific area in the cortex which has evolved to accomplish facial recognition, an important function for the social animals humans are, which is why we are motivated to seek out face shapes even in the most abstract of patterns. We are familiar with the celluloid close-up face looming huge on the screen but here the film was projected onto walls and trees and the viewer's perceptual apparatus had to struggle to translate incomplete images into recognisable and meaningful representations, receiving a small jolt of pleasure as a reward in doing so. Having thus programmed our perception by finding one filmic face, we could make out others in the leaves and branches of the trees. I breathe in. I gasp! And yet there was nothing there at all.

14. Tony Oursler,
*The Influence
Machine* (2000). Soho
Square, London.
Commissioned by
Artangel. Photograph:
P. Taghizadeh. Courtesy
Artangel.

Art's images bear resemblances to things we literally know and they offer to the mind an opportunity to engage in puzzling out a meaning which is partly literal, but gesturally symbolic, partly decodable and rationally explicable, partly fraught still with hidden implications and always physically 'felt' in our imaginations. We make tentative projections but when the forms present unusual information the pleasure inherent in the act of recognition is deferred. The deferral becomes a pleasure in itself, a foreplay which may never be fully consummated in the most effective works which delightfully tantalise us with hidden meanings.

Abstract and non-figurative art can deliberately confound our perceptual expectations and it is hard to resist trying to predict sense from its distorted perspectives. The brain finds it particularly difficult to cope with conflicting information, a phenomenon famously exploited by Escher, whose staircases seem to be simultaneously viewed from above and below, floating confusingly in between two realities. This can be simple visual trickery but it can also disturbingly stress the emotional content in a work. Marcus Harvey's notorious portrait of the accessory to child murder Myra Hindley looks, at a distance, like a standard painting but on closer inspection it is ghoulishly found to be made from a montage of children's handprints. It is hard to focus on both the composite picture and its components simultaneously and it is genuinely upsetting. At first sight, Ron Muerk's sculptures of people look uncannily life-like but we soon realise that there is something worryingly wrong with them because the artist has made subtle and unexpected adjustments of scale. Such ambiguity is disturbing: a touching sculpture of a mother gazing at the newborn child huddled on her belly looks convincingly realistic – but they are eerily exactly half life-size. A sculpture of a life-sized swaddled baby is placed next to one of a diminutive naked man in a boat. Which is the 'right' one? Our perceptions are not simply informational but vested with associative emotions, which may be more acutely felt if they are evoked from jangling disorder, partial or ambiguous information. Art playfully teases the mind – materially by setting up stimuli in the limbic system – but it also sets up private reverberations for each individual observer.

Memory Pathways

A great deal of our perceptual apparatus is genetically innate so we may all generally share the same ways of seeing – as far as we are able to tell. From infancy onward we quickly commit an image to memory. We learn to

classify types of things which helps us short-cut identification processes. An individual table is but one of a subset of furniture items filed, as it were, under the genus 'table'. Zeki calls such groupings 'constancies' and he compares them with Plato's ideal forms.[6] But we also have uniquely personal associations, shaped and stimulated by the different environments around us and, while we all share the same basic perceptual processes linked to the same drives for survival, we all to some extent see and experience things differently. Experiments in which young animals have been deprived of certain stimuli from birth – of straight vertical lines, for example – have shown that they cannot thereafter discern vertical shapes in the general environment. Brain-cells are able to reorganise themselves (a phenomenon known as 'plasticity'), particularly in infancy. Brain regions will respond to stimuli and form accretions of memory but, un-stimulated, many may die and our early environmental learning is crucial. The artist Warren Neidich trained as a neurologist. 'After we are born,' he says:

> through a process of selection, certain neuron groups and networks
> are competitively selected by objects, object relations, and contexts,
> while others which do not have counterparts in the outside world die
> through a process of apoptosis [cell death]. Gradually, the brain is
> pruned like a fruit-tree and is sculpted by the world it encounters.

In the Muller-Lyer test, human subjects conditioned to read perspective from straight lines reliably report that A is longer than B. But people who have not been brought up in what Richard Gregory calls a 'carpentered' environment, built of straight lines and corners, but in cultures with curved buildings and natural patterns are not fooled and can confirm that the lines are of identical length.[7] We have acquired the ability to read three-dimensional perspective from the arrangement of converging lines and shadows in two-dimensional pictures and photographs but it is interesting to remember that the early photographs taken by anthropologists of indigenous peoples were often visually incomprehensible to their subjects if they had had no experience of reading two-dimensional images in this form. Gregory proposes that top-down perception is influenced by 'the prevailing perceptual hypothesis' and this can be variously influenced by different motivations, contexts, expectations and cognitive habits, but also, interestingly, by different cultural backgrounds, values and beliefs.[8] Sometimes our perceptiveness can be retrained as adults, if there are new contexts and

15. Muller-Lyer diagram – classic optical illusion.

expectations. The taxonomist George McGavin, from the Hope Entomological Unit at the Oxford Museum of Natural History, is an expert in tropical bugs called treehoppers, species of which mimic thorns or seeds and are therefore hard to see unless you know what to look for. He writes:

> Our brains, like those of birds, trout and other hunters dependent on vision, take a little while to form the appropriate 'search image'. As a young student I had worked on spiders for a while and then changed my attention to immature plant bugs. For several collecting trips after the changeover all I could see in my net were spiders and yet more spiders. Gradually my brain got used to seeing plant bug nymphs, and the spiders, although still present in large numbers, became almost invisible.[9]

It is fascinating to wonder how far such perceptual acquisitioning might bear out the views of historicist theorists who believe that our world picture depends on the culture we are brought up in, all the way from our perception

of physical objects, patternings and iconographies around us to our complex belief systems. Contrary to the ethos of the Hollywood movie and the TV docudrama, people from the past were not exactly like us in old-fashioned clothes. They actually saw the world differently, as many an art historian has been at pains to explain, and part of our challenge as observers of art, whether it is of work from the past or from different cultures, or from contemporary artists with unusual insight, is to try to imagine a unique and different way of seeing things.

Experiencing the Here and Now

Our sense of actually being in the world in the here and now is experienced with a sensation of vivid immediacy. Some philosophers of mind use the term *qualia* to describe the freshness and vigour that is our felt experience of things in the world in real time – the redness of this particular rose, the unique aroma of this cup of coffee, the silkiness of my baby's skin. Gregory believes that our keen experience of *qualia* is necessary to 'flag the present in consciousness to avoid confusion with the past'.[10] Art isn't real life in the here and now and it is interesting to observe how far it is able to simulate the same sense of vivid sensation and how far we distance it from the reality we otherwise recognise. A great deal of naturalistic depiction in art is intended to look convincing but unless it is a particularly contrived (though usually short-lived) *trompe d'oeil*, our pleasure really comes from comparing the synthetic with the real, perhaps marvelling at the artist's craftsmanship but also acknowledging his originality and the way in which he captures the spirit of the world he inhabits. Here is that master of minutiae, the writer Nicholson Baker, vividly describing what it is like to eat a pear:

> My pear had bird's-egg specklings of a delicacy I'd never before seen
> on a pear, and seldom on a bird's egg, either. It wasn't quite ripe,
> though; it didn't have that superb grittiness of skin, when the flesh
> dissolves and the disintegrating skin grinds against your molars.
> Apple skin must be chewed heavily and steadily, and even so its slick,
> sharp-cornered surfaces survive a lot of molaring. But eating a ripe
> pear is similar to cutting a piece of paper with a pair of scissors:
> you feel the grit of the cut paper transmitted back through the
> blades to your fingers, you can sense that fulcrumed point of sharp
> intersection.[11]

We can share the experience with Baker because we recognise such sensations but we also appreciate the fact that this is Baker's unique reconstruction, achieved through choosing sensuous words with fine precision and making his own analogies to help us understand what he feels, so we can almost relive it for ourselves and in doing so experience a kind of thrill of recognition, a phantom memory of the real pear-eating experience.

A new aesthetic phenomenology is emerging via advances in digital technology which might lead us to muse how far the paradoxically named 'virtual' brings us closer to lived experience. In his 1992 work *Tall Ships*, the artist Gary Hill triggers our deeply felt sensations and personal memories. He has created a walk-in installation in which the viewer enters a pitch-black narrow room to become aware that on either side are small monochrome photographs of people. As an image is approached it inflates to life-size, its subject eerily appearing to move directly towards the viewer, even making eye contact, until, apparently on the brink of communication, it turns away and the image shrinks and retreats back to a state of suspended paralysis, to be re-awakened by another approach. Such work displays the increasing advances in digital technology, combining video projection, laserdisc and automatic electronic triggering devices, all programmed and activated by computer and projected 'live', rather than passively on video or film, so ghostly images appear which intermingle with real people.

'I imagined a ship on the high seas, that frontal view of extreme verticality coming towards you,' Hill writes. 'There's a majestic quality to it that when applied to the human figure projects a kind of power and grace. That person will come forth no matter what.'[12] The analogy with ships is apposite, for besides explaining the choreographic dimensions that shape the piece, it is suggestive, too, of the phrase 'ships that pass in the night' which we use to describe the fleeting nature of our encounters with people in our lives, those who touch us for a short while and then disappear, like our memories. As we have noted, we are programmed to want to see human forms, faces in particular, and in this work we project them on to the blurred images in split second time, just as those images project themselves on to us. This is genuine interactive technology. And though the images are monochrome and don't possess the vividness of genuine *qualia* they do 'flag the present' – they appear to interact in real time. This illusion is emphasised by the fact that the experience is suffused with emotion. As these 'people' make what feels like actual eye contact, conveying a yearning look, a sense that they are stopped

on the brink of communication, we are immediately able to make what feels
like genuine eye-contact and read their emotional state and feel it within
ourselves. We also bring to bear on the work our personal autobiographical
associations and memories. The black and white images – a child in an old-
fashioned dress, an older woman, a young man and so on – are creatures
from a photographed past we all share, having similar images in our own
albums. Here they arrive momentarily as in a waking dream, ghosts from our
own remembered past and so nearly alive. And then they disappear. Ships that
pass in the night. It is an extremely moving experience.

16. Gary Hill, *Tall Ships*
(1992). 16-channel
video installation, 16
modified four-inch
b/w monitors with
projection lenses, 16
laserdisc players and
discs. Courtesy of the
artist and Donald Young
Gallery.

Mapping the Body

The neuroscientist Antonio Damasio explains that one of the brain's main
tasks is continually to monitor and regulate our bodily functions, and it
does this through establishing self-reflexive maps – images linking circuits of
neurons which are established in the brain to correspond to different bodily
activities, between which there is two-way feedback. This is essential to our
well-being and obviously applies to routine physical functions such as the
monitoring of body temperature, or the release of hormones to increase
appetite stimulated by a fragrant waft of cooking, for example. Living in the

world is a complicated business, so the brain constantly keeps in touch with the feedback from various systems and continues to regulate responses.

Artist Alexa Wright has undertaken an intriguing project with patients with Phantom Limb Syndrome, which occurs where people who have had amputations continue to experience sensations in the non-existent limb.[13] Neurologists understand that sensations arise as a result of a dynamic plasticity in the brain which allows it to re-map bodily awareness, often very soon after the limb has been removed. Areas on the cortex which formerly received sensory input from the amputated limb continue to be activated from parts of the brain on adjacent areas of the cortex linked to parts of the body surface close to the amputated limb, so it feels as if the limb is still there, though not always in a normal state. 'One man had a phantom arm fixed at right angles which he had to accommodate when passing through a door,' writes neuropsychologist Peter Halligan who with his colleague John Kew worked with Wright, 'another was plagued by his phantom arm floating up through the bedclothes when he was trying to sleep.'

Wright conducted interviews with eight patients and photographed them as they appeared to the outside world and then digitally manipulated photographs to create visual evidence of their actual felt experience, reconstituting the missing limb parts. Viewing the actual and the phantomised images side by side helped patients begin to come to terms with the nature of their revised self-image. The neuroscientist V. S. Ramachandran has explained how patients can retrain their brains through visual feedback and reports on one of his own phantom limb patients who was encouraged to place his arm in a box fitted with internal mirrors which gave the illusion that his missing arm was intact. After practising with this simple device he found that the phantom arm he had known for over ten years had all but disappeared. The experiment suggested that when his brain was presented with conflicting signals – visual feedback informing it that his arm was moving again even while his muscles denied the fact – his mind resorted to 'a kind of denial' and was alerted to the real situation.[14]

Wright's photographs may have a gentle therapeutic effect but they have also been exhibited in conventional gallery spaces and they are moving because of their paradoxical ordinariness, enabling viewers to share an intimate identification with the subjects' unconventional self-perceptions. One, 'GN', a safety inspector who had had his right arm amputated as a result of a motorbike accident thirty-four years ago, reported that his phantom

17. Alexa Wright, *After Image* (1997). Courtesy the artist.

limb had shrunk over the years and that he now felt only the presence of his thumb, attached to his shoulder stump.

That the brain can compensate for loss, even if in strange ways, that it can continue to alter and re-programme itself, is somehow both reassuring and marvellous too. But though we are talking here of actual material plasticity with real change in brain tissue and the brain's capacity to invent and reinvent experience, it almost explains the flexibility and scope of the imagination. The creation and manipulation of mental maps are essential to our survival but as a secondary function they give rise to the ideas, thoughts, plans and fantasies by which we distinguish our imaginations, our creativity and, indeed, our art.

Mind or Body - or Body and Mind

In his book *Descartes' Error*,[15] Damasio discusses how the seventeenth-century philosopher's underestimation of the intrinsic relationship between mind and body has influenced philosophical and scientific thinking in the West, so much so that until relatively recently they were regarded as separate entities.

Of course, such dualism has long been challenged in the discourse of critical theory in the writings of phenomenologists such as Merleau-Ponty and in the feminist psychoanalysis of such as Julia Kristeva and Luce Irigaray. The work of women artists, in particular – Helen Chadwick, Mona Hatoum, Orlan, Alice Maher, Tracey Emin and many others – demonstrates a conviction that our very identity and cognitive take on the world is firmly grounded in physical function and sensation. Damasio's hard evidence is from neuroscience and his book, *The Feeling of What Happens* (the title is taken from a line of a poem by Seamus Heaney) describes 'body and emotion in the making of consciousness'. In *Looking for Spinoza*, he rediscovers in the seventeenth-century philosopher's writings a prefiguring of the modern neuroscientific view that the mind and body are part of a single self-regulatory system.

In investigating the nature of consciousness, Damasio stresses that of central importance is this ability to monitor closely and continually the physical states and sensations of our bodily processes, essential as a feedback, self-regulatory system to ensure the well-being of our organisms as a whole. Our minds are therefore connected to physical sensation and all our responses, no matter how abstract or reasoned they seem, are bound up with our visceral, or genital, or hormonal systems, or the rhythms of our circulatory systems, in continual response to modifications caused by encounters in the environment. All our ways of perceiving, then, are inextricably related to emotions and feelings and with the urge to take action, and besides enjoying the pleasing tease of recognition when we engage with a work of art, we experience other physical sensations, though we may not consciously acknowledge them. In crude survival terms these may be related to ancient urges towards fright or flight, and our awareness of them may be so remote as to pass unnoticed, the palms of our hands secreting sweat, minute changes in heartbeat or adrenalin release or brain activity. But sometimes we are conscious of being affected, as many of our commonplace images demonstrate. Trying to explain our response to a particularly effective work, we may talk of feeling a *tingling on the back of the neck*, or being *weak at the knees*, experiencing a *gut feeling*, blood literally and metaphorically *pulses through our veins* and so on.

According to Damasio, *emotions* are not conscious states in themselves, they happen beyond our control, though they may be on show in public. Our linguistic metaphors give us a clue here – we are 'filled with' dread, a surge of contentment 'suffuses' us, a sense of the ridiculous 'comes over' us. Sometimes our *feelings,* too, remain unregistered but when they are, they are private

property, experienced by the individual alone. 'Feelings open the door for some measure of wilful control of the automated emotions,' Damasio writes.[16]

We have become used to looking for rational concepts in contemporary art, expecting to find cultural reference and autobiographical hint and, often, a sardonic irony, in order to think, talk or write about it, so it is harder to admit to the passion and disturbance that emerges and is felt directly. It is worth analysing a work which is usually explained conceptually to see how it impacts on our emotions and feelings.

Chris Ofili's installation *The Upper Room* is arranged in a long, dark, wood-lined upstairs room,[17] a space which the artist constructed in collaboration with the architect David Adjaye at London's Victoria Miro Gallery in the summer of 2002. The room displays thirteen large bright paintings. Each painting shows the same image – in an abstract jungle is a monkey wearing a turban and a little jacket and holding a goblet, above which is a lump of elephant dung. The central painting in the group, in the apse at the far end, is *Mono Oro* – Spanish for 'Golden Monkey' – though the word 'Mono' may also relate to the fact that each of the paintings is monochrome – this one is dazzling gold and the others Mono Rojo, Mono Marron, Mono Blanco, Mono Negro, and so on. Indeed, the works seem at first sight to be simply a homage to colour.

We learn that the monkey image was taken from a 1957 Andy Warhol drawing. What does it mean? Ofili is black British, of Nigerian descent, which might give a clue about the trademark elephant dung. Ofili's monkeys are both cute and sinister, defiant 'little monkeys' or emblems of racist taunt, but they are also Darwin's monkeys, out of Africa, a heart of darkness. And the arrangement is identifiable too – the Upper Room where the Last Supper took place, the golden monkey Christ in the centre, the twelve disciples ritually arranged around him. We remember that Ofili is, or was, Catholic. Is this irony, subversion, defiance? What does Ofili *mean* by thus offering us fragments from his autobiography?

Ofili and Adjaye know how to manipulate space in order to elicit from its viewer/communicants an attitude of solemnity, devoutness and apprehension. The lighting is employed with daring and grace, so that the colours and shapes from each painting, lit individually by concealed spotlights, are reflected on the floor in lucent pools. Looming out of the darkness the paintings are stained glass windows or formal columns from some ceremony back-lit by fire or evening sunlight caught through trees.

Added to this is Ofili's astonishing way with paint. He applies polyester resin to form translucent layers to bring out a multiplicity of different brush-stokes. The raised dots are influenced by African cave-painting tradition and make the visible tactile. Other paint-strokes form swirls, drips and curves which contrast with sharp, clean lines, through which drifts of stars and sparkle shimmer, the whole work embodying a physical vigour. And then there's the elephant dung. We know the story – that Ofili had the idea of using it after a British Council scholarship to Zimbabwe but that, in a kind of exile himself, he collects it from elephants in exile, in British zoos. We know how much – somewhat comically – it offends the bourgeoisie, who say they think the use of it is a provocative cliché, because we are naturally repelled by shit, especially by a defiant African shit. A visit to the African bush, however, would make its meaning plainer, for elephant dung there is part of the earth, fragrant, friable, grassy stuff that compounds with sunshine and bird-cry and breeze – as well as elephant-plundered shrubs and trees – to form the essence of wilderness. That it is commodified in Ofili's paintings, presented as glossy, varnished, paint-studded lumps within the picture's text or, outside the frame, propping up the works against the walls, says much about how far we have departed from this Eden. We know that millennia ago we shared this real Eden before we came out of Africa and the works may remind us of this fact.

Ofili's flagrant yellows may be associated with Africa, its sunshine, fabrics, beads or artwork. For some peoples colours have special significance: for Zulus, for example, green represents peace or bliss; blue yearning; Xhosa adults traditionally wear red; different subgroups use different colours as decoration, each with separate intricate meanings and therefore associations. In Islam, green and blue and gold are significant. In the European tradition, yellow has been associated with intelligence and enlightenment but also with illness, jealousy, cowardice or torture. And then we have our private associations, their source not always traceable. Why does yellow *upset* me? Or make someone else feel light-headed? And how far do these feelings come into play when confronted with Ofili's palette? The viewer's own emotional associations will decide.

In discussing the effect of the arrangement of the installation, anthropologists might refer to religious ritual, Catholics with liturgy, Jungians would talk about the collective unconscious, and evolutionary psychologists take us back to the Savannah where we were apparently preoccupied with survival and sexual selection. But then there are the memories laid down

along the infinite neural networks that make up our own autobiographical selves. Rather as strong sensations can emanate from functions arising from mere matter in the brain, strong sensations can be evoked through the mere matter of paint and theatre lighting – the manipulation of light and dark, order and disorder, neutrality and colour, stillness and movement, sense and nonsense – partial information that stimulates the viewer's brain to fill in the gaps with her own feelings and memories. There is nothing take-it-or-leave-it about such work. Beyond the reach of rational explanation, Ofili's outrageously defiant display provokes unbidden emotions and strong visceral feelings no matter how we may suppress them – anger, fear, awe, amusement, bliss – both universally human and uniquely autobiographical.

Consciousness and the Unique Self

Neuroscientists are much exercised by the fact (or is it the illusion?) that out of the material structures and processes in the brain arises a strong sense of personal consciousness. The ultra-materialist view is that consciousness and the material universe are one and that the brain operates like a computer with no conscious awareness but an automatic facility to respond to and translate a complexity of codes which give instructions for appropriate action, the illusion of *qualia* being surplus to requirements. The functionalist version regards the mind as a continually self-regulating process, which interacts, mentally and physically, with its environment. Others (particularly in the arts and cultural theory) posit that we construct our view of ourselves inhabiting the world through our senses, or phenomenologically, and narrate or perform our self-made fictions. At the furthest extreme is a quasi-mystical pan-psychism where all is illusion and we are merely fictions in the mind of God or the Universe (whoever those are). What seems clear is that the mind is a complex biological system, out of which *emerges* consciousness, something that is more than the sum of its parts. Two molecules of hydrogen and one of oxygen become something else – water. Consciousness is *epiphenomenal.*[18]

Neuroscientists agree that consciousness may be an extension of self-regulatory brain systems that occur all the way along the animal continuum, from single-celled creatures, to those with few cells and on to organisms which are the sum of many parts. A single cell already has a sense of boundary and while it could not exactly be described as 'self-aware', it will regulate its activities in the context of its own boundaries, defined by its outer cellular wall. It could therefore be said to have a sense of 'me' and 'not me' – and

will respond to potentially beneficial or harmful stimuli, through an evolved process of self-regulation (controlling the impulse to grow, to move, to feed, to regulate temperature, to die and so on). Of course very many organisms, simple or complex, operate as groups – diatoms, insects, fish, birds, primates – and, more than we may recognise – humans. Along the continuum of consciousness, there occur interactions from the micro to the macro scale – individually and collectively between molecules or neurons, cells, brains and bodies, or between members of groups, so that over time there is laid down a sense of past experience and an ability to anticipate future possibilities. Behaviours might be the consequence of specific hard-wired or genetically inherited dispositions, instinctive or acquired, as appears in animals which undertake complex feats, birds navigating by the stars, returning to the same small creek after going half way round the world, or sheep learning from the rest of the flock the skill of what shepherds call 'hefting', or territory-marking, on open landscapes. There can be many interesting discussions about the point at which consciousness and then 'self-consciousness' arises along the continuum of living species – how aware of itself is a geranium, an ant, a dog, a chimp? – for there seems to be no critical point at which a species can be said to have fully acquired it. Indeed, there are many occasions in our daily lives when we individual humans are not alertly aware of who and where we are – when we are asleep or, alternatively, concentrating hard on one thing, when we are driving a car – experiences known as 'time-gapping' where we seem to run on automatic pilot, what Daniel Dennett calls 'rolling consciousness with swift memory loss' – until particular events compel our attention.[19] 'Sometimes I sits and thinks,' as the saying goes, 'and sometimes I just sits.' Where is the recursively self-conscious Self?

Damasio posits that the 'self' operates at a base-level stage as a *proto-self*, manifested in the brain's routine and automatic mapping, constantly updating its many-faceted representations of the body. This gives rise to *core-consciousness* which occurs when the brain monitors itself in registering the need to respond to an object of attention by initiating action. Of central importance to us as humans and artists, there emerges from these states the *autobiographical self* – that sense of unique personal being, with its own histories, memories, hopes and fears and its full, rich sense of lived experience. This self is formed as much from bodily experiences and projections as it is from mental reverie and speculation. Reason and passion, cognition and emotion are inextricably bound up.

Who's Who?

The term 'stream of consciousness' was invented in 1892 by the American psychologist William James to describe the way the self 'changes continuously as it moves forward in time, even as we retain a sense that the self remains the same while our existence continues.'[20] The idea was made vivid in literatures where authors attempted to record the detailed non-sequential processes of their protagonist's minds, as in the novels of Henry James (brother of William), Marcel Proust, James Joyce, Virginia Woolf and William Faulkner, all of whom tried to capture in interior monologue the felt detail of private existence by recording an inchoate blend of sense-perceptions, thoughts, feelings and memories. Not all literature takes this internalised stance and more conventionally we are used to an interplay between the protagonist's subjective voice and the narrator's objective commentary, a form which seems to echo the way we sometimes monitor our selves in everyday life. Conditioned as we are by fiction, film and art in western life, we quite likely appropriate their narrative forms to explain ourselves to ourselves and to others. Indeed, I would suggest that humans maintain a ceaseless interplay between current styles in symbolic or narrative reflections on their existence and real life as it is experienced, the one influencing the other, and that such processes are important to survival.

It is interesting to observe how current scientific constructs of the mind are affecting the way we portray ourselves in art and fiction. There is, for example, a vogue for destabilising the illusion of the single self with internal voices, sometimes attributed to other narrators, sometimes split personalities of the single narrator. Such devices reflect the neuroscientific concept that we are mere bundles of impulses, sensations and chemical processes, with no guiding inner self except one that is spontaneously improvised or performed. Objective and subjective selves interweave or blur, as in the currently popular form of fictionalised biography by such as Peter Akroyd, Iain Sinclair or Jeanette Winterson, or the 'prose fiction' of W. G. Sebald. Borges and Calvino, present fiction as fact or fact as fiction. In 'travel' books by such as Paul Theroux or Jonathan Raban, documentary blurs with reveries on geography or literary criticism, all presented by authors caught in the act of fictionalising themselves. The voiceovers in the fact/fiction films of Patrick Keiller (as in *Robinson in Space*) and Andrew Kotting (*Gallivant*) are disembodied, presenting the reveries of apparently real people who may or may not be the authors themselves, who inhabit landscapes which seem imaginary even while they are recognisably real.

Teasing out the layers of confusion in such genres, A. S. Byatt's book *The Biographer's Tale* presents a biographer (the first-person narrator) trying to understand the mind of another biographer whose life's work is understanding the minds of his subjects. 'How do we put the idea of a person together?' the book asks, 'Everywhere he looks he finds fragments and gaps, disconnected type-scripts, bones and husks, boxes of marbles, collections of photographs.' We give ourselves up to the illusion the book sets up, taking us into the mind of its subject and thence into that of his subject and again into the minds of his subjects – once 'real' people, Linnaeus, Galton and Ibsen, all of whom were famous for creating their own taxonomies and fictions. But even as we do so, we know that the book we hold in our hands is a fiction created by Byatt and we are aware of her ironic detachment hovering over the whole.

In the visual arts, viewers subtly place themselves into the picture and share the artist's own stream of consciousness in which autobiographical experience is blurred, presenting a 'conscious' objectification of the subject/object's internalised view, linking the personal to the general and vice versa. 'I am my body,' the phenomenologist Merleau-Ponty asserts, both an 'I' and an 'it'. Mona Hatoum views herself literally from the outside in and inside out, through the videoed coloscopies and endoscopies which penetrate her insides in her 1994 work *Corps étranger*. The viewer enters a cylindrical viewing-chamber to gaze down at the floor and follows a dizzying succulent-seeming journey through her interior channels, accompanied by the sound of her heartbeat and breathing, so close that it merges with one's own. In exposing to her own objective stance and to the viewer the substance of which she is a part, both intimate body and foreign object, she invites an identification between artist and viewer – we all possess bodies and brains about which we feel a squeamish mixture of intellectual curiosity and felt possessiveness – and that boundary is blurred too.

The Canadian artists Janet Cardiff and George Bures Miller create what they call 'aural hallucinations'. In *The Missing Voice (Case Study B)*, the participant takes a walk around East London, wearing headphones which provide convincing 3D sound. The soundtrack is a disjointed narrative created by a stream of interrupted consciousness which cuts in and out, weaving medieval plainsong into the dark narratives of pulp fiction and film noir, to eighteenth-century historical reference, now charged with a sense of the ominous, now of the ridiculous. It is an unsettling experience but at the same time the participant cannot help but apply a distancing objectivity to monitor

its effectiveness and ponder where she really is in time and place, pursuing an internal reverie, partly imposed, partly her own, while interacting with the real world out there.

The application of new technologies in art create their own sense of introspection. In that which exists on the Internet, the viewer is alone in 'virtual' correspondence with the artist and also with all the other bodiless 'visitors' who may or may not make their mark on the work. The British artist Stefan Gec engages with the 'real' and the 'virtual' on many levels. His ongoing work, *Buoy*, derives from his discovery, in the docks at Blyth in the north of England, of eight decommissioned Soviet submarines. Out of this material he first cast eight bells, forming two works, *Trace Elements* (1990) and *Detached Bell Tower* (1995), which were then melted down to form the ballast for a fully operational maritime buoy, first as a land-based sculpture then registered as a temporary marker buoy. It went into active service at the harbour entrances in Belfast and Dublin and then, retracing the routes of the Soviet submarines from which its mass is formed, it was towed across the sea to guard the harbours of Rotterdam, Reykjavik, Copenhagen, Oslo and Stockholm, ending up in Murmansk where the original subs had started their commissions.[21]

18. Stefan Gec, *Buoy* (1996). Positioned in Befast Lough, Northern Ireland. Photography by Stefan Gec. Courtesy the artist.

Buoy is an artwork carrying within its heavy workaday structure ephemeral memories, both literally molecular memory and virtual. Invested with a Boy's Own romance about engineering and machines, especially war machines, the work has deep personal resonance for Gec who is of Ukrainian origin. His British childhood was dominated by post-war, cold-war politics and the work expresses a rueful reflection on the place of the individual in the unfolding of wider historical events. But by remaking the materials of war into those of peace – literally recreating a safe haven out of an instrument of destruction – his actions betoken a generous gesture of healing and restoration. And though it exists as a piece of industrial hardware on a real voyage, it is equally present on the Internet, where viewers can observe its virtual journey across the virtual seas in what William Gibson, the inventor of the term, describes as the 'consensual hallucination' of 'cyberspace',[22] where the phantom artwork is internalised and even 'felt' as a physical presence through its imagined weight and mass, its water, wind and sky. Where is it – in imagined territory? On the high seas, or in the mind?

Many visual artists use cinematic tricks to create an immersive experience in which the viewer can give up her own identity and revel in emotions which are other than her own. This is what ancient ritual and theatre have always done, of course, and being plunged into the cinematic dark is both comforting and unsettling. Mark Wallinger's *Threshold to the Kingdom* (2000) cleverly destabilises the viewer's emotions by putting together two incongruous art forms – a slow-motion film of people entering the arrivals lounge of an airport to the soundtrack of a dramatic and poignant piece of church music, the *Miserere* by the Italian composer Allegri (1582–1652), in which a boy treble's voice soars high over textured plainchant. For many European observers, brought up with the pure sounds of church music as part of a residual heritage, the commonplace arrivals lounge begins to take on the significance of the gates of heaven, which, of course, the title more than hints at. In an earlier work, *Angel* (1997), Wallinger is seen walking backwards up the escalator at the Angel tube station in Islington, London, intoning the opening to the Gospel of St John ('In the beginning was the Word and the Word was made flesh...') but played *backwards*. This might be wryly amusing or intellectually deep in terms of its reference to the primacy of the Word in Judaeo-Christian doctrine, were it not for the fact that the piece is accompanied by another piece of richly moving music of iconic status, Handel's magnificent 1727 coronation anthem *Zadok the Priest*, which carries

associations for many British people of the Queen's coronation, establishment order, public ritual and so on, though such irony might well be lost in the sheer passion of the music, which starts quietly and then surreptitiously builds to a heart-stopping climax with an exclamatory burst of voices that must surely have a genuine physiological effect, whatever one's cultural expectations. Wallinger is a clever arranger of the *mise en scène*, bringing together close-ups of faces experiencing extreme emotion, fast-paced action, engaging narratives and unusual metaphorical connections, all underscored by very emotive soundtracks. No wonder there is sometimes scarcely a dry eye in the house.

In viewing art, we recognise that we are not alone, confined by our mental and physical boundaries. We merge into a collective consciousness. Of course this happens in other circumstances, too, in rituals or riots, but to experience person to person – artist to viewer – a shared sensation, the confirmation that someone can feel, if only for a split second, *exactly* as one does, provides a kind of elation to the lonely self and we sometimes need to return to an artwork to experience this reassurance.

Another Point of View - Theory of Mind

Provoking the act of recognition in others depends on the ability to project oneself into another's imagination. This facility is a stage in normal child development (around the age of four) and is known by psychologists as 'theory of mind'. In a classic psychological test Sally and Ann are characterised as two rag dolls. Sally gives Ann some sweets which she asks her to keep safe. She watches as Ann puts them in her pocket and then leaves, promising to come back. As soon as she disappears, however, Ann takes the sweets out of her pocket and hides them behind a stone. Sally returns. At this point, observers are asked a question. Where does Sally think the sweets are?

This scenario, or others similar, is used to assess the possibility of autism in children. Autism is a brain disorder which is manifest as severe self-preoccupation and social withdrawal. At its extreme, its sufferers are unable to see the world from anyone else's point of view but their own. Faced with this little scene, then, unable to imagine that Sally has not witnessed the change they have seen themselves, they will testify to the facts as they are, not as they appear to be from someone else's point of view. Sally knows the sweets are behind the stone – doesn't she? – because that's where they are.

An ability to empathise with others is innate. Even animals observe each

other and mimic and very small babies will follow the path of someone else's gaze. Pop psychology books will point out that we unconsciously mirror each other's body language. Facial expression is even more inducive of mimicry. We respond with smiles and frowns of our own. Observe your family watching TV and note how their faces lighten up or darken, willy-nilly. Facial expressions are not just some kind of mannered outward signal but send back communications to the areas of the brain involved with the experience of actually feeling pleasure or pain. We feel the empathy we express or, on some occasions, consciously suppress. And seeing and feeling are connected to the possibility of taking action. Brain imaging studies on what are called 'mirror neurons' show that when a monkey observes another undertaking a particular action, the neurons which are activated in its brain are those which would come into play if it were itself undertaking the same action.[23] As the science writer Rita Carter explains, in humans the same motor area is alerted in the observer as in the observed, and cells in Broca's area also respond. This is the part of the brain which processes the articulation of speech and is also implicated in some aspects of grammatical processing.[24] So, besides physically mimicking the action, we also activate language-based concepts, themselves linked to the potential for action. Carter posits that this might be the basis of a sophisticated Theory of Mind in humans, 'an abstracted form of mimicry in which we create in ourselves concepts which match those in another's mind.'[25]

'What can it be like to be a bat?' the philosopher of science Thomas Nagel asks.[26] 'Our own experience provides the basic material for our imagination, whose range is therefore limited.' Subjective experience is defined, then, as 'what it is "like" to be something'. We know that bats don't see the world as we do, they are a byword for blindness, and it is hard to imagine what it is like to navigate space through echo-location, let alone hang upside down all day and 'think' like a bat.

The artist Marcus Coates has tried to enter the consciousness of other animals in order to feel directly what it is they feel.[27] The experience is physical and not a feat of simple anthropomorphised imagination and it is, of course, ludicrous. As artist in residence at Grizedale, Cumbria, Coates transformed himself into different species of British wildlife in order to find out first hand (or first wing, or paw, or talon) what it is like to be other than humanly himself, recording his efforts through video, painting, text, sound, sculpture and performance. As a goshawk he spent hours up a tree. 'Under

19. Marcus Coates, *Red Deer* (2001). Marcus Coates as performer in stills from digital video filmed by Adam Sutherland. Courtesy the artist and Grizedale Arts.

the skin' of a deer (actually with a deerhide strapped inelegantly to his back), he crawled on all fours through woodland and stream. From the rooftop of the stately home Compton Verney he relayed bird impersonations made with primary-school children. *Tis-yo-siss-yuoo-tiss-ee* (nestlings), they called, *Cabow, cabow, cabeck, cabeck, beck, beck, beck, beck, beck* (Red Grouse), *ar, ar, ar, ar, ar* (Duck). And in a painful attempt to run like a stoat he made a pair of low wooden stilts which he tied to his socks and teetered down a track on the two thin supports, repeatedly turning and twisting his ankles but managing to get up the occasional stoat-like equilibrium and pace, as his video work displays. His failure is profound as well as comic. Other artists have attempted to make this link between human and animal consciousness: Terry Fox tied dying fish to his tongue, penis and hair in *Pisces*, in an attempt to share the sensation of their death throes, Joseph Beuys spent a week in a gallery with the aim of living on the same terms with a coyote, Rebecca Horn's bizarre

body extensions turn her into a kind of animal or something in-between animal and human. Informed by zoological research and by studies into feral children allegedly brought up amongst animals, Coates is attempting to explore the territory between human consciousness and animal experience, reminding us that human consciousness is part of an animal continuum. 'The dominant emotions of birds...will be wildly different from those of man,' he quotes Charles Hartshorne in *Born to Sing, An Interpretation and World Survey of Bird Song*,[28] 'but not absolutely different or simply incomparable.' And although he is never able to answer Nagel's central question, which is not simply 'What is it like to be a bat?' but 'What it is like *for a bat* to be a bat?' [my italics] the artworks help us reflect more sharply on what it is 'like' to be human, and especially what it is 'like' to be another human.

Cause and Effect, Fate and Free Will

In 1985, the experimental psychologist Benjamin Libet undertook a series of experiments. Volunteers were asked to make simple hand movements at their own conscious whim and, using a fast-moving analogue clock, they were to note precisely the point at which they made the decision to move. At the same time, EEG sensors picked up signals from their cerebral cortices. Surprisingly, these showed that the readiness to move occurred *before* the conscious decision to do so. This is not the same as the reflex action which occurs when our hand automatically rebounds from fire. It relates to actions over which we believe we have, not just control, but prior decision-making autonomy. Apparently we don't. Not everyone is convinced by the experiment, which may have methodological problems. An interesting variation, however, is the idea that while we may indeed be at the mercy of unconscious impulses to action, we are able to *inhibit* them and this gives us the illusion that we choose our fate.

Either way, the implications are alarming. Seen in the light of eternity, some scientists would claim that every movement, every nerve impulse, every molecular twitch, every electrical charge is part of a complex sequence of causal processes, every tiny event the consequence of another back to the beginnings of time and space. Our emotional responses, too, occur outside our control. Lesion studies on people with brain disorders disclose the disquieting fact that even emotions as intimate as sadness and joy, despair and anger are located in specific centres in the brain which can be mechanically or electrically aroused, as is possible in people with particular brain dysfunction,

or under the influence of drugs, or even by especially consummate performers. The effect can come *before* the cause, in other words. Are our lives entirely inevitable?

In the Greek myth of Oedipus, the God Apollo declares that the baby born to King Laius and Queen Jocasta will grow up to kill his father and marry his mother. He is therefore banished from the state but as a young man he arrives at a crossroads where he comes across an old man. Impatiently he turns on him and ends up killing him. The kingdom of Thebes has lost its leader but young Oedipus arrives and marries the queen. When he finds out the true situation he puts out his eyes. Although Freud famously appropriated this myth as a foundation for his theories concerning repressed incestuous desire, its original significance related to contemplations as to whether it was ever possible to avoid the imperative of Fate.

Debates about fate and free will have always been fundamental to philosophy. Some thinkers make no distinction between decision-making processes and brain activity – conscious thinking is embodied in the brain and is an inextricable part of it, the primary cause of everything. Others are able to distinguish between different kinds of free will where there are 'efficient causes' which allow for personal intervention, or a theory of 'compatibility' which postulates that we have free will outside certain constraints. Daniel Dennett's view is that biological determinism does not imply inevitability because the human brain has evolved to 'generate and assimilate culture' so we can use our intelligence to plan ahead and our skills with language to communicate our intentions and we can even intervene with nature itself. The notion that we are free as individuals to act and, hopefully, to act responsibly, is part of the humanist legacy which informs much thinking in contemporary liberal western life and art. How far can we circumvent fate?

A contemporary film amusingly rehearses the arguments. There is little action in the first part of Spike Jonze's film *Adaptation*,[29] where the blocked screen-writer hero (played by Nicolas Cage) shares with us his struggle to find a plot from a plot-less piece of high-class journalism written by a smart New Yorker (played by Meryl Streep). It's about the rarefied world of orchid collecting, and he has been commissioned to adapt it into a feature film. Just as in life itself, neither the writer nor the audience know what's going to happen, and though we are presented with dangling plot-lines, we can't find any of the usual clues to make predictive sense of the film. A further distraction complicates the plot's trajectory, as real-life situations are

enmeshed into the movie's internal world. The real-life screenplay is written by brothers Charlie Kaufman and Donald Kaufman (the names of the twin brothers in the film, both played by Cage); indeed, the film opens where an agent (played by actress Tilda Swinton) is congratulating Charlie for his (real-life) screenplay *Being John Malkovich*. Just when the plot is meandering hopelessly – the plot both of the film we are watching and Charlie's fictional one – his twin brother Donald takes over the viewer's interest. He has also been trying to write a screenplay but, unlike our hero who is desperate to avoid plot cliché, he's been taking crash courses in scriptwriting and shapes up the mother of all Hollywood scenarios, which, of course, soon becomes hot property. The directionless Charlie reluctantly allows his twin to advise him and suddenly the brothers find themselves in a plot where fiction turns into reality. And the plot of the film we are watching escalates into action-filled cliché apparently reflecting what happens within Charlie's new plot. The critical moment occurs as our hero is caught spying on the journalist who is having sex and snorting drugs with her orchid-dealer lover (as one does). Realising that her reputation will go down the chute, Streep is given the *inevitable* movie line – 'We're just gonna have to kill him.' One train of events has led to another. And he becomes the hapless victim of the fate that is the Hollywood plot. Actually, with a nice 'twist', it's his twin (or is it his alter-ego?) who gets killed (at the point where his pursuer is attacked by a *crocodile* – naturally – it's survival of the fittest out there) and he gets the girl in the end. But that's Hollywood for you. And that's 'adaptation' – as directionless as evolution, hence the pun in the title. Just as in biological adaptation or new models of consciousness, one action leads to another, partly in response to the whim of circumstance but partly also as a demonstration of our capacity for free will – imagining, forecasting, planning ahead to circumvent events, or making snap judgements under pressure. In the microcosm that is the film's world we can see how human intelligence tries to circumvent fate both by responding to chance stimuli and by inventing alternative scenarios. If we follow the forward-thrust of the plot's trajectory and identify with the hero, the future presents endless unknown possibilities. His self-determined twin, however, makes choices to divert and alter circumstance. But it depends on your perspective in time, for in retrospect the plot seems inevitable and it's the twin who tries to circumvent his fate who gets killed off. Increasingly in the art which echoes and blurs with so called 'real life', it is not clear how far we manipulate our own fate or how far it manipulates us.[30]

The Ultimate Manipulation

Experts in some branches of consciousness studies use the metaphor of our time – the digital computer – as a model for explaining how the brain works. Indeed, some scientists believe that the brain is actually little more than a sophisticated artificial intelligence which might well be able to be remodelled entirely from silicon in the future, convincingly enough to pass the Turing Test – an artificial intelligence which, when substituted for a human subject, can answers questions about its mental state so convincingly it can fool its interrogator.[31] The engineer Steve Grand is currently engaged in building such a virtual mind within the physical body of an orang-utan doll called Lucy.[32] Grand does not use the information systems technology and algorithms commonly used in artificial intelligence but works 'structurally', building his robot bottom-up by painstakingly creating a brain that develops in response to its physical environment. This is an important acknowledgement for robotics. Brains that are bodiless are not able to experience the emotions and physical feelings that inform all our perceptions and thoughts. As Damasio has shown, the human mind evolved as a physical sensory system inextricably connected to a physiology and, if Lucy is to be at all plausible, then Grand must not make Descartes' error and separate mental and physical function. It is a massively audacious task because even if he concentrates on building a primary visual cortex (the best understood system of the brain), he is able to work on only very limited aspects of its capacity at once – currently on the parts that define boundaries and distinguish shape. His eventual aim is that Lucy should experience objects as richly as we do, as *qualia* – the smelt, felt, curvy, shiny, red/green appleness of an apple, the squishy, rubbery, dry-moist, pungent sweetness that is a real banana. Presumably her ability to pass the Turing Test will be a measure of what we might not otherwise believe.

Simply to imagine Grand's project is daunting, given that even the most basic human task requires countless hugely complex neural interactions, a feat that nature has taken millions of years to achieve. On the evidence of his hands-on engineered thought experiments, he believes that the evolving brain, at a crucial foetal/post-natal stage is much more plastic than do most neo-Darwinians, who believe that many domains are hard-wired and arrive ready to perform. But in reality he has still not resolved the Cartesian mind/ body dilemma for though Lucy is made manifest physically – from aluminium with hair and fabric – she is essentially virtual and her sensations are synthetic. So that she may 'feel', the chemical processes that are intrinsic to human

emotions are mimicked, triggered by an interaction with the environment certainly, but processed through computerised differential equations – dry code, not wet chemistry. This may result in an exact simulacrum of human responses and behaviours but it might be difficult to determine whether Lucy can become a real and fully conscious being rather than a cleverly constructed zombie.

Unless, of course, we are all zombie manifestations of virtual instructions? While Steve Grand is building Lucy one neuron at a time, some neuroscientists can see the potential to extend the capabilities of our existing brains. Once we are able to translate the cascade of information-processing into molecular chemistries, there may be ways of reproducing actual experience artificially. It might become easy to monitor the electrical signals that pulse down the fibres of the optic nerve and convert them into a digitised form. These might then be implanted directly into someone else's brain as a silicon chip. 'The question arises,' says scientist George Poste:

> as to whether this would evoke the same response that the original viewer had experienced. If this is possible, could a historical digital archive of an individual's visual experiences, and the accompanying repertoire of evoked emotions and memories, be transferred to another individual? Stored mental information could be transferable between individuals in life, and to others after-life.[33]

Strangely, however, this phenomenon may not be all that different from what we already experience. We absorb images and ideas that are not our own all the time but we make them our own by interpreting and remembering them uniquely. What are novels or pictures or virtual communications and the whole panoply we call 'artworks' but presentations of codes to be accessed and decoded and passed on to each other and privately committed to memory? Why go to the bother of inventing new ways of penetrating other people's consciousness?

If computer software can be continually transposed as the hardware upgrades, then presumably, unless someone pulls the switch and commits virtual murder, Lucy can live forever. Will she grow irrevocably wiser, leaving us all behind? Or will she, like humans but not – as far as we can tell – other animals, reach a stage in her childhood when she becomes aware of that fact that she may die? And indeed, that she *will* die. If the answer is no, then this

would mark her as inevitably always different from a human. She may be regarded as a kind of animal but she will otherwise be confined to that imaginary territory we have invented as cyberspace. Unless she's a work of art?

Chapter 7

New Bodies for Old

The Art and Science
of the Body Elective

The nurse took my right wrist
in both of her strong hands, and I
saw the doctor lean toward me,
a tiny chrome knife glinting in
one hand and tweezers in the other.
I could feel nothing, and then he said
proudly, 'I have it!' and held up
the perfect little blue star, no
longer me and now bloodless. 'And do
you know what we have under it?'
'No,' I said. 'Another perfect star.'

Philip Levine, *The Doctor of Starlight*

We so sensuously inhabit our own bodies that it is hard to see them as systems
of knowledge, even in the purified arena of the laboratory or operating table.
As Damasio's theory of consciousness shows, our response to the world is
physical and involuntarily emotional and so is our response to art, even
where it is entirely abstract or when it claims to be cerebral or fashionably
conceptual. Indeed, I would claim that art doesn't 'work' unless it provokes
some kind of visceral response. So, especially when we view bodies in art

we insinuate ourselves into the picture, empathising with the subject/object, imagining pleasure and pain, exhibiting emotion even if it registers so faintly as to be manifest only in slightly dampened palms. Studies with brain scans show specific areas 'lighting up' at the sight of a face, a synaptic flinch when we witness pain.

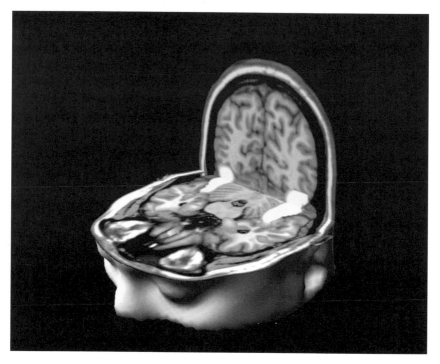

20. Mark Lythgoe and Chloe Hutton, *Face Recognition Image* (2003). This 3D reconstruction of a functional Magnetic Resonance Imaging (fMRI) brain scan shows that when the subject recognises a familiar face there is increased blood flow in the specific regions associated with facial recognition. The image, courtesy the artists, won a Novartis/*Daily Telegraph* 'Visions of Science' award in 2003.

Looking Inside

Not all artists are curious about the anatomy of inside. If bodies portrayed by Francis Bacon, Lucian Freud or Jenny Saville are as fatty and sinewy as meat, they are draped in skin, prone to discolouration and decay, yet robustly animate

and inhabitants of the outside world. Such images stand in vigorous contrast to the cool views presented by medicine's radical scanning techniques. As the artist and critic Andrea Duncan has pointed out, such technologies have enabled artists like Mona Hatoum, Orlan and Helen Chadwick to reconfigure feminist perspectives on notions of well-being, glamour and fertility, and in their work they are caught in the act of taking control of their own corporality, complicit with the bio-scientists and clinicians, in internal examination (Hatoum's coloscopies and endoscopies), intervention (Orlan's surgery which transcends the 'cosmetic') and cellular manipulation (Chadwick's *in vitro* fertilisation).[1] Self-possessed young women need not lament the 'abject body as a contested site', as the feminist discourse of the past few decades has persuaded them, but instead they are free to play a part in making decisions to alter themselves radically if so they wish, exercising choice in deciding how much to disclose to the male gaze, celebrating intellectual knowledge and new technological exploration in order to play ironically with the tradition that women embody an alluring softness, an insubstantial haze of memory and desire. And for all the artists queuing up to do projects at Old Operating Theatres to make ironic show of the pale dissected corpse as the object of expert interventions, there are as many who put on surgical gowns and masks and participate as eager observers, there to admire both the technical purity and the mysteries of procedure.

Jordan Baseman's film of open-heart surgery at Papworth Hospital, called *Under the Blood*, is ostensibly a documentary record but the contrast of light and darkness in the composition is reminiscent of a Caravaggio, and its mesmeric soundtrack, in which the voice of evangelist Billy Graham relishes in the blood of Biblical quotation, makes a tenuous link with the rituals of surgical preparation where death is a hovering presence. An accompanying film, *1+1=1*, is an interview with a patient, Patrick Wilkins, who received a heart and lung transplant in 1999. On-screen is a visual image of a digitally manipulated semi-organic form that rotates, moves, grows and recedes, a hypnotic force which abstracts the patient's account of the bizarre bodily sensations and dreams he experienced before and after the operation, as much an active participant in the process as his doctors. The artist stands at the point at which the subjective and objective converge.

How different is this from the insides presented by German impresario Gunther von Hagens in his international touring show, *Body Worlds*. Flayed corpses presented with an uncanny vitality are displayed amongst groups

of indoor plants like cars with their bonnets open. In poses bordering on the high camp, they disclose to the world their inner structures, kept rigid through von Hagens' unique plastination technique, a method of preservation by which the corpses and their constituent parts are impregnated with plastics such as silicone and polyester resin. *Time Out* critic Sarah Kent reports being overwhelmed by the exceptional beauty of the bodily structures. The delicate tracery of blood vessels, extricated from the head with astonishing expertise, resemble veins on a dried leaf. 'The man holding his own skin turns out to be one of the best exhibits of a fascinating show,' Kent writes. 'He brings home the thickness of our envelope which measures 1.5 metres square, protects and cools us by sweating up to 2 litres an hour and, at 9 kilos, weighs roughly the same as the skeleton.'[2]

The exhibition is a celebration of engineering – bodies are so many metres of cabling and plumbing; joints and muscles are joinery and clockwork. Such delight in facts for their own fascination reflects a renewed interest in the body as machine but may also be a consequence of the fact that people in urban societies are no longer familiar with the messy stuff inside. Much more rarely are butchers' doorways festooned with animal carcasses or the streets alive with the squeal of the piglet in panic as it is chased to the slaughterhouse. Like the supermarket meat that comes packaged and chilled, the human flesh in *Body Worlds* is clean and odourless and delicatessen-cured, and there are few glimpses of the fact that it belonged to individuals rather than mannequins, apart from the occasional skin tattoo or, more uneasily, the sight of lips which once must have spoken or kissed.

The presentation of the corpse in historical collections, whether whole, dissected or in component parts, is more profoundly strange because there lingers a sense of devotional reverence we can no longer share. One suspects that Martin Kemp and Marina Wallace, curators of the Hayward Gallery's 2000–2001 exhibition *Spectacular Bodies: The Art and Science of the Human Body from Leonardo to Now*, were bemused by the cod sensationalism of the scary body art voguish in some areas of the art world.[3] Their trawl of medical museums across Europe brought to the fore a heap of glistening viscera, in paint, drawing, early photograph, wax model or actual specimen. The exhibition demonstrates how radically attitudes to the body can change. An eighteenth-century fœtus ('human preparation in glass jar'), its sightless eyes and placid expression curiously lovely, wears bead bracelets on its pale limbs, grave goods as a homage to what must have been routine calamity. A bodiless

baby's head suspended in formalin is perpetually asleep, the lace edging her bonnet like a corolla fringing a mermaid's sea-flower. A wax model female by the eighteenth-century artist Giovan-Battista Manfredini provocatively holds up the skin of her belly to reveal her viscera, out of which bulges a shiny pregnant uterus. Still vital-seeming, her docile nakedness draped in a Virgin blue cloak, she is greatly more disturbing than the sanitised models of the von Hagens school, reminding us how alien is even the recent past, when neo-natal death was to be expected and public hanging, drawing and quartering commonplace. In each case the body was regarded as precious, sanctified, its public mutilation a ritual desecration, its anatomical revelations a testimony to the ingenuity bestowed on man by God.

In today's godless world, Marc Quinn's use of actual human material for his portraits presents the living as sufficient unto itself. Such is *Self* (1999), the 'sculptured' head made from his own blood which has been poured into a mould and kept 'alive' through refrigeration, the eyes closed like those of the sleeping fœtuses. The severed neck stands on a stainless-steel base and though the dark reflection of blood on blood is disturbing it evokes only a ghoulish chuckle. Viewers are also entertained by Quinn's 2001 *Portrait of Sir John Sulston*, commissioned by the National Portrait Gallery to celebrate the achievements of the Nobel Prizewinning geneticist. Instead of the traditional portrait of a character-full face and bearing, this is made from a sample of Sir John's genome sequenced from his semen and preserved in agar, organic evidence of his distinctive DNA. Sir John did not object to the 'taking' of a portrait so seemingly impersonal to our perceptual processes, which have evolved to recognise facial but not microscopic distinction in each other. It is a selfless man, in every sense, who agrees to be commemorated in this way.

Almost all the new bio-sciences examine the structures and functions of the body at a level which eye and brain cannot straightforwardly comprehend. These alienating devices compound the sense of the body reified and present a challenge to artists seeking to startle the viewer with meaningful communication, especially where the imagery is so unyielding. The illuminated vaguenesses of X-rays, infrasound, EEG, PET, fMRI, MEG or TMS scans need explanation if they are to be understood[4] and even then the science is still intractably crude. So two yellow blobs indicate areas of the brain responding to familiar faces? (see plate 20, p. 134) How much less evocative is this than traditional images of faces themselves in the act of recognition. There is already rather too much bad and boring body-scan art

around, often grindingly literal, such as the work undertaken by one artist in residence who was attached to a pathology laboratory from which she procured copies of cervical smear images. Aligning them in repeated patterns, she made a kind of wallpaper, presumably not to inform and hardly to cheer up the worried women in waiting room.

Traditional media, such as pencil drawing or paint, are often more successful than high-tech images at communicating metaphorical meaning, perhaps because we can tune into human agency, perception and inventiveness. We cannot see though the eyes of a machine but we can enter the artist's imagination and see through hers. The painter Madeleine Strindberg uses fMRI scans – functional Magnetic Resonance Imaging, which tracks neural activity in the brain – as a starting point to make delicate paintings of the fine traceries of the central nervous system. She reconfigures specimen sections in order to render the mysterious patterning of the brain as the abstract matter from which processes emerge. Traverse sections of the medulla oblongata float like butterflies over a golden yellow background, an adulation of form for its own sake. It also helps to know that the medulla oblongata controls bodily movement and the maintenance of equilibrium, so the butterflies' tentative balance is more meaningful intellectually.[5]

Artist Annie Cattrell makes fine bodily structures using filigree glass – hearts and lungs, formed by intimate hands- and lips-on glass-blowing and sculpting techniques. But in making sculptures of the brain, she does more than simply reproduce architectural form. The brain is the silent receptacle of consciousness and the route to perception, and she seems to seek the animate spirit that resides in matter, the non-existent ghost in the machine. In finding a way to convey this, Cattrell has turned to technology but brought her own inventiveness to the process. Rapid Prototyping (RP) is usually used in engineering or by brain surgeons trying to identify potentially life-threatening conditions before operations. 3D computer information, stereolithography, is transferred through laser technology into different materials, such as wax, resin and nylon, so they can be seen and felt as 'real'. Working with neuroscientists Steve Smith and Mark Lythgoe, Cattrell captured fMRI digital data relayed while subjects were caught in the act of looking and listening, and then used RP to transform these isolated processes into computerised virtual models. Out of these she made waxy resin sculptures, embedding them in solid square 'brain-boxes' made of transparent hot-cure resin. These split-second moments of seeing and hearing look like pieces of yellowy-

brown ribbon seaweed set in a clear block of ice. But as the viewer's own saccadic (minute jumpy) eye movements shift about the light and shine of the transparent materials, so the images continually change position and shape, the high-tech imaging reflecting the high-tech imaging of the observer's brain. Unencumbered with irony, the work reinvigorates an Enlightenment spirit of intrigue and wonder.[6]

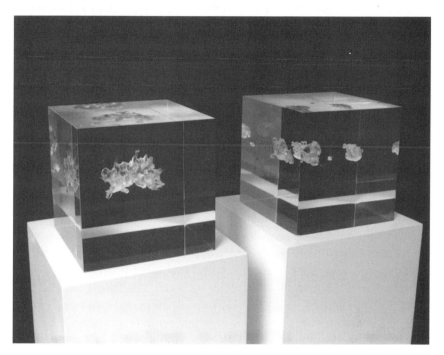

21. Annie Cattrell, *Seeing and Hearing* (2001/2002). Photograph by Peter Cattrell. Courtesy of the artist and collaborating scientist Mark Lythgoe.

Specimen Collections: Hirst and Borland

Such a sense of awe is absent from Damien Hirst's ironically obsessive engagement with science – its pharmaceuticals, sections, vitrines and forensic investigation. *Pharmacy*, which stands as a room-size installation, is a pristine and ordered display of the modern world's pharmaceuticals in their boxes, as much an iconography of mystery and wishful thinking as the traditional apothecary jars which stand in lucent primary colours on the counter. The

viewer can be amazed at the audacity of size and number – both of the pharmaceuticals and Hirst's super-clean trainspotter collection of them – and also seduced by the overall aesthetic, in which *World of Interiors* good taste is manifest in the stripped wood floor and neat shelving. The jarring Hirstly joke takes the form of an electric fly-killer. Vermin here amongst such purity? Surely not.

The Void, a glass display case of 8,000 replicas of currently available pills and potions, displays a similar obsession with pharmaceutical collection and classification. Again, the attention both to detail and number is impressive and the precision of the display – each coloured tablet calculatingly equidistant from the next – is satisfying in a way that strikes at some deep desire for order. *The Last Supper* consists of a series of thirteen panels arranged in light mockery of the Leonardo painting. Each is designed with the elegant colour coding and characteristic typefaces created by the product design teams employed by the major pharmaceutical companies. But instead of commercial brand-names the labels signify commonplace food items: *Beans and Chips*, *Cauliflower Cheese*, *Omelette* and, in the centre, an acid yellow label for a box which contains *200ml of Christ (ferrous Fumarate BP 140mg)*. Quick as we have become at reading and decoding the puns and puffery of advertising, the work is soon hoist by its own petard and draws little more than a guffaw. This is not to deny its slickness and one might admire in Hirst the advertising copywriter manqué rather than the lapsed Catholic. In the pleasant setting of the urban art gallery, any political or iconoclastic motive is lost, perhaps reflecting the fact that we are all only momentarily concerned but shrug off any responsible thinking. There may even be a sense that on our behalf Hirst is wavering into a collusion with the pharmaceutical companies, celebrating the abundant ways of designing pain out of our lives. pharmacologically – and profitably – if you were to read more than cool flippancy into the work.

Other pieces of Hirst's science-inspired work seem more primitive and ancient, perhaps, not surprisingly, where clean white skeletons and skulls are delicately suspended. In *Stripteaser* two specimen skeletons dangle in their separate compartments next to two double sections containing obsessively ordered clinical instruments and apparatus. The frail skeletons in themselves, the tracery of their bones glancing off glass or reflected in shadow, contain a fragile beauty and a cautious reverence for humankind. In *Skullduggery*, a skull is spliced vertically and re-presented with each half matched up and positioned upside down at the crux of four glass panels. But two ping-pong

ball eyeballs are detached and suspended above each socket. In *Death is Irrelevant*, a full skeleton is similarly spliced and realigned along a horizontally placed glass cross, its arms wide-stretched in crucified supplication but its eyeballs, ghastly, poised above their sockets. Clean corpses, these are not just references to Christ's crucifixion and veneration, but are reminiscent of the rituals widespread in early human burial ceremonies and still conducted by certain tribes, where the dead are periodically exhumed after initial burial until the wet flesh is separated from the increasingly clean and sacred bones which are then 'turned' and rearranged. But instead of eliciting a sense of gradual calm from a ritual process employed to make peace with the dead and set in motion a cycle of regeneration, Hirst's corpses are unsettling and ridiculous. As A. S. Byatt has observed in her story *Body Art*, skulls always smile. The startling eyeballs are props from a comic-horror movie and the specimen bones await the meddling of medical students in a world where death is desecrate, bodies objects – perhaps a reminder, too, of the hidden history of grave-robbing for anatomical purposes.

Some of this work was shown at the Gagosian Gallery, New York in 2000 at an exhibition called, in over-the-top mock-sci parody, *Theories, Models, Methods, Approaches, Assumptions, Results and Findings.* Here were Hirst's characteristic life-size vitrines, some displaying fish swimming amongst gynaecological apparatus (the volatile chemical trimethylamine produced in human vaginal secretions – didn't you know? – is the principal chemical essence of decaying fish).[7] Others encapsulate scientific experiment, all white coats and protective clothing, organised equipment display, tidy protocols, but amongst such rituals are tokens of filth and disease – dead flies, overflowing ashtrays. Much more shocking, however, is the exhibition catalogue, a haphazard arrangement of installation photographs with two (good) critical appraisals (by Gordon Burn and George Poste), but presented mainly as a textbook of technical information for aspiring forensic scientists. Taking prurience over the boundaries of decency and compassion, authentic scene-of-crime photographs abound, with titles like, *The back of the head of a woman who was killed by a blow with a piece of timber*, *Victim of asphyxia by hanging* and – most horribly pathetic – *The body of a young female inside a bath tub with hands tied, prior to suspension from the shower unit.* There is abundant information about matters such as *Suicide by self-cutting and self-stabbing, Examination and Significance of 'tied up' bodies*, the necessarily official language operating in grotesque contrast to the ugliness of the crimes. Hirst

once said, 'I wanted to find out where the boundaries were, so far I've found there aren't any. I want to be stopped and no one will stop me.' In today's liberal culture, presumably no one is prepared to call a halt even at the point where art ends and snuff-movie begins. It is one thing to inform the public about the inhumanity of man to man and the death of God, or to point up that it is someone's job to deal with the aftermath of violence, but to show such material in the art marketplace is to reveal a derisory lack of compassion or respect for the killed, presumably on the spurious claim that irony itself allows the artist to occupy a moral high ground. If viewers fail to collude with such cool effrontery, there is a sense that they might be no better than weaklings themselves, fit to meet the scorn of right-on bullies in a mock display of survival of the fittest, or worse, to take the role of the victim, trussed up for torture in a world where there is no mercy. If this is the case, it is the ultimate expression of the selfish gene and, given Hirst's renewed interest in Catholic dogma, of a world where the rituals of science have taken the heart out of the rituals of religion.

The Scottish artist Christine Borland also addresses forensic horror but her treatment of the material is more humane. Like Hirst, she presents artworks with a clean, pure and ordered aesthetic but also works with bones, blood, deformity, disease and the shattered aftermath of war and murder, as if by breaking down the components of violence, her understanding will lead to healing and wholeness again.

Borland's early work in the 1990s sees a fascination with the consequences of bullet damage. Human-scale sheets of glass are rendered delicate with the web-tracery of repeated shots, evoking a kind of visible synaesthesia where the crack of the shot continues to echo in the silence. Working with ballistics experts, she has had shots fired into comforting domestic items – a shoe, household crockery, tailor's dummies wearing home-made bullet-proof vests in soft cotton (one with diamonds sewn into it), or rosy red apples each punctured with a neat hole and arranged in a circle on a formal marble floor – the history of every place in the world where domestic normality has been catastrophically disturbed out of the blue. She seems to crave a ritual for healing and sanctifying in the aftermath of violence. Retrieving a blanket from a police shooting range in Berlin, she has carefully repaired each hole. An eight-year project (1991–1999), *Small Objects That Save Lives* invited people to send by post an object which fulfilled the title's aim. Each rich with hidden personal narrative, likely and unlikely objects were sent and included

a torch, an inhaler, a book of Yeats' poetry, a bottle of hair dye, a crucifix and a hand mirror, all laid out with neat labels according to the protocol of forensic exhibition, a wishful-thinking scene of prevention rather than grim scene of crime.

Delicate and witty though such exhibits are, Borland does not shirk the macabre and often engages with medical history. In 1996 she gained permission to record material from the Museum of Anatomy in Montpellier but was allowed to make drawings only. Disregarding this order, however, she smuggled in a microfilm spy-camera and photographed eighty exhibits, many of them displaying bodies or body parts which had been damaged by war, violence or mutilation. At the exhibition at the Frac Languedoc-Roussillon in Montpellier, four distinct works were grouped spatially and conceptually, beginning with 'The Monster's Library', some of the books which formed the monster's literary education in Mary Shelley's *Frankenstein, or the Modern Prometheus*: Milton's *Paradise Lost*, Goethe's *Young Werther* and Plutarch's *Lives*. The viewer then proceeded to find bound photocopies of a French translation of five central chapters of *Frankenstein*, with the recorded sound of a sixteen-year-old reading the monster's speech playing on a background loop. On small shelves placed either side of the gallery's pregnant convex wall were two identical leather dolls, endearingly floppy, childbirth demonstration models, made with bodies filled with sawdust, their skulls taken from real fœtuses. The eighty forbidden slides were shown in sequence opposite a display of the artist's anatomical drawings.

The images in themselves are as grotesque as those in Hirst's catalogue pictures but taken out of documentary context, juxtaposed with other material and distanced always by a sense of the artist's hovering and appalled presence, they are rendered art. The war-deformed physiognomies, the clutter of grasping hands or spongy lungs, the sweetie-jars with their contents of drowned fœtuses are no less gruesome, indeed are even more so, because the spy-camera's blurriness suggests the artist had to rush her way through a forbidden charnel house, replete with terrible secrets. The seemingly haphazard arrangements and scrappy labelling is suggestive of a monstrous spare-part cache and this is borne out in the work's title, *Cet Être-là, c'est à toi de le créer!* which elides quotations in French translation from Mary Shelley's *Frankenstein* – 'This being you must create.'

The original exhibition's centrepiece display of sickening body images was mediated through distancing devices – literary association, cultural cliché,

blurred photographs, drawings, all part of a reassuringly calm gallery ethos. Perversely, however, they served only to stimulate the viewer's capacity to imagine a horror which is yet more horrible than the real, as if the artifice deliberately withholds its true potential, thereby creating an unresolved cycle of fear and the desire for consummation.

22. Christine Borland, *Cet Être-là, c'est à toi de le créer! Vous devez le créer!* (1997). Slides taken by artist with spy-camera while pretending to draw in the Anatomical Museum, Montpellier. Courtesy the artist.

This is still evident in the photograph of a flayed and severed leg, its splintered bone sticking out backwards. In the picture we catch the ghostly reflected image of the photographer herself in the act of squinting through her spy-camera, her drawing book and pencils discarded on the table in the foreground. The picture is simultaneously reassuring – it is 'only a photograph' – and repellent – the shattered disembodied leg. How can the photographer keep so objectively calm? We sense her serious desire to make a record with which to show respect for the dead, even when they are reduced to a collection of body parts.

Bodies Wet and Dry

Borland's compassion and reverence for human life contrasts with Hirst's deliberately provocative desecrations, which question whether human life is sacred or special any more or just a bundle of sensations. A great deal of 'body art' hovers between these two positions and reflects some of the debates in consciousness studies. Is the human body a soul-less, self-less object at the mercy of automatic internal processes or indifferent outside stimuli, or is it a precious vessel containing a unique individual formed by felt physical encounters with the world and with other equally precious people?

We form sensuous relationships with living matter, its substance suggests moistness, palpability and sentience, like our own substance, and any trickery can be experienced as an intrusion into our own bodies, as if by association. The performance artist franko b actually slashes cuts in his body until he bleeds to entertain and appal his viewers and make them think, he hopes profoundly, about the body as 'an unmediated site for representation of the sacred, the beautiful, the untouchable, the unspeakable and for the pain, the love, the hate, the loss, the power and the fears of the human condition'. If this seems warped, one has only to visit any gallery and look at the overwhelming appeal of pictures of crucifixion, of St Sebastian, ancient rituals in which the body has to endure mutilation and selfless sacrifice in order to acquire an exquisite transcendence and therefore even greater respect.

The Australian performance artist Stelarc, on the other hand, believes the human body to be obsolete, dramatically declaring, 'We are at the end of philosophy and human physiology.' His art is to demonstrate ways of extending the concept of the body through an application of various new technologies in which clunky robotics dominates soft and sentient flesh and where electronic wizardry interferes with the neural transmissions involved in the brain's motor control. Stelarc believes 'We have never had a mind of our own, we often perform – involuntarily, conditioned and externally puppeted.' In other words, 'Bodies are both zombies and cyborgs.' Stelarc has created a prosthetic 'third arm', equipped with a variety of joint movements which are triggered remotely. When he performs with this attached to his right arm, his left arm is also wired up to respond to off-site commands. Watching his body obey stimuli outside its control has something of the entertainment value of stage hypnosis and makes one reflect on how far and how many of our supposedly autonomous actions are actually automatic.

Stelarc has been working with the Performance Art Digital Research Unit

at Nottingham Trent University and the School of Cognitive and Computing Sciences at the University of Sussex to create *Hexapod*, a hybrid human-machine powered by a combination of electrical and pneumatic systems, which looks like a large wired-up metal insect, in the midst of which he will stand, shifting his body weight and turning his torso to activate a dog-like walking motion. This may have all the appeal of watching a small boy wearing a Meccano set, but the ideas that inform it are much larger than the execution and Stelarc's primitive mechanics shake up one's intellectual complacency. For a start, they inspire one to recognise that, far from being obsolete, the body is a pretty marvellous machine. The human hand alone can execute a vast range of tasks, from picking up a pin to throwing a cricket ball to tickling a baby's chin (the philosopher Raymond Tallis argues that a great deal of our intelligence derives from our ability literally to manipulate the world).[8] And the human body may be limited on its own, but its brain has invented amazing extensions to our basic capacities – the laptop I carry round with me becomes an extension not just of my own private brain but allows my body virtually to leap huge distances, construct engines and philosophies, converse with others. Another project, *Parasite*, has Stelarc's body linked to random Internet searches which simultaneously display the digital data on his body and electronically stimulate his muscles to move involuntarily. His body becomes 'a reactive mode in an extended virtual nervous system' and one can only wonder what kind of similar research is going on in the secret laboratories run by the armament industries who can buy the best 'brains' in the business.

As a humble performance artist dealing with the interface between men and machines, Stelarc may not have the blockbuster impact of the *Terminator* movies, but he has a cottage industry mad-inventor appeal, which makes him amusing, mind-provoking and in some work literally stomach-churning. His *Stomach Sculpture* was designed to 'situate the sculpture in an internal space...as an aesthetic adornment'. A closed capsule, with beeping sound and flashing light and tethered on a flexi-drive cable to a control box, was swallowed while endoscopic devices sucked out excess stomach fluid and inflated the stomach with air. A video endoscopy documented the sculpture's presence but 'excess saliva was still a problem, necessitating hasty removal of all the probes on several occasions'.

In a current project, Stelarc intends to grow a third ear, made of his own cartilage and bone marrow, grown in the laboratory and nurtured into the shape of an ear. Originally he planned to place the new ear beside one of

his home-grown ones but this would interfere with the nerves in his cheek. Instead, the ear will be cultured on his arm as a permanent part of his body and he hopes to fit it with a sound chip which will emit words when people approach. Stelarc would have to be invented if he didn't already exist, and his tireless curiosity, his energetic humour and his capacity for self-exploitation startles the imagination.

Unavoidably Mortal

The mystery of death may lie at the heart of artists' obsession with the sentient body but it is a curiosity shared with biomedical researchers and clinicians. And, of course, the medical world is not all clean, alien technology. Junior doctor and anaesthetist Kevin Fong describes his initiation into an intensive care which regrettably often fails:

> I remember the first time I saw a cardiac arrest...My principal
> impression was that it was messy and noisy and sad. At the
> end of the thing the woman lay there with the clothes shorn
> unceremoniously from her body, oozing blood from the needle
> puncture sites, blue, cold and alone. It was the first time that I had
> ever been present at the moment of someone's death. I remember
> being determined to record the event accurately in my mind,
> recognising it in some way as a rite of passage. By the end of the
> shift I couldn't even remember her name. And then you qualify and
> the whole thing rapidly ceases to hold any mystery. Eventually you
> see so many that it doesn't even register. I used to wonder if that
> might be a bad thing. Now I don't even wonder about that.[9]

It is unsettling to read such medical confessionals because we hope to acquire from clinicians the sanity of objective knowledge with which to combat our own chaotic fears. But the idea of the doctor as high priest is changing, as hitherto mystical medical knowledge becomes freely available to everyone. Sufferers of diseases need not feel ignorant and helpless, they can come to the surgery armed with information gleaned from specialist websites, bringing the subjective experience of illness into the clinical diagnosis and taking a view on the range of treatments available. At the same time doctors and clinicians have become interested in the 'narrative of medicine' and the value of subjective experience in diagnosis and treatment.[10] When objective

knowledge meets subjective feeling, we are all coincidentally inside and outside, subjective/objective, subject and object.

Film-maker Andrew Kotting has worked in collaboration with neuroscientist Mark Lythgoe on the installation and film *Mapping Perception* which gives an out-of-joint view of the world from the perspective of Eden, his fourteen-year-old daughter.[11] Eden has Joubert's syndrome, which is a hereditary disorder in which a small part of the lower portion of the brain – the cerebellum – is underdeveloped. Eden is shown from babyhood onwards in touching home-movie mode, a normal child making curious contact with the world, participating in the to and fro of family banter and communicating through a series of peacock-cry affirmatives and formal sign language, which she uses as a medium as non-rational and as sensuously expressive as poetry.

The film makes use of public information voiceovers from old National Health Service documentary material, which give what we would now regard as highly patronising information about mental disorder ('they're in a special unit on their own with – deformities', 'the child's parents must be encouraged not to aim too high'), yet here is someone with a fully formed personality, who has a purchase on the world which is many-layered and intensely vigorous. Kotting has related how he felt when Lythgoe read out to him Eden's hospital notes on her diagnosis:

> Visual impairment with bilateral ptosis, gazed-evoked nystagmus, impaired up-gaze, impaired visual acuity, optic atrophy and a pigmentary retinopathy; cerebellar ataxia; hypotonia and ligamentous laxity; however she can see a shoe at 3 metres, a spoon or banana at 2 metres, a cup and watch at 1 metre.

Such dispassionate language is, of course, a necessity in medical investigation, presenting terms which carry a consensus of meaning in order to avoid ambiguity and, perhaps deliberately, they also distance the clinician from too much empathy which might hinder his judgement, although there is something very poignant about the use of domestic items, spoons, cups and shoes, as measuring apparatus. But no one pretends that this accurately describes a unique individual. 'I remember seeing Andrew smile,' Lythgoe writes. '"But what about her sense of humour?" he asked.'

Eden is quite clearly not a medical condition but a strong-willed, funny and expressive individual, and underlying Kotting and Lythgoe's film, an

ostensibly gentle and open-minded exploration of the mind's perceptual processes, there is a core of grief, frustration and rage, Kotting's own, rather than Eden's, however. Some of this may be railed against the whim of fate – the random bad luck of genetic inheritance, rather than the wrath of a vengeful god; some against the resolute clinical objectivity of medical knowledge and its ultimate shortcomings, but much, too, concerns perceptions of normality and abnormality. What is Eden's subjective experience and isn't it as valid as anyone's?

The helplessness of suffering is combated with the proactive desire for knowledge, even of the process of our own deaths, and good art can uniquely enter this sensitive territory, countering objective reason with intensely felt empathy. *It's Inside* is a factual work produced by the artist Alistair Skinner (now sadly deceased) with his wife, the artist Kate Meynell.[12] Relatively young, Skinner was diagnosed with advanced cancer of the colon and decided to keep a diary to record the process of dying. 'With the knowledge of the diagnosis everything changed,' they wrote, 'Alistair's identity was altered and friends recognised him differently.' In one of their artwork videos the camera pans very slowly up and down his naked body which, apart from a couple of plasters covering needle-puncture wounds, looks like that of any healthy adult male. Partway (re)objectified as a dying man to his friends, the subject is without personality, boundary or identity to the medical experts who are trying to help him, a view of himself he can strangely also share.

The American writer Don DeLillo's work comments on the way in which the technologies and languages of modern medicine objectify and reify the sensate body:

> You are said to be dying and yet are separate from the dying, can ponder it at your leisure, literally see on the X-ray photograph or computer screen the horrible alien logic of it all. It is when death is rendered graphically, is televised, so to speak, that you sense an eerie separation between your condition and yourself. A network of symbols has been introduced, an entire awesome technology wrested from the gods. It makes you feel like a stranger in your own dying.[13]

In the context of personal deliberation, the dispassionate technicality of the science – and the fact that everything has a cost – becomes charged with shocking pathos. A medical report reads:

> We recently determined the cost-effectiveness ratio of adding
> irinotecan to the regimen of fluorouracil and leucovorin in patients
> with advanced colorectal cancer and found an unfavourable
> pharmacoeconomic index (about 50,000 euros [$47,578]/year of life
> gained) using the clinical results reported by Douillard et al...

Skinner's sensation is thus:

> On day six after the course of treatment it is as if a light goes on
> and I can think again. As my mind clears so my body stops feeling
> exhausted and I feel better than I have for months. The terrible night
> sweats have stopped; before the treatment I would wake with cold
> clammy sheets and snuggle up to Kate to try and get a bit of dry
> bed. Eventually we would get up and change the bed or put down
> a towel and go back to sleep. Awake at dawn to go to the toilet, I
> hear the black birds singing in the quiet of the urban night and it is
> lovely. How does that fit into cost per square meter?

The eventual work has been realised as an installation in which viewers
wander contemplating different soundtracks and abstract visual images – of
cell structures and landscapes, casts, drawing and writings – 'those' they
write, 'which seem to have an equivalence with the visceral understanding of
the disease'. The images of cell structures may look like those exhibited with
pride and indifference by science imagers but 'the beautiful traces of dye in
biopsy material', as they report, is affectingly personal made strange. In some
presentations of the installation performance artist Gary Stevens, who has a
deadpan comic delivery, personifies a cell mutating and relocating. 'In this
way, humour and storytelling counterbalance tension while at the same time
providing a version of available knowledge.'

The late Andrea Duncan undertook a three-year residency with the Department
of Haematology at King's College Hospital, London where she collaborated
with clinical staff and patients with leukaemia. Like Kotting and Lythgoe and
Skinner and Meynell, she was intrigued by the way in which staff and patients
describe the same experience in two seemingly irreconcilable languages:

> Specialist languages and terminologies are reduced to a series of
> acronyms constellated round a diagnosis...information is processed
> too fast for meaning. Is language adequate to deal with both the

physical metamorphosis and sense of suspended animation which the
illness imposes?

Duncan included in her catalogue genuine medical record material,
Rosetta Stones which reflect arcane attempts to make order out of disorder.
Haematology Chart shows the Haematology Outpatients Clinic timetable;
Diagram the numerical chart of chromosomes deleted or inverted in acute
myeloid leukaemia. She also made new work, a digital print, *Twenty Three*

23. Andrea Duncan, *Twenty Three Pairs* (2002). Digital print, 130 x
110 cm. Courtesy the artist.

Pairs (2002) in which on a dark blue background twenty-three numbered pairs of worn socks are sorted in diminishing sizes, from adult to baby-size.

'I spent hours in cytogenetics,' Duncan wrote:

> and appreciated the scientists' painstaking approach by doing some
> of the same exercises – basic chromosome and pairing recognition
> which their 'beginners' do. There was something humbling about the
> work because it had to be 'right' and the eye had to be educated to
> its rightness. Yet there seemed so much variation even with normal
> chromosomes, it seemed to me the issue of an aesthetic had to be
> applied to the equivalent of the 'odd sock drawer'.[14]

The use of socks is moving – a little like the twenty-three pairs of human chromosome pairs in appearance, so personal and domestic are these quaint objects they are poignant reminders of their individual wearers and their unique genetic inheritances.

Codes and Interferences - Art and Genetics

Unless they happen to live in creationist Kansas, where the state has banned references to evolutionary theory from the science curriculum, the basic theory of genetics is taught to every schoolchild. This is not to say, however, that it has become a natural part of our cultural language. The double helix, the letters representing the four bases ACGT, the processes whereby DNA instructs RNA to build proteins using ribosomes, organelles which unite amino acids; or the ways in which genes have structural elements (which code for a particular protein) and regulatory elements (which 'switch on' instructions) and so on, all require laboratory understanding and intellectual elaboration. Art has traditionally illustrated the science gorgeously, through paintings of selectively bred cattle, racehorses or tulip varieties – depicting the glossy product rather than the process. In 1936, the American artist Edward Steichen showed new work at the Museum of Modern Art in New York, consisting of fabulous displays of delphiniums whose seed had been genetically altered with the use of the drug colchinine. In such works, intellectual knowledge enhances the appreciation of the art without too much attempting to wrestle with the technology or the ethical debates.

The new genetic artwork, however, has become more literal. Some relies on making analogies between DNA coding and the signs, codes and information

systems employed throughout the ages by various cultures – the ideograms, mantras or iconographies of mapping – but there is something rather dry and cerebral (and sometimes obvious) in the insistence of such association. A kind of Hawaiian shirt aesthetic results – all symbol, little meaning – but, unlike Hawaiian shirts, the codes seem extrinsic, tacked on, not culturally evolved. If the artwork is successful, then it is so because the artist's style is already distinctively attractive, not because of its laboured symbolic gestures. Such is fashion artist Helen Storey's project *Primitive Streak*, derived from collaboration with her sister, developmental biologist Kate Storey, which chronicles the first 1,000 hours of human embryonic development. The designs – of frocks and headdresses – are operatically fabulous, all the more so when they utilise new technologies such as fibre optics and sound imaging but the biology still looks didactically imposed – scientific symbols used as pattern, DNA bar-coded. Artist Neal White, in residence at the Human Genome Mapping Project in Cambridge, on the other hand, quickly decided against elaborating on the technique whereby Polymer Chain Reaction is used to generate copies of DNA, regarding it as too inaccessibly technical and visually tedious. Human DNA is all about heritability. His medium instead was the family photograph album which is much more immediately potent.[15]

'Anything to avoid the wretched double helix,' Denna Jones, curator of the Wellcome Trust's Two10 Gallery in London, says, about the theme of its exhibition to acknowledge the fiftieth anniversary of the discovery of the structure of DNA. Her choice instead was to commission new work addressing the unique personalities of the four protagonists in the discovery of the structure of DNA, Francis Crick and James Watson, Maurice Wilkins and Rosalind Franklin. The most resonant pieces in the show for me were documentary, the memories of artist Penny McCarthy, who made pencil drawings of the seminal 1953 *Nature* paper, inspired by the fact that her father worked alongside Crick and Watson in the 1960s. The way she describes the gentleness of the father/daughter relationship sharpens the implications of a science which has a supreme grasp of the true meaning of 'family'. Little glimpses of family life come over as touching and also somehow portentous: 'In our house his clones lived in the fridge and in searching for the butter you always ran the risk of knocking them over,' she writes. 'For me the letters DNA are the fragments of an overheard conversation, incompletely understood.'

The new 'transgenic artists' are engaged in more unsettling activities. Eduardo Kac's 1999 work *Genesis* uses a 'synthetic gene' which is a translation

into Morse Code of the line from the first chapter of the Bible, with obvious implications – 'Let man have dominion over the fish of the sea, and over the fowl of the air, and over every living thing that moves upon the earth.' The Morse Code is converted into DNA base pairs according to a conversion principle specially developed by the artist for this work and the 'gene' is then incorporated into bacteria. The cultures are shown in gallery conditions and participants on the Web can turn on an ultraviolet light in the gallery to trigger real biological mutations in the bacteria, altering the order of the letters in the original biblical sentence.[16] Kac's attitude appears ambivalent. While positing a view that we have reached a point at which ancient mantras can be disturbingly reinterpreted by science, the work manifests a clear enthusiasm for participating in its new technologies. Nothing may be sacred anymore but so what, if the bad old commandments are superseded? Artists become biologists, keen to re-create with the ultimate of materials. So American artist David Kremers makes living sculptures in which genetically engineered mutant zebrafish are redesigned twice a year and displayed next to a collection of the un-manipulated wild type.

Some genetic art isolates parts from the individual body, as in the laboratory, laying them out for analysis and scrutiny, and thereby turning experience into the squelchy data of biopsy. The Australian group SymbioticA has mounted in Perth's Science Museum an installation in which muscle and nerve tissue has been grown over miniaturised replicas of prehistoric stone tools. Yet more squeamish is the work of Dutch-based British artist Paul Perry, who has hybridised one of his own white blood cells with a cancer cell from a mouse, thereby forming a new immortal cell, a hybridoma, which is kept alive and growing in a bioreactor. As an artwork, called *Good and Evil*, this is placed in a canoe set on scaffolding, perhaps in homage to the sacred status of canoes in the lives of people from Maori and South Pacific cultures. We can be sure the artist is not simply rejoicing in the cell's 'beauty'. The work may offer satiric comment on science's Oncomouse, into which has been inserted a human gene sequence that confers susceptibility to cancer – the first genetically engineered mammal to be patented. But there is ambivalence here too. It is Good and Evil. If the process and the commercial investment in it leads to a cure for breast cancer (the Oncomouse's function) the experiment is probably justifiable.

Such interventions may have as much to do with a fearful fascination with the mutant and monstrous as with parodying new scientific practice,

making solid the nightmares of distortion and uncontrolled mutation, the half-man/half-beast chimera common to all world mythologies, ghost stories and science fiction, to say nothing of the vast lived mythology of terror surrounding cancer. The normal, the healthy, the survivable is symmetrical and aesthetically pleasing and, instinctively, we dread abnormality. To seek it out deliberately suggests morality run riot. SymbioticA is a biological art agency devoted to pushing such questions to the limit and has developed the work of artists Oron Catts and Ionat Zurr, in collaboration with Guy Ben-Ary, who worked with scientists at a residency at the Tissue Engineering and Organ Fabrication Laboratory, Massachusetts General Hospital and Harvard Medical School, to produce a gruesome artwork, *Pig Wings*.[17] Using tissue

24. The Tissue Culture & Art (Oron Catts, Ionat Zurr and Guy Ben-Ary), *Pig Wings – The Chiropteran Version* (2000-2001). Pig mesenchymal cells (bone marrow stem cells) and biodegradable/ bioabsorbable polymers (PGA, P4HB). Original dimensions: 4 x 2 x 0.5 cm. Courtesy the artists and collaborating scientists.

engineering and stem-cell technologies (a culture of pig bone marrow stem cells transmuted into bioabsorbable polymers), they have grown living pig bone-tissue in the shape of three sets of wings. The wing shapes represent

three evolutionary solutions to flight in vertebrates, designs also endowed with cultural value – the extinct pterosaur, angel wings and evil-seeming bat wings. The engineered flesh looks strangely familiar, like supermarket portions of crispy pork ('wings'), and reminds us that we already manipulate animal bodies for human consumption. 'This absurd work presents some serious ethical questions regarding a near future where semi-living objects exist and animal organs will be transplanted into humans,' they write. 'What kind of relationships will we form with such objects? How are we going to treat animals with human DNA?'

Or humans with animal DNA? Pigs are already being genetically altered for medical purposes, producing human proteins that resist rejection in order to ease the xenotransplantation of pig hearts or livers, and also for brain transplants in order to reconnect nerve tissue in patients with Parkinson's disease. Bovine nuclei have been inserted into human embryos in experiments conducted by the controversial pioneer of human cloning Dr Severino Aninori. Such practice gives a queasy modern twist to the savage belief that ingesting another's organs will appease the gods and endow the consumer with the victim's essential strength.

Eduardo Kac – not entirely tongue in cheek – proposes a new role for artists. 'With at least one endangered species becoming extinct every day, I suggest that artists can contribute to increase global diversity by inventing new life forms,' he writes. These can then 'be taken home by the public to be grown in the back yard or raised as human companions.'[18] Such is Kac's best known work, *GFP Bunny*, commissioned from a French laboratory, a live rabbit called Alba, into which was expressed Green Fluorescent Protein (GFP). This protein is isolated from the Pacific Northwest jellyfish and glows bright green when exposed to ultraviolet or blue light. The process is harmless but Alba was not permitted to enter Kac's Chicago backyard, such is the moral quandary of the authorities. In *The Eighth Day*, Kac has brought together a collection of creatures – plants, fish and mice – which are novel in the sense that each has been created by the cloning of a gene that codes for the production of GFP. Visible through a four-foot diameter Plexiglas dome which they share with a biological robot, their bioluminescence is visible to the naked eye. Put together, they are not individual laboratory specimens but a proposed ecology belonging to a newer world.

GFP is now routinely used as a marker gene in science, and commerce has inevitably entered the arena. Taiwanese scientists have created genetically

modified fish that glow in the dark, some containing fluorescent hearts that shine through their flesh, and will soon be available by mail order to brighten home aquaria. American scientist Jerry Young has produced the world's first allergen-free cats. It can only be a matter of time before cat-lovers will peer into their gardens at night to locate their moggy by its distinctive fashion-colour glow.

Critical Art Ensemble is a US-based performance group, founded in 1987, which has developed a kind of participatory theatre which encourages audiences to engage in active discussion about biotechnology and the potential impact of genetics and transgenic engineering on our daily lives. As curator Robin Held explains, the company's practice is grounded in laboratory research and collaboration with scientists and it tries to take a neutral position in debates. Their shows address the need to legitimate fears from hysteria about recent biotechnology, humorously exploring the potential impact of genomics on health care, reproductive choice, personal privacy and DNA ownership. Each of the works uses actual genetic materials and laboratory practice. *Flesh Machine* invites audiences to participate in on-site DNA amplification and cell cryo-preservation; *Cult of the New Eve* offers beer brewed with human DNA; in *GenTerra*, participants release benign transgenic bacteria into the air. The company also sets up simulation games in which the audience participates in creating a new biotechnology corporation which balances a commitment to producing profits for its shareholders with a sense of social responsibility. In one 'game' they operate a transgenic 'roulette wheel' – a bacteria release machine with nine empty chambers and one active chamber. Participants are informed that the transgenic bacteria they may be releasing is a benign, crippled lab strain of a kind that is routinely released in real laboratories. To release or not release becomes a personal, ethical decision for each participant.[19]

Such open demonstration and discussion has recently come under scrutiny as a consequence of an exaggerated fear of anything biological or scientifically engineered, because of its potential as a terrorist weapon. Critical Art Ensemble now have to meet review and approval by the Institutional Biosafety Committee and register with the National Institute of Health. The politics of science, in America especially, are fraught with paradox, as might be expected in a country where a hugely profitable bio-medical industry coexists with fundamentalist creationism and a rhetoric of freedom and democracy with protected rights of ownership, secrecy and suspicion. The widespread

cultivation of genetically modified crops goes on with little controversy; stem cell research – and, of course, elective abortion – is often vilified. It seems okay to meddle with the environment but not with God's blueprint for humankind – unless you're prepared to pay. And, since 9/11, everything is suspect, everyone a potential terrorist.

The Ethics of the Future

There are currently debates being held to see whether it is feasible to establish a code of ethics for biological art. Back in 1987, Simon Costin's necklace containing bodily fluids was confiscated from a London gallery; in 1989, Rick Gibson made earrings from freeze-dried human fœtuses, showing them at the Young Unknowns Gallery at Waterloo, and was subsequently found guilty of indecency by an Old Bailey jury. Artist Anthony-Noel Kelly was found guilty of theft and imprisoned in 1997–1998 for taking specimens from the Royal College of Surgeons in a groundbreaking case which found that skilled anatomists had a right to possession of the human corpse, hitherto not ruled to constitute property. There has been new anxiety in the UK, where revelations about the practice of hospitals and mortuaries retaining human organs without permission has shocked the public into reviving discussions about consent, ownership and decency.[20] The debates about human material are even more pertinent in light of the fact that human genes are being commercially patented for science. In *Moore versus the University of California*, the Court denied an individual proprietary rights to his own body tissue after he discovered that cells from his removed spleen had been patented by his physician. While one might not object to making a contribution towards medical research with proper permission, the fact that there are profits to be made by others is clearly disturbing. The ethics and protocols concerning the use of human or animal material, whether for what some may regard as frivolous purposes for art or deadly serious ones for science, may well be the next major issue. This may be particularly so in the light of new post-humanist debates by philosophers such as Peter Singer and John Gray, which take as a starting point the belief that there is no logical argument to support the idea that humans are different from animals, and vice versa, and that both therefore have 'rights'.[21] Science has brought us to a turning point where distinctions break down, where individual selves and personalities are apparently reduced to mere information systems which can be shared, or, more dubiously, profited from.

The political economist Francis Fukuyama presents a dismal view of the post-genetic world in which he believes that biotechnology will subvert for ever notions of equality, engendering, in effect, a privatised eugenics programme for the rich as we choose to promote new and rigid concepts of normality, with unnerving implications for the balance of power in the world. Ideal people will be healthy, beautiful, clever, the men strong and pleasant, the women attractive and high-achieving. Strong western women will feminise politics, men will become ineffectual, except in the Third World where normal aggression will rule. Homosexuality may be phased out, as might any form of disability, and the prolonging of our lifespan means the young will have to look after the old. Neuro-pharmacologies will also transform our personalities, Prozac bringing us lotus-eating calm and Ritalin sapping any inconvenient disaffection in younger generations. Margaret Atwood's novel *Oryx and Crake*[22] is a horrific Swiftian view of a dystopian future in which genetic technology has catastrophically put paid to the human race, a story that hovers on the boundaries of credibility given recent panics about Ebola, BSE, SARS and Avian Influenza where animal diseases can jump the species barrier and trigger incurable epidemics in humans. As fast as we find ways to transform nature, it seems that nature is able to catch us out in the same game – a situation that begs us to consider the ethics of interference.

Fay Weldon wrote her prescient novel *The Cloning of Joanna May* in 1985, in which a woman reaches the age of forty to discover that her mad scientist-captain of industry husband has had her cloned twenty years before so that when her looks fade she can be replaced by young and beautiful replicas of herself. She now has four daughter/siblings who have been brought up in different families. But far from discovering them to be zombie threats, she comes to love them for their different personalities – for they are not identical but unique confident young women who have grown up without the self-doubt of their mother's generation, for whom a woman's identity could be someone else's property without the bother of biotechnical intervention. Always mischievously perverse, Weldon is often prophetic and it is worth heeding her words:

> And cloning? Every child a chosen child? It's bound to come.
> Governments are going to want their best citizens replicated, and so
> will individuals. No one really wants to leave anything to chance any
> more. Why risk an unloveable baby when a loveable one is to hand?

Why have an angry, argumentative, plain population when you could have a nice, kind, peace-loving assembly of attractive, constructive citizens? And governments can leave it to parents to make their individual decisions; they won't even have to impose choices from on high. So watch out for a relaxation of the rules and regulations on cloning. It may take 50 years or so, but watch this space.[23]

Kac's artist-invented life forms may also be more than fantasy. 'Truth is stranger than fiction,' Weldon writes, 'and if the writer can think of it, someone somewhere is bound to be doing it, the world is so large and strange.' The same is true in the case of artists. Some of them are already doing it, appropriating scientific techniques and imagining futuristic scenarios beyond the boundaries of science fiction. Good work will be stunning on its own terms and naturally stimulate us to raise ethical questions and to ponder more deeply on the human condition, as I believe it should, even while I wouldn't want to see art that is too one-dimensionally didactic. But some of the new work seems to be rather coolly frivolous and we may feel ambivalent about using the tissues of life itself simply to shock or entertain.

Part IV: The Fragile Environment and the Future

Chapter 8

It's All Over, Johnny

Art and the Fragile Environment

Irrevocable Changes

Thomas Hardy's 1917 poem 'In Time of "The Breaking of Nations"' is a wartime lament which looks for consolation beyond local grief to the enduring nature of human existence:

> Only a man harrowing clods
> In a slow silent walk
> With an old horse that stumbles and nods
> Half asleep as they stalk.
>
> Only thin smoke without flame
> From the heaps of couch-grass;
> Yet this will go onward the same
> Though Dynasties pass.
>
> Yonder a maid and her wight
> Come whispering by:
> War's annals will cloud into night
> Ere their story die.

Hardy was wrong. He was wrong not just because by the middle of the century war's annals were to include the most annihilating means of clouding the night, but because the simple agrarian life of the man harrowing clods was by the century's end to change for ever, everywhere. If they are not employed in farm factories producing food for worldwide export, the maid and her wight have moved to the city where they are working in service industries in 'the knowledge economy'. They are living in a house with all the luxuries that enterprise brings – furniture designed in Sweden and made with wood imported from all over the world, or from man-made laminates, a washing machine, a dishwasher and not just an indoor toilet but an en suite bathroom. And in the garden the tinkle of a water-feature replaces the full-hearted evensong of Hardy's darkling thrush. Their family draws more water over a weekend than their great-grandparents would have used in a month. Instead of wandering work-weary down a country lane they are taking European holidays at resorts 'developed' on barren shorelines where fishermen once risked their lives, or perhaps they are walking in the Himalayas, as eco-tourists, expressing a distaste for the junk abandoned beside the trails even so high up in the world, or are trekking in Africa where the national flower is said to be a wind-torn plastic bag.

This is if they're lucky, of course. In some parts of the world, they will become the new slaves, as the radical writer Naomi Klein has witnessed, sleeping on concrete floors in dormitories, under virtual house arrest, so they may work long hours stitching designer clothes for the rest of us to wear, or cutting down the rainforest to pave the way for more profitable monoculture crops.[1] We may mourn our loss of innocence and despair for the desecration of our fragile environment but there are too many vested interests and profits to be made from plundering the world's bounty, and to protest is to appear meek. And do we not all enjoy the fruits of such unnatural behaviour?

In under a century human beings have devastated the landscape, the sea and the air above us for short-term gain. While the planet has periodically gone through periods of extreme climatic change and the geological record shows five major extinctions, many earth scientists believe it is heading for a sixth and this is greatly exacerbated by human spoliation. The earth is in crisis. Europe alone has lost most of its sea mammals, natural forests, grasslands and many other habitats and species.[2] At the *Cityscape><Landscape* Symposium held in Windermere in the UK's Lake District in 2000, environmentalists came

together to 'think global' and the artist Mark Dion provided a visual lexicon which glances over our plight:

B

Bambi

An acronym for Ballistic Missile Boost Intercept, a star wars satellite defence system. The protagonist of a novel and Disney film which traces the development of a fawn to a buck.

An animal or surrogate which elicits sentimental reflection.

Biocides

Any of the over 85,000 aerosol, liquid, oil, powder or granular formations designed to exterminate pest species, insecticides, rodenticides, fungicides, algicides, herbicides and lavalicides.

Brown Tree Snake

A species of bird and egg eating snake inhabiting isolated South Pacific Islands. Since World War II the snake has been island hopping by stowing away on cargo planes and ships. The snake has utterly denuded Guam and several other islands of all bird life, resulting in ecosystem collapse. The invader is probably the most catastrophic of all modern introduced species.

C

Caroline Parakeet

The only endemic parrot species in North America. It was hunted to total extermination as a crop pest and game bird. Its gregarious nature made it easy prey. The last individual died on September 1st 1994 at the Cincinnati Zoo.

Rachel Carson (1907–1964)

American marine biologist and author of the landmark exposé on the bioaccumulation of biocides 'Silent Spring'. The best seller was instrumental in launching the American environmental movement; while now considered a heroine, when her work was first published industry scientists fiercely attacked her. Many of the attacks were

personal and misogynist.

Cat

A carnivorous mammal domesticated as a catcher of rats and mice and as a pet.

An animal of the felis genus including lion, tiger and leopard.

An animal which eats without labour, finds shelter without restrictions and gets affection without the slightest condition.[3]

(He might have added that in Australia the feral cat is responsible for a huge number of predations on indigenous creatures.)

Contemporary art has become an urban phenomenon and artists who do engage with Nature can no longer regard it as a sublime route to the ineffable. Dion's fast-fired litany is charged with energy and wit but, above all, a sense of personal responsibility and desire for action. The world doesn't need more wringing of hands. It needs science.

The Gaia story is an interesting case. Working as a scientist involved with NASA's planetary exploration programme in the 1970s, the scientist James Lovelock had been pondering why the Earth was different from Mars or Venus. He arrived at the insight that it is able to survive catastrophic events and nurture life because its surface acts as an autopoesic – a self-contained and self-regulating – organism. The name 'Gaia' was suggested by Lovelock's friend, the novelist William Golding, after the Greek goddess of the Earth. But this mythical association was to become a major hindrance to the credibility of the hypothesis in the science community at large. Attractively accessible to the layperson, the idea began to take on mythic status in its own right and it accorded well with the sentiments of the time which derived from a mesh of hippie philosophies appropriated from a pick and mix of eastern religions, magic mushrooms and macrobiotic diets. It was not taken seriously. 'Until 1995,' Lovelock writes, 'it was nearly impossible for a scientist anywhere to publish a paper on Gaia, unless to disprove or disparage it; now at last it is a candidate theory awaiting approval.'[4] Re-branded as Earth System Science or Geophysiology, and 'speaking science in its own strict language', the Gaia Hypothesis has finally become an acceptable theory. The corollary to this is that Green activists have accused Lovelock of selling out and he expresses some regret that its new scientific status might be to the detriment of public understanding of the situation. But this, I believe, is to underestimate the public's new regard

for science and its rigorous methodologies. As Lovelock points out, many of us do attribute blame to ourselves for our over-consumption, and if we are to combat the more gigantic perpetrators – the multinationals, the profiteers, the gene patent-holders, the energy-guzzling electorates in the first world – we must combat science with science, not flagrant emotion, though wit is a useful armament. Or, perhaps, art?

Nature Studies

A beautiful sadness lingers about the work of the late-twentieth-century artists such as Andy Goldsworthy and Richard Long who operate, literally, in the field, making quiet satisfyingly ordered arrangements with stones, leaves, ice and other natural objects. Childlike in the best sense for their preoccupying playfulness, the works seem inspired by a spiritual faith in the eternal rhythms and cycles of nature. More urgently, however, our appreciation is sharpened with an awareness of the increasing threats to the environment, undoubtedly exacerbated by human activity which has left great gouges and gashes on the earth's surface, visible from space: dry deforested plains, huge dams that have altered the shape and ecology of thousands of miles of terrain, and filthy cities spilling heat, pollution and light into the atmosphere. Long and Goldsworthy's interventions are poignant by their very contrast with this, no more intrusive than the archaeological remains and burial chambers of early humans, indeed, they are almost as much works in memoriam as in celebration.

But just as Lovelock is unsentimental about future remedies (many in the Green movement have been shocked by his support for nuclear energy in preference to fossil fuels), artists do not necessarily hanker after the idea that natural beauty can only reside in unblemished, pristine environments. Richard Deacon has pointed out that while demolishing rainforests might be regrettable ecologically, the new landscapes that emerge have dramatic new aesthetic qualities. Indeed, we now admire the heathy wildness of the Scottish Highlands, forgetting that it resulted from the ravages of the Clearances. Richard Wentworth has even expressed enthusiasm for the aesthetics of the notorious poly-tunnels boosting strawberry-growing in middle England.

And there is nothing gentle or regretful about the challenging work of the New York painter Alexis Rockman. His medium is bright, garish and defiantly funny, representing the natural world with an accuracy that pushes scientific photo-realism over the boundaries into a fantasy that is nearly plausible. With

an obsession for anatomical detail in plant, insect or animal he forecasts the next evolutionary progressions. In the stony desert that is all that will be left to us in *The Neozoic*, a rabbit needing to leap higher and faster has become a rabbitangaroo; big insect-birds have developed proboscies so menacingly sharp they penetrate beyond the canvas; an aggressively fit dandelion challenges all human efforts at deracination by throwing down a super-root which coils long and vigorous under the topsoil and into a new geological layer composed of land-fill trash. In *Man-Eating Plant*, Rockman himself appears as a gung-ho Tarzan, struggling with the whip-like tendrils and dagger-like spines of a man-eating crypto-plant, the Yate-Veo ('the Portuguese "Ya te veo" means "I see you", or "It's all over Johnny",' he tells us) in a jungle that looks like a startlingly vivid version of the usually emaciated backdrops to old-fashioned museum displays. But Rockman's work is more than Pop-art for fun and demonstrates a brash and sexy confidence of a survival-of-the-fittest ethos teetering on the edge of breakdown. It is not cynical because Rockman is too interested in real science not to be fascinated by it. 'I find the very ideas of parody and irony totally idiotic,' he says, 'irony, you know, is a distancing mechanism for pain.' The alternative is to understand nature and our relationship with it and to be as much part of the action as scientists, many of whom greatly respect his work.

Rockman's mother was an archaeologist and he spent a great deal of his childhood in the American Museum of Natural History, familiarising himself with the collections, and drawing them devotedly. A recent visit to Aspen, Colorado, haven for eco-tourism, sees him making delicate drawings of insects in the tradition of early science illustrators, which, though accurate down to the last detail, manifest an overwhelming sense of his affectionate regard for the combination of fragility and tenacity that is embodied in many small species. Rockman has also been on uncomfortable expeditions to Guyana in homage to early naturalists such as Darwin and Beebe, in order to observe, collect, draw and paint many plant and animal species. In *Tropical Hazard*, our redoubtable hero poses cheerfully at the prow of his infested jungle riverboat wearing only baggy shorts, the sight of his bare chest, legs and feet bringing out all-over stings and itches in the viewer. Like a comic warning poster, he has appended close-ups of the enemy in small circular inserts on the canvas, including one displaying the diminutive yet dreaded Candiru catfish (*vandellia cirrhosa*) which allegedly can swim up a man's urethra if he happens to be peeing in the Amazon River. Another expedition has taken him

to equatorial South America in the company of artists Mark Dion, Peter Cole and Bob Braine, whom he depicts as a group in a painting, *Big Game*, where the chaps are caught in a pose around the fresh kill of the extinct giant sloth, the megatherium. This may be an in-joke – these artists are the last you would expect to be in at the kill – but it is a reminder of early natural historians, who were able to explore new habitats in the wake of an expanding empire which used the new territories as a playground as well as a laboratory.

Rockman is a tough ally to have on board as part of any inquiry into the future of the environment, because as well as being open-minded and curious, he is unsentimental and healthily perverse. He has made work to support the conservation campaign to stand against General Electric's pollution of the Hudson River in New York but he is also enthusiastically pro stem-cell research. 'It is tremendously frightening,' he says:

> but it is also one of the few hopes for conservation because it really does make the best use of available resources. All my scientist friends are mostly concerned about fresh water. Global temperature rise and lack of fresh water are serious issues, so everything else pales into comparison, including the cloning issues. Clones need water too, you know.[5]

His painting *The Farm* (2000), a public artwork commissioned by Creative Time, addressing the bioengineering of plant and animal life, brings out this ambivalence. Against a landscape of cultivated plant rows which recede into the distance, farm animals are shown at three stages of evolution: an originally skinny pair – a cow and a pig – have become plump and ripe for slaughter but their fate is to end up cuboid, so their engineered bodies may provide more and better food, as well as organs for transplant. A handsome cockerel transmogrifies into a creature bereft of inconvenient feathers and with triple wings, all ready to be bread-crumbed and deep-fried; giant tomatoes grow corners so they can fill up all the space in their basket. In the foreground a simple mouse becomes complex: an escapee from the notorious laboratory experiment, it has a human ear for who-knows-what super-mouse listening. But to the edge of the painting a rosette motif shows a prizewinning poodle, over-bred and clipped to the point of idiocy, as if to remind us that we've been modifying organisms for some time now, and for little purpose beyond misplaced vanity.

25. Alexis Rockman, *The Farm* (2000). Oil and acrylic on wood, 72 x 84 in. Courtesy the artist.

Rockman bring a whiff of Romanticism to science, presumably derived from his childhood pottering round museum displays with his mother at a comforting distance, but in his provocative self-parodying works he punctures this romance. New works for his residency at Camden Art Centre, London, shown in 2004, are set in the near future and examine human culture and its relationship to biotechnology as an everyday reality. Athletes equipped with super-charged hearts and wired up prosthetic hands play a mean game of basketball, the pet shop has on offer genetically engineered animals and birds to suit our aesthetic, lifestyle and social class preferences – a rabbit with reflexes sharp enough to play table tennis, a Rottweiler with prizewinning fangs and a pussy cat as furry and flat as a rug to curl up on.

Specimen Collections and Creations

The British painter Mark Fairnington creates reproductions of insects in supernatural dimensions – taxonomic specimens of species of *Membracidae*

26. Mark Fairnington, *Specimen (1)* (1999). Oil on canvas, 202 x 66 cm. Courtesy the artist and the Ruskin School of Drawing and Fine Art, Oxford.

(treehopper) and *Mantidae*[6] – and accurate to the finest detail. Unavoidably anthropomorphising them, we confront them poised between living and dead, their crackly limbs held up in astonishment, their crumpled wings shaken out or folded so as to allow the light to gleam on their coloured markings, their globulous eyes and unwittingly smiling mouths bidding us to admire them, striding giants in some huge carnivalesque procession. In reality, treehoppers are less than ten millimetres from head to tail and difficult to find, not just because they are so small but because they have evolved to blend in with their background. Fairnington's distortion of scale in depictions otherwise true to form reminds us how arrogantly we judge all other species by our own dimensions, forgetting the fact that insect species are much more numerous than any other group and are amongst the oldest creatures on earth.

Fairnington accompanied entomologist George McGavin from the Museum of Natural History in Oxford on a field trip to Belize's Chiquibul Forest, learning how he finds and collects individuals from new species, kills the catch with ethyl acetate and pins them fresh, to be taken back to his home laboratory for further study. Fairnington took many photographs of McGavin's

pinned specimens and back in London built up the paintings by conflating the photographic images, accommodating their differences – the subtle shifts of perspective, the magnification or the light reflection in each component – to merge the various parts into a coherent whole. He has described how the process of selecting and layering seems to bring him closer to the experience of evolution itself.[7] Evolution is 'non-teleological', directionless and responsive to circumstance and, rather than projecting on to his canvas a pre-conceived image of the whole, Fairnington works responsively, layering the piecemeal images until they evolve into a unique and extraordinary compilation.

The process of evolution through natural selection is continually astonishing. A genetic quirk, a chance mutation and then a group of chance mutations may bestow on an individual insect a physical feature which just happens to begin to resemble the bark, leaves or the thorns of the tree it uses as a habitat so that it is less detectable to predators. It will have procreated and passed on these new genes and, over generations, further mutations, tending towards increased invisibility or unintentional background mimicry, will have ensured the survival of the fittest.

Dick Vane-Wright, Keeper of Entomology at the Natural History Museum, London describes how the colour patterns on butterfly wings (at least 200,000 different patterns have been identified) are built up over evolutionary time in a process that brings to mind Fairnington's patient build-up of form, gradually applying layers of paint towards realising the astonishing whole. Nature builds up form through evolution, Vane-Wright explains:

> by the waxing and waning, shifting, fusion, re-alignment or outright loss, piece by piece, of basic 'pattern elements'. During individual development these act as controls that affect the colouration of whole groups, patches of zones on the wing scales, and together make up a set of building blocks from which almost all butterfly patterns seem to have derived...an array of thousands of flattened hairs, or 'scales', which coat the wings. The colour of each scale can be different, and the patterns are built up, like mosaics, or the pixelated images on a computer screen.

In this context, the work of the Portuguese artist Marta de Menezes is disturbing. In *Nature?*, she employs the laboratory technique of micro-cautery, in which a fine heated needle is used to damage specific regions of a

butterfly's wings at pupal stage in order to generate novel eyespot patterns or alter the patterns of colour patches. The process does not harm the creatures but, like the genetically modified creatures of Eduardo Kac and David Kremers described in Chapter 7, they emerge to spend their brief lives as artworks rather than accidents of natural evolution. Works like these, which involve the actual act of interfering with biological material, make us uneasy, raising fine ethical questions about the extent to which human interference with nature for its own sake – or as art – is benign or excessively arrogant.

Giles Revell imitates nature's patient layering techniques with high-resolution digital technology in order to create images of common garden insects, such as ladybirds or grasshoppers. Each image takes him about four months to complete, employing micro-engineering techniques on hundreds of electron-microscope images which he synthesises into single images, which are further highlighted, using customised software, to be finally ink-jetted into ultra-high-resolution prints. Like Fairnington's, Revell's works are of supernatural size – nine-foot-high, ultra-clear prints showing the insects' sculptural forms

27. Giles Revell, *Ladybird*. Courtesy the artist.

in luminous grey, both as familiar and as bizarre as nature can be, but while Fairnington's insects appear to be on the brink between death and resurrection, Revell's chilled specimens look very hard and dead, their curled-up symmetries a glory of form. The work of each artist depends on hard-headed intellectual information-gathering but each express a quiet delight in nature's strangeness and a fervent desire to contain and protect it through imitating it.

New forms of classification using DNA and systematics are taking over from traditional field taxonomy, though the work of taxonomists, more than at any other time, should play a vital role in the wider agenda for biodiversity. We need to keep readjusting the way we order the world because living forms ought always to be seen in terms of their habitat and their relationship with the wider environment, not simply as single items or isolated species. Artists such as the American Mark Dion and the Dutch artist, philosopher and poet herman de vries (he refuses to use capital letters) question the stock methods of naming and categorising objects in nature according to received hierarchies. In their work, they arrange specimens in conventional lines and grids but regroup their categories, inspired by intuition rather than rules – focusing on colour, or shape, texture, sound or smell, by cultural association or personal preference, in order to demonstrate that things as we find them in the world are always related to a number of contexts. Though it consciously follows in the long tradition of specimen illustration and collection and celebrates the unselfconscious loveliness of historical presentations, such work is essentially about survival, conservation and living culture in the context of a whole ecology, not isolated for museum obsession.

The Observer and the Observed

The photographic artist Susan Derges has always been interested in the idea of abnegating herself as an active agent, in order to allow the underlying structures and dynamics of natural systems – things as they are – to come to the surface.[8] She is particularly struck by a construct in theoretical physics, that of 'the observer and the observed', which derives from experiments at quantum level in which the observer influences the outcome of events through the very act of observation. How far can natural phenomena be observed in their self-contained state – as they really are? Derges was walking by the pond outside her Devon studio one bright spring morning when she noticed how shafts of sunlight penetrated the floating gel of frogspawn, projecting lacy patterns onto the pond floor to create a 'sun-print'. She scooped up some spawn and

took it back to her studio where she suspended it in a glass of water, passing light from an enlarger on to sensitive Cibachrome photographic paper which had been placed below the glass to create a photogram. She soon realised that the 'true' picture depended on the time exposures she chose to use. Darting tadpoles caught by a strobe light appeared in blurry motion but under slower exposures the tank looked empty. Should the artist record their position or momentum? Where and when do they exist 'in reality' without the interference of human observation?

Derges has produced a major series of works about her local river, the Taw, which flows from high ground in Dartmoor to the north Devon coast.[9] Though aware that she will never capture a whole fixed reality, especially in a dynamic system, her process still gestures towards self-abnegation and the results are breathtaking, as though nature has been caught unexpectedly as the river surges towards the sea through the seasons, never the same river twice but the sum of its infinitesimal parts and moments. She works at night, immersing photographic paper in a large aluminium slide, placing it just beneath the surface of the water. She then shines a micro-second of flashlight from above so the river itself acts as a photographic transparency, its eddies and vortices imprinted directly onto the paper. We therefore see the river's own view from below. The colour of each picture is influenced by whatever ambient light exists at the time, whether pitch black night, starlight or early dawn, and it ranges from sage grey to green to cyan, waterfalls veined violet or mottled green/beige, while on the seashore where the river eventually arrives, artificial street lighting rebounding from the cloud-layer above brings out synthetic magentas and turquoises.

The photographs are of human scale and dimension, the river ones tall and upright, the shorelines lying horizontal, and there is something about the flow-forms which resonates in the viewer's own consciousness. Derges and her viewers somehow become the river and we share the sensation of its forward trajectory from source to sea. Sluggish, fast, serene, dappled with greeny-grey feathery flow-patterns, or iced-up with cracks or pockmarks, reflecting moonlit branches or dragging weed, frogspawn or autumn leaves, finally onshore it comes into contact with the gritty resistance of sand and tide ripple and spreads out wide with mottled lacy fringes.

One can note the influence of Derges's stay in Japan in the 1980s and of Japanese artists such as Hokusai and Ando whose patient build-up of separate lines, curves and branches form whole patterns, conveying the

28. Susan Derges, *River Taw 1 April 1998 (Oak)* (1998). Cibachrome photogram, 531/2 x 24. Courtesy the artist.

sense of a deep rhythm pulsing through nature, where every element is seen inevitably to be part of a hidden totality, fractal perhaps or physicist David Bohm's implicate order, where human observation resonates as an integral part. Derges describes her work as:

> an inquiry into ways of representing nature and culture as a creative and dynamic process rather than as separate and predetermined existences unaffected by human consciousness. The vibration

of liquids, embryology, life cycles of frogs and bee colonies are metaphorically rich subjects that have enabled reflection upon the embodiment of form in external nature as well as the internal forms of thought and consciousness.[10]

Perhaps human thought processes form the same swirls and eddies as rivers and frogspawn. We have evolved from nature so it is no wonder that our engagement with it takes the form of that ceaseless Kantian interplay between outward form and inner constructions of it.

What Derges does with water, the American artist James Turrell does with light, allowing it, as far as possible, to be itself. 'The work is made of light. It's not about light or a record of it, but it is light,' he says, of all his works. 'Light is not so much something that reveals, as it is itself the revelation.'[11]

Turrell is known for his extraordinary gallery installations in which viewers enter dark spaces and accustom their eyes to illusions of solidity created entirely with coloured artificial light. Turrell studied perceptual psychology but this is not trickery because one senses that he is always in awe of nature's processes, allowing nature, as Derges does, to interact on its own terms with our perception of it, stimulating the viewer to wonder where objective reality ends and imagination begins. In other works, he creates openings in walls and ceilings that frame a portion of the sky, allowing the viewer to stare into its ever-changing patterns, and in doing so become drawn into a sensuous interaction with nature. Turrell's most ambitious work, begun in 1972, is still in progress. This is *Roden Crater*, a natural cinder volcano in the Painted Desert in northern Arizona which is being transformed into a large-scale artwork that uses the medium of light to become a huge naked-eye observatory, combining ancient astronomic principles with a contemporary understanding of perceptual psychology. The crater holds a series of viewing chambers and tunnels, mathematically oriented to capture the sky at all times and in all weathers and seasons, its sunrises and sunsets, moons and stars and its rare celestial events.

Turrell is now constructing a permanent light sculpture at Waterloo Bridge on the River Thames in London in sequences, which will occur from dusk to midnight, in which the façades of surrounding buildings will be gently washed in a slowly changing display of colour, highlighting the abstract shapes of the arches that span the length of the bridge and symbolically uniting north to south bank. Fundamental to Turrell's scheme is the need to consider the

effects of light pollution, so the display is not obtrusive but fits harmoniously into the ambient light, while delicately challenging the viewer's perceptions. This is natural art in the heart of an urban setting.

Nature and Culture: Art and Science Together

Irish artist Dorothy Cross places her work securely within a historical and cultural nexus drawing on nineteenth-century history but bringing it up to date with current research. Her subject is that most ambiguously lovely/ugly of creatures, the jellyfish, specifically the species common to Irish waters off the south coast island of Valentia. This location was chosen not just because Cross's brother, Dr Tom Cross, a marine biologist, is based at the National University of Ireland, Cork but, because she was intrigued by the life of an amateur naturalist, Maude Delap, who lived on the island between 1866 and 1953 and was the first person ever to breed jellyfish in captivity, keeping her bell jars in the kitchen of her priest father's house. Cross's work is narrative and focuses on three stories: the elusive Maude Delap; the German zoologist Ernst Haeckel, whose 'Villa Medusa' in Jena, Germany is covered with designs and patterns of jellyfish; and the father and son glass-makers Rudolf and Leopold Blashka, whose intricately constructed jellyfish are extraordinarily beautiful. The artist and her brother add an ongoing dimension to the story, undertaking scientific research into the creatures' habits and their place in the biodiversity of the ocean. Cross's art videos revel in the strangeness of these creatures, so ungainly out of water, so iridescent and graceful in it. The film plunges into blue waters accompanied by the soundtracks of voices distorted by underwater sound. Then there are investigations into the quaint history of Maude Delap and the ways in which jellyfish connect her to Haeckel, the astonishing Blashka works, and a more straightforward art/science documentary in which Cross accompanies her brother on scientific diving trips in the Atlantic and off the coast of Australia. It is not always easy to reconcile the various aspects of this work – the rich historical evidence, the sensuous quality of the images and the data collection and interpretation which preoccupy modern scientists. But the placing of art and science side by side enhances both perspectives, bringing together our capacity simultaneously to respond emotionally and rationalise objectively.

Swiss artist Cornelia Hesse-Honegger is much more direct and certainly more controversial. Her aquarelle paintings of jewel-like bugs and flies are exquisite, but a little scrutiny soon reveals the fact that the creatures have

features that are distorted or deformed; there are disturbing irregularities, bulges and tumours. These, she believes, are the consequence of increased radiation in the atmosphere. The bugs were collected in parts of Europe particularly affected by the fallout from the Chernobyl disaster in the former USSR and also from sites around nuclear power stations. Trained as a science illustrator, Hesse-Honegger knew enough to be able to form hypotheses about the apparently increasing prevalence of such adverse mutation. But the science community has become incensed by her claims, pointing out that both mutation and radiation are normal in nature and that no conclusions should be drawn without undertaking a proper controlled study. Hesse-Honegger does not believe this to be possible, even if the huge resources – let alone the political will – were available to undertake such a thorough investigation, because there is nowhere on earth unaffected by radiation after decades of atomic testing and of nuclear power generation. If as a scientist she is seen as sensationalist, however, as an artist she is taken seriously and the Swiss Federal Office of Culture has supported her exhibitions and international tours. Has their success as artworks resigned them to a secondary status? Confined to galleries they may appear to be less provocative but if politicians won't support science that is not obviously profitable, the debates must be held somewhere.

Australian artist Lynette Wallworth respectfully uses the images of professional science-imagers to make unique artworks which immerse the viewer in a moving experience of a nature that is beyond normal perception.[12] Her images are fragile and fleeting and we have to concentrate in order to capture them. In *Hold Vessel #1* (2001), viewers enter a dark corridor holding a delicate porcelain bowl where they try to catch light-infused moving images of nature projected from above – the luminescence of light-emitting stars; the fluorescence of microscopic underwater coral taken by a bio-Rad confocal laser-scanning microscope on the Great Barrier Reef, the bioluminescence of marine worms and sea-stars and time-lapse imagery of the sky's aurora phenomena. In *Hold Vessel #2*, the viewer looks down at the gallery floor into a dark well which reflects back images of the night sky or of the deep ocean. Here is an artist who pays tribute to the great skill of science imagers, bringing their work into the gallery and creating conditions for us to engage with it sensuously and intellectually. 'We scoop up the image,' Wallworth says, 'finding the place where it is most clear, most defined. The sensation is not about delivery, but catchment; an experience of extreme visual intimacy, the

bowls constantly overflowing and replenished.' The only scale of reference for these images of minute or vast natural phenomena is ourselves – what else? – and to cup our hands to hold a vessel of precious liquid is a very ancient gesture. We both give and receive and we seem to hold the fate of the fragile universe in the palms of our hands. This is something which artists and scientists can share.

29. Lynette Walworth, *Hold Vessel #2 (details)* (2001). Projections, digital imagery collection, Australian Centre for the Moving Image. Underwater stills © David Hannan. Courtesy the artist.

Chapter 9

Reconnections

A Muted Curiosity

Why Are Things Beautiful? I Don't Know
Nicholson Baker, *A Box of Matches* (2003)

Contemporary art seems to have come as far away as it can from sharing science's conventionally objective and therefore ultimately consoling vision of a nature governed by rules which underlie all things – its beauty. And, indeed, the science world itself is in turmoil as current research leaps ahead into controversial territory – genetic engineering, cloning, nanotechnology, nuclear energy, weapons of mass destruction, the potential to make radical alterations to human nature. But while there may exist in some of the world's laboratories glittering-eyed Dr Strangeloves, driven by an insane curiosity to pursue a line of enquiry regardless of its consequences, thankfully, responsible science is required to operate within very tight protocols. The high regard for the principle of peer review in evaluating the methodology and results of experiments in all areas of research generally ensures that everyone should play by the rules, even where fierce competitiveness prevails. And all but the most corrupt share the same desire to find some kind of truth about the structures, behaviours and contexts of the phenomena they study within their specialisms, even if they have to stay prepared for revolutionary changes of perspective. Anything does not 'go' and the hopefully impartial views of

other experts are critical. And the quest for knowledge, real knowledge, drives everyone before it.

The art world does not as a whole believe that real knowledge can be found, and it accommodates very many movements and styles and uniquely individual forms of expression and opinion. Some individual artists may be deeply 'spiritual' and subscribe to some kind of belief in a metaphysical wholeness. But, by and large, they question and doubt claims to an absolute truth and fixed taxonomies. Meaning depends on countless variables. However, the increasing predominance of science and technology in our daily lives is bound to provide a stimulus for new art and its pronouncements are already being embraced with interest, intelligent questioning and subjective reinterpretation. These are two quite different forms of knowledge, not reconcilable, but mutually curious to each other and as individuals we can accommodate both simultaneously. A better understanding of and respect for art as a reflection of what it feels like to live in the world should affect our reinterpretation of science. A knowledge of science, its rational discourse, metaphors, images, technologies and politics, can invigorate our reinterpretation of art.

In previous chapters, we have looked at the work of artists who deliberately address science but in this chapter I shall start by looking at the work of two contemporary artists who make work which conveys what it is like to live in a world bearing the legacy of science, industry and technology but without directly drawing on scientific methodology or imagery. Broadly speaking, they represent two major threads in contemporary art – the conceptual and the abstract. One, Richard Wentworth, addresses the world not through the straight broad highways of rational thought but in the messy byways and culs-de-sac of an industrialised world, wresting from things in themselves hints of an incoherent and tenuous human existence which is both poignant and funny. The other, Thérèse Oulton, presents a veiled vision of an underlying 'reality' which scientists may recognise, even though the work is rooted in human experience, as art always is. I shall go on to question how far science can actually be regarded as art, as some scientists claim, and end by acknowledging that seeing the world through different lenses may be essential to our future well-being.

Nicholson Baker's novels muse on arbitrary encounters with objects in the material world as if in search for some kind of distracted meaning in the minutiae of existence in the twenty-first century, a preoccupation of

countless contemporary artists. In *A Box of Matches*, the protagonist relishes his early mornings, feeling his way through the dark, going through the rituals of making coffee, lighting the fire and observing the thoughts that pass through his mind:

> At around four-thirty, sometimes later, the freight-train whistle goes off...I would like to visit the factory that makes train horns, and ask them how they are able to arrive at that chord of eternal mournfulness. Is it deliberately sad? Are the horns saying, Be careful, stay away from this train or it will run you over and then people will grieve, and their grief will be as the inconsolable wail of this horn through the night? The out-of-tuneness wail of the triad is part of its beauty.

Sitting in the dark by the kindling fire:

> I leaned forward just now so that I could turn to the right and take hold of the handle of my coffee mug, and I moved it around toward me in a wide slow curve, and the sight of this movement in the fiery dimness had a beauty to it. Why are things beautiful? I don't know.[1]

Beauty in contemporary art, as in literature, often derives from the incidental, the occasional and the marginal. Baker slows us down so insignificant things compel our attention. The artist Richard Wentworth presents the same wry compound of humour and melancholy. His sculptures position ordinary household objects together, suspended at angles where they hover on the brink of falling, as if they hover on the brink between meaning and pointlessness.[2] He is quick to spot the chance juxtapositions which occur when abandoned objects wash up on the street, arrangements which he reassembles for display, creating an uncertain significance out of insignificant things. Some of his stuff is found object, some designed to look un-designed. In one of his sculptures, a large tyre finds an equilibrium atop a steel ladder, next to a double sided ladder at the crux of which is stuck one of Wentworth's characteristic childlike, upside-down galvanised metal 'house' shapes (*When in Rome, 1989*). *eel* (1987) is a line of three shiny galvanised steel tubs connected by the sheet metal which shines on their surfaces like frozen metallic water, spilling over from one to the next.

30. Richard Wentworth, *eel* (1987). Galvanised steel, 35 x 245 x 100 cm. Courtesy the artist.

Wentworth's ongoing archive of photographs (over 20,000 so far), under the generic title *Making Do and Getting By*, contains snaps which hone in on the kind of detail our intelligence usually processes out – residual scraps of bizarre fussiness on the one hand, slapdash improvisation on the other.

'Like all photography they may not be truths,' Wentworth writes:

> but I tell the truth – they co-incide with me, they are strictly circumstantial and the only interference is my point-of-view (both kinds) which I try to keep matter-of-fact...What we experience in cities are, literally and metaphorically, overheard conversations and the best of my work are *images* which stand for our unavoidable voyeuristic/gazing condition.[3]

One imagines an archaeologist in the far future encountering Wentworth's works and attempting to discover some hint of their provenance. But, like life itself, Wentworth's art doesn't possess rational meaning, it is arbitrary, left-over stuff. His photographs capture plastic cups stuffed between the railings of a fence, or poked through a hole in brickwork, or they have accumulated to form an impromptu collection behind a drainpipe. An electric bell is stifled by a half unwrapped chocolate bar stuffed under its clapper; someone has placed a child's hat on top of a concrete bollard where it can be seen and hopefully found, though its tattered condition may suggest otherwise and the child will probably never return; a single lost glove points to heaven from a railing spear. The linguist Laura Wright has remarked that Wentworth's photographs of incidental street life are the visual equivalent of the many expressions of meaning possible in the interjection 'oh'. This is a direct antithesis to the main clauses and cascade of subordinate clauses that make up the grammar and syntax of scientific and rational thinking but ought to be regarded as quite as significant as an observation on the physical world.

Such mild delight in detritus is in direct contradiction to the ever more sophisticated, clean and perfect images of the world we have at our disposal

31. Richard Wentworth, *Caledonian Road, London* (2002). Courtesy the artist.

as a result of the widespread application of digital technologies that now seem essential to all human production, in art and, of course, in science, images which seem to present an ideal rather than a messy reality. In their own work, scientists are looking for models of nature which, though they may encapsulate dense information, will ultimately offer the 'universality, simplicity, inevitability and elemental power' that Graham Farmelo attributes to the most elegant of mathematical equations or formulae. Artists don't aim for a reductive simplicity (thought some might occasionally) but they, too, have an encompassing sense of what Coleridge called 'cohaerence' – the 'clinging together' of all the elements in a work to make some kind of whole which is psychically satisfying. This is not to suggest that there is an ultimate fixed reality to be found but the artist's personal vision will re-inform and reinvent a view of it, sometimes honing in on things that are apparently redundant and inconsequential and paradoxically presenting us with a coherent reflection of a corner of reality that we perhaps should not overlook.

A Cacophonous Meeting Ground of the Invisibles

Thérèse Oulton creates paintings which present scraps of incidental abstract forms and shapes but there is a suggestion in her paintings of an underlying vision of something underneath the surface partially glimpsed. Her structures and forms draw – but only half-consciously – on the iconographies which emanate from current scientific theories related to the development of forms and processes in nature. Her earlier work has been described as 'cellular', 'molecular' or 'genetic', and draws on the idea of the cell's capacity to self-replicate, forming dense honeycomb-like structures. But such images are conceived not as any kind of faithful reproduction of reality but more as a glimpse of a human intuition at work, uniquely and subjectively presenting a surface view that is partial, under-layered and semi-translucent, revealing 'outside' and 'inside' simultaneously, inventing as much as it reproduces.[4] The fractal theorist Benoit Mandelbrot has analysed one of her paintings and found in it a fractal quality, 'each part containing a great deal of the message of the structure that the whole painting contains',[5] but this is not to say that Oulton has deliberately made her pictures recursive or set out to make each part a microcosm of the whole. What it does reflect is that she may well be particularly in tune to this contemporary insight into the structure of the material universe, just as in the distant past an artist would have made work in which can be found references to the four elements of ancient cosmologies.

32. Thérèse Oulton,
Shades (111) (2001).
Oil on canvas, 75 x
46 in/193 x 117 cm.
Courtesy the artist and
Marlborough Fine Art.

In her most recent work, Oulton uses as a starting point the iterative nature not of fractals from the world of science, but of negative photographic strips from the world of art, which provide a series of frames in which the partially scratched out coloured surfaces look identical, but which, like the frames in a film, alter subtly as they move past a light source. The works reflect the fleeting impermanence of things:

> a serial image, between stillness and motion...My real is an
> inbetweenedness, a cacophonous meeting ground of the invisibles,
> the thoughts, associations, pasts and futures with the physical
> presentness of the surface.

Her contact with reality centres on lived human experience; the 'now' is a disjunction between partial memories and uncertain desires, the unresolved

and un-resolvable nature of existence, moments which we try to capture on film, but her vision also resonates with current scientific views on the flow and patterns in dynamic systems over time in the wider universe. Looking at her abstract images, analogies can be made with human artefacts – scattered shards of porcelain, damaged palimpsests, over-exposed film – but also with organic forms in nature. Dry leaves are caught mid-drift between poise and float against fine fragments of cloud, sand under shallow water, or shadow on snow. The provisional, unstable and disintegrating is seen both as dispassionately inevitable in nature and passionately regrettable in human life. 'If I do have a sense of the real,' she says, 'it's in the mutability of experience and that with all its incumbent melancholy.'

Like the Gnostic mystics who sought the truth in darkness, she sees light as an obliterating, obscuring force: 'It reveals itself at the expense of obscuring something else,' she says. Anything represented 'is only recorded in patches of light and dark. It's no longer there. And it could (either or both) be darkness obliterating form or the dematerialising power of light.' This sounds rather like an intuitive grasp of the nature of dark matter which invisibly makes up at least nine tenths of the universe and which provides such mystery for modern cosmologists. Oulton's work is rooted in the fleeting nature of human experience but it is also acutely sensitive, almost prophetically so, to current theories related to the hidden dynamics of the universe, alive to the ceaseless energy of the natural world but never far from pensiveness.

Science – The New Art?

Some scientists claim that the images produced by the new scanning technologies possess a beauty that is sufficient unto itself, a new form of abstract art. They point to the creeping crescendos and diminuendos of colour in on-screen emergent systems, to the swirl and coil of fractal patterns, to the spiky lucent cells, captured by electron microscope, where the illusion of three-dimensionality is so convincing they appear about to crab-walk out of the frame, their several parts flagellating. But as unmediated science realism, this is abstract expressionism minus both the expressionism and the abstract, because not intentionally art, their function is the unambiguous communication of specific information – encoded messages for a specialist cognoscenti to translate. Intellectually, we can be extremely impressed by images which give us a greater understanding of a natural world we were never equipped to see. But although 'aesthetic' judgement may go into

the selection and creation of such technological enquiry, it is painstakingly *un*invested with subjective emotion and if it gives a frisson of visual pleasure then it is probably no more than the brain's reward system going into overdrive as Ramachandran's peak-shift effect comes into play. When we are informed as to what these weird objects actually are, they may be more likely to evoke in us a shudder of repulsion, an experience of a Burkean sublime, where our wonder is tinged with a sense of fear and a foreboding, a squeamishness at the sight of normally hidden cellular or molecular processes which connect us to fears about our own mortality, contemporary *memento mori* in other words. This might not be quite what beauty-affirming scientists mean.

Can science images be art? Some scientists claim they can but there are surely radical differences. Artist Catherine Yass has been working side by side with Dr William James at the William Dunn School of Pathology in Oxford, to see if there are any parallels in their respective image-making.[6] James is working on a process which involves ways of discovering nucleic acid shapes that complement the form of pathogens. Once 'discovered' they are illustrated in the form of digital pictures, artificially coloured in order to reveal how the shapes interact. Yass's photographs present her own distinctive view of the world. Characteristically, she photographs scenes from a work-space – corridors, uninhabited work-rooms, an arrangement of technical objects – which are then charged with eerily vivid blues, greens or purples, an effect she obtains from overlaying a positive that has been processed as a negative. James is seeking a method of refining his coding techniques in order more precisely to interpret his observations about a molecular process: Yass is trying to draw a lusciousness not obviously inherent to the forms to produce quasi-abstract compositions which are an end unto themselves. Her images may present a mildly ironical view of the unreal world of the laboratory, devoid of humans but filled with stuff which resonates with its own arcane purpose. They can also look like alien forests or futuristic office-blocks, or be enjoyed simply as form and colour. The viewer will play a part in a ceaseless revision of meaning. But this kind of analogising is illegitimate in science, which is trying to find the single most accurate representation. The partnership may help James become more sensitive to the boundaries between aesthetic preference and logical scrutiny, and offer Yass an opportunity to observe the scientist's rigour in making and measuring fine distinctions in connection-making, but their goals are different and his images will be distinctively science, while hers will be art. As with all pure science imagery, James strives to negate human

agency from the intervention, so he can find objective meaning in it. Yass, meanwhile, brings a trained aesthetic sense to rearrange, distort and fine-tune, in order to create artworks which will convey to her viewers a unique take on the world, which they are at liberty to reinterpret.

The doyenne of scientific imaging, the American science photographer Felice Frankel, is resolutely a research scientist, based at the Massachusetts Institute of Technology. She uses the term 'envisioning' to describe the way in which she photographs scientific images, often at microscopic scales, in order to meet the potentially conflicting demands of remaining true to the integrity of the science yet making her work accessible to the public. Her book *Envisioning Science*, which is principally a guidebook for scientists, contains much technical advice about the best way of presenting images, with recommendations about equipment, sample preparation, background setting, composition, lighting conditions, camera angles and exposures, all to make scientific images more 'interesting'. Like all good artists, she recognises the primacy of 'creating order' and her text demonstrates how well she understands the principles of human perception in decoding and interpreting two-dimensional images, reading clues to determine scale, perspective and shadow. Indeed, the precision that goes into her process begs the viewer to question how far such manipulation enhances or detracts from what is intended to be a depiction of reality. It is peculiar to observe a scientist declaring that 'a good sense of composition is innate' and 'the "best" exposure depends on your taste' and her glossily gorgeous work has been much acclaimed as art in its own right, by the science community particularly. Stereomicroscope pictures of flowery yeast colonies look as living as they evidently were when she photographed them, pale fluffy powder puffs with dark wriggling centres pulsing out soft fringes against the light; there are vivid compound microscope images of feathery mouse embryo lungs, a tiny riot of herringbone intricacy when gold warps, and many more. They are undoubtedly attractive and Frankel is a mistress of her craft, but I would suggest that to the layperson they would be no more distinguished than many such impressive images produced by the best art photographers, artists and magazine illustrators, if one did not know what they represented. Viewed with this knowledge, however, the works become awesome and are original because of the way she presents extraordinary subject matter by bringing together a scientific detachment with an aesthetic which may unwittingly be part of the current visual zeitgeist, to which she

adds her particular flair. This may be something which only time will tell but rather as we treasure the drawings in Robert Hooke's 1662 *Micrographia* and Ernst Haeckel's *Art Forms in Nature* (1899–1904), I suspect in the future we shall be treasuring Felice Frankel images of hitherto unknown aspects of nature for their pioneering skill and their unique vision.[7] But she refuses to talk about aesthetics, 'They might appear as personal interpretations but they are not,' she declares. She does not pretend that questions of taste and personal judgement don't sometimes come into consideration, just as she offers tips to surprise the complacent witness into looking more closely, by manipulating lighting, colour and scale, but her whole aim is to direct the attention to the image's principal purpose – an illustration of an evidenced piece of research.

Scientific imaging technology is currently extremely expensive and few artists have the opportunity to play with it for its own sake. It is possible, however, that over the coming years they will be able to bring a flagrant aestheticism to the medium. As we have seen, Giles Revell makes cold, bold pictures from his electron microscopic images of bugs; Rob Kesseler, with shockingly up-to-date gentility, prints outsized electron microscopic pollen grains onto ceramic dinner-services. While these still carry scientific association and, by implication, a kind of authority, when such images are contextualised as art, whole new ways of reflecting on the experience of being human and living in the world will become available.

The work of artists Bruce Gilchrist and Jo Joelson focuses on an experience of nature which is both scientific and subjective. The artists have become interested in the ways in which we encounter nature phenomenologically and sometimes work in the field with scientists, setting up equipment to measure human physiological experience alongside hard science meteorological investigations. In August 2001, they travelled to remote North East Greenland during the transition from twenty-four-hour daylight to the twilight onset of winter darkness. Using an instrument called a spectroradiometer, they measured the patterns of twenty-four-hour daylight at six-hourly intervals. At the same time, bio-monitoring equipment (ESR) was used to measure the physiological effects of their own bodies' daily responses to the changing light. Back in Britain, the data was used to control an artificial daylight installation in a work called *Polaria*,[8] where viewers were able to interact with the spectral patterns of Arctic light. Participants were given a white jacket and overshoes and sat in a room on a specially designed chair, which had conductive

33. Bruce Gilchrist and Jo Joelson, *Polaria* (2001). Photograph by
Bruce Gilchrist and Jo Joelson. Courtesy the artists.

bronze plates in the armrests sensitive to the skin's response, allowing their
physiological feedback to trigger one of twenty-four artificial daylight states.
White light altered subtly from blue to green or to warm yellow. Interacting
with the environment so intuitively, so physically, the viewer could tune in to
ancient responses to changes in the earth's ambient light. There is something
deeply moving about such an encounter with nature, even if it is at second
remove. Digital technology is transforming art as it is science but to be other
than alien, the artist has to find a connection with the viewers' felt physical
and temporal experience.

Light pollution sends the busy glow of civilisation into all but the most

remote parts of Britain but if we get far enough away, or are lucky enough to go further, to Africa or Australia, for example, where the skies are pitch black bowls studded with diamonds, we are able to recall a collective past as if it were part of our personal childhoods, when the moon and stars were magical and strange. Simple 'astronomy' – 'star-naming or ordering' – has become astrophysics, a stupefying science. The Latvian artist Vija Celmins uses soft pencil to compress the night sky into millions of dots, industriously filtering nature's proliferation through the human mind to create pictures that amaze with quantity, detail and precision. We marvel at the artist's obsessive achievement. David Malin's photographs of the universe began at several removes, as dispassionate scientific images, but they have since become art.[9] British-born Malin started his professional life in chemistry where he acquired an expertise in image-making, using optical and electron microscopes and X-ray diffraction techniques to explore the minuscule. When he moved to Australia, however, he was able to pursue his self-taught interest in astronomy professionally and became a Photographic Scientist at the Anglo-Australian Observatory. Here he developed unique new ways of making colour photographs of the most massive and distant objects in the known universe and even beyond it. His hyper-sensitising processes enabled him to discover some of the faintest objects ever detected by a ground-based telescope, the result of a photographic process which came to be called 'Malinisation'.

Like Felice Frankel, here is an image-maker who is a master craftsman at manipulating his media and his works are as likely to be found in art galleries as at science exhibitions. He creates coloured images of stars and galaxies by synthesising black and white and three-colour plates and filters, taken from repeated exposures recorded over different periods of time, to create a single clear picture – but one that is so much more than scientific data. Clouds of light tower like giant waves, galaxies whirl, the colours suggest intense heat in a sky of black ice, millions of stars shine, some spinning into the foreground, others faintly distant as single entities or as specks in dense storm-clouds of the finest most luminescent dust:

> Light seeking light doth light of light beguile;
> So, ere you find where light in darkness lies,
> Your light grows dark by losing of your eyes.[10]

Malin's cosmology does not really exist. No one can see the skies like this

unaided and while new digital techniques can create such images, I would suggest that Malin's is the ultimate achievement in playing off the reality out there against a human selection and reconstruction of a part of it. His images are forged from dispassionate scientific knowledge combined with astonishing technological virtuosity but are translated into a product that moves and stimulates the imagination like art. These scientific images do not alienate because we can relate to them in human terms and place ourselves in the wider picture. Looking up at the heavens in wonder is a very primitive experience and though these new images of our universe may render us infinitesimally ephemeral, paradoxically we also feel physically and tangibly present. For a moment we are simultaneously in the here and now and part of the wider reaches of space and time.

34. David Malin, *The Horsehead Nebula*. Courtesy David Malin.

Contemporary science provides astounding new views of phenomena and therefore new philosophical insights on experience. But our capacity to manipulate nature as never before could take us to the edge of terror as

well as beauty. The potential for new catastrophes lurk – global warming, biological and chemical warfare, casual nuclear attack or accident, virulent pandemics, genetic mutation gone wrong. A super-collider experiment may generate a phase transition that could collapse the whole universe into a vacuum. 'A superintelligent machine might be the last invention that humans need ever make,' says the Astronomer Royal, Martin Rees.[11] Even without such disasters, it is hard to envisage what we will become if, as both neuroscientist Susan Greenfield and artist Stelarc from their different perspectives predict, our individuality is tampered with electronically, or through genetic engineering; or as science writer Brian Appleyard and economist Francis Fukuyama point out, when the rich will be able to engineer their well-being to the increasing detriment of the poor, as in a silicon version of an old H. G. Wells story.

Perhaps partly motivated by such futuristic gloom but also, I think, because they cannot resist the idea of sweeping together into one wholesome theory both physical and metaphysical enquiry, many popular science books end with a Final Chapter in which their authors, having engagingly addressed the material world, express a heartfelt desire for what the biologist Edward O. Wilson calls 'Consilience', or 'The Unity of Knowledge'. This was a consummation also devoutly to be wished by the biologist, the late Stephen Jay Gould, who hoped to 'mend and mind the misconceived gap between science and the humanities'. Moreover, as we have seen, Richard Dawkins has appropriated memetics as a cultural counterpart to genetic theory, and a number of evolutionary psychologists believe they can explain art simply in terms of its adaptational purpose or as a universal response to symmetry and asymmetry in nature, outside any cultural context.[12] Well-meaning though such intentions are, however, they seem to overlook the fact that very many different groups of people in the world also seek a Unity of Knowledge and a mending of misconceived gaps, but on their own terms, through different religious beliefs, spiritual, fundamentalist or otherwise, or through varieties of totalitarian rule, or, paradoxically, through visions of anarchy and disorder.

A quest for unified knowledge can sound dangerous, even megalomaniacal, no matter how rational and sincere its motives. And it is hard to see the majority of people in the arts and humanities subscribing en masse to any agreed world-view, or any consensus for evermore as to what makes art work for everyone at all times, let alone on how we should live. The history of humankind is a history of mistrust. And contemporary art and the discourses that surround it are made in an always questioning spirit, refusing to come to

terms. The shifting grounds of the novel, the provisional scenarios of movies, the restless reinterpretations of contemporary existence in art, the plural casuistic analyses which make up critical theory, all demonstrate a reluctance to define and agree on big impossible terms such as Meaning, Knowledge, Reality and Truth. Consequently, when scientists attempt, with the best will in the world, to undertake the task of reconciling science and religion, or rational and postmodernist discourse, or scientific knowledge and artistic invention, they fail to convince and often end up by dismissing their opponents' beliefs altogether, explaining them 'scientifically' but not engaging with them on their own terms, regarding their arguments as not 'real' but ultimately irrational and unscholarly. And *that's the point*, one wants to say. Sometimes there is no meeting place. We beg to differ. Indeed, I would argue that it is *biologically* healthy to live in two cultures. We need always to take note of the constructs and thought experiments of our times and keep testing them out, ceaselessly reconfiguring models, images, hypotheses, myths, stories and even jokes. For if we're not prepared always to wonder what it's like to see things from an entirely different point of view, to imagine impossible scenarios and adapt to unknown circumstances, it may spell the end of the human race. It is good to see the world from the point of view of many 'others'. The arts and humanities constituencies can certainly see the benefit in sometimes pursuing a quest for rigorous objectivity, taking all variables and risks into account, as in the best scientific enquiry, and they welcome new philosophical insights, new technologies and new ethical questions. By the same token, scientists can respect difference, personal opinion, the idea that there may be multiple interpretations and that a uniquely individual sensuous description or a flagrant invention may be as true a version of reality as a peer-reviewed set of averages. Indeed, pioneering scientists have always challenged the status quo, operating through guesswork and intuition sometimes more than through deductive logic. But both are valid, neither is exclusive. Stay alert, stay contrary. And think of evolution which has advanced at random and without any vision or goal.

Take the study of consciousness, for example. There can be no exclusive or privileged explanation for what goes on in our brains. We interpret the world with acquired top-down preconceptions and good art startles us into looking again afresh, often relishing in ambiguity. So, too, does good science.

Here is the neuroscientist Susan Greenfield:

I suggest that there is no magic ingredient in the brain that mediates consciousness. A critical factor could be the number of neurons that are corralled at any one time and it is the extent of these assemblies that will determine consciousness. The most valuable approach would lie in brain imaging in conscious volunteer subjects as they were undergoing different tests that one could predict would modify their neuronal assemblies in certain ways. But at the moment the time and space resolution, although awesome in what has been developed over the past ten years, is still not sufficient. At the moment, only voltage-sensitive dyes showing up areas of activity in response to an epicentre can be used – and then only in experimental animals. By virtue of the fine temporal resolution available from their use, such studies show, for example, that a second assembly will not form because the first is acting as a rival. That is the kind of precision, the sort of timing we are going to need to characterize how neuronal assemblies relate to consciousness.[13]

And here is Iris Murdoch in her first novel, *Under the Net*, published in 1954. At the end of the book, the picaresque hero, Jake Donaghue, is travelling down Oxford Street on a bus, accompanied by Mister Mars, the ageing film-star dog he's acquired, and thinking wistfully about the girl he's loved and lost.

As I looked down now on the crowds in Oxford Street and stroked Mars's head I felt neither happy nor sad, only rather unreal, like a man shut in a glass. Events stream past us like these crowds and the face of each is seen only for a minute. What is urgent is not urgent for ever but only ephemerally. All work and all love, the search for wealth and fame, the search for truth, like itself, are made up of moments which pass and become nothing. Yet through this shaft of nothings we drive onward with that miraculous vitality that creates our precarious habitations in the past and the future. So we live; a spirit that broods and hovers over the continual death of time, the lost meaning, the unrecaptured moment, the unremembered face, until the final chop that ends all our moments and plunges that spirit back into the void from whence it came.[14]

Greenfield's field of enquiry is fascinating in its attempt to understand how the brain resolves perceptual and cognitive ambiguities to arrive at a state of consciousness. Perhaps in future she and her fellows will understand the process enough to recognise that in fact it never quite does. Murdoch, like all artists, acknowledges the transient nature of experience. Both science and art hint at truths we almost recognise, both are life-affirming, neither is forever *right*. As an individual, I don't have a problem with accommodating both forms of knowledge. Indeed, I enjoy considering them side by side and I am only amused when I hear artists complain that scientists are too reductive or when scientists express exasperation about the intangible nature of art. I propose that each attempts to learn more in order to keep an open and curious mind and to enjoy that ceaseless Kantian interplay between intuitive imagination and conceptual understanding that keeps us alert in the world.

Notes

1. Edwin Morgan, *Pleasures of a Technological University*. Reproduced with the permission of Carcanet Press Ltd.

Introduction: Ambiguities and Singularities

1. David Lodge, *Consciousness and the Novel* (London: Secker and Warburg, 2002), 87.
2. Roland Barthes, *S/Z*, trans. Richard Miller, 1970 (London: Jonathan Cape, 1975), 5–6.
3. See Alan D. Sokal and Jean Bricmont, *Intellectual Impostures* (London: Profile Books, 1998).
4. Marcus du Sautoy, *The Music of the Primes* (London and New York: Fourth Estate, 2003).
5. Thomas Kuhn, *The Structure of Scientific Revolutions* (2nd edn., Chicago: University of Chicago Press, 1970).
6. Paul Feyerabend, *Against Method* (London: New Left Books, 1975), 295–6.

Chapter 1: Everything Is Connected in Life

1. Keats, *Lamia* (1820), quoted in Richard Dawkins, *Unweaving the Rainbow* (London: Allen Lane, 1998), 39.
2. Marcus du Sautoy, from *Science, Not Art: Ten Scientists' Diaries* (London: Calouste Gulbenkian Foundation, 2003).
3. Graham Farmelo (ed.), *It Must Be Beautiful: An Anthology of the Great Equations of Modern Science* (London: Granta Books, 2002).
4. Levinas, from the essay 'Reality and Its Shadow', 1948.
5. The school of logical positivism which originated with the Vienna Circle in the 1920s still influences science with its belief that there is one kind of knowledge, scientific knowledge, verifiable through experience.
6. See Tom Sorell, *Scientism: Philosophy and the Infatuation with Science* (London: Routledge, 1994).
7. Wendy Steiner, *The Trouble with Beauty* (London: Heinemann, 2001).

8. Pythagoras (c.580–c.500 BC). Richard Mankiewicz, *The Story of Mathematics* (London: Cassell and Co, 2000), 24.

9. Heraclitus (c.540–480 BC), Anaxagoras (500–428 BC), Democritus (460–370 BC).

10. The neuroscientist Semir Zeki turns to the Platonic Ideal as a model for the way in which the brain searches for constancies within its stored memory in order to categorise a particularity into a general scheme. In mathematical set theory the position on the independent existence of abstract objects is called *Platonism*.

11. Richard Mankiewicz, *The Story of Mathematics*, 30, which informs the mathematical explanations in this chapter. Euclid (c.300 BC).

12. Spinoza, *Ethics* (1677).

13. Sir Isaac Newton (1642–1727), in Book III of his *Philosophiae naturalis principia mathematica*, usually referred to as the *Principia*. Francis Bacon (1561–1626) is credited with being the first empiricist and philosopher of science.

14. David Hume (1711–1776), 'Of the Standard of Taste' (1757), *Essays, Moral, Political, and Literary*, eds. T. H. Green and T. H. Grose (1875).

15. See A. N. Wilson's book, *God's Funeral* (London: John Murray, 1999).

16. Ernst Haeckel, *Art Forms in Nature* (Leipzig: Verlag des Bibliographischen Instituts, 1899–1904).

17. In 1915, Einstein's General Theory demonstrated that gravitation and acceleration are equivalent, which led to the conclusion that space itself is curved.

18. The speed of light does not appear to travel any faster, even if an observer is moving rapidly towards it.

19. Einstein to Eduard Büsching, 25 October 1929, quoted in Max Jammer, *Einstein and Religion: Physics and Theology* (Princeton: Princeton University Press, 1999).

20. Michael Frayn, *Copenhagen* (London: Methuen Drama, 1998), 73.

21. Mark Dion's work *The Thames Dig* (1999) is at Tate Modern. See Alex Coles (ed.), *Mark Dion: Archaeology* (London: Black Dog Publishing, 1999). Further information provided by artist Robert Williams, who worked with Dion.

22. The modern view of atomic structures and chemical elements is based on quantum theory and quantum computers are being developed.

23. See note 2.

24. Explained by Janna Levin in *How the Universe Got its Spots* (London: Weidenfeld and Nicolson, 2002), 190.

25. Tom Stoppard, *Arcadia* (London: Faber and Faber, 1993), 63. A number of Stoppard's plays, like Michael Frayn's *Copenhagen* above, wittily address contemporary scientific paradigms and also use them metaphorically to inform their plays' subtext, structure and language.

26. Richard Mankiewicz, *The Story of Mathematics*. The second law of thermodynamics states that heat does not flow from a colder body to a hotter one; the entropy of a system can only increase or remain the same.

27. Explained in Stephen Wolfram's book *A New Kind of Science* (2002).

28. According, controversially, to the physicist Joao Magueijo in his book *Faster than the Speed of Light: The Story of a Scientific Speculation* (London: Heinemann, 2003).

29. William Blake, opening lines of 'The Auguries of Innocence', *c.*1803.

Chapter 2: Disconnections and Asymmetries

1. E. H. Gombrich, *Art and Illusion: A Study in the Psychology of Pictorial Representation* (6th edn., London, Phaidon Press, 2002), 134.

2. Ian Jenkins, 'Ideas of Antiquity: Classical and Other Ancient Civilizations in the Age of Enlightenment', in Kim Sloan with Andrew Burnett (eds.), *Enlightenment: Discovering the World in the Eighteenth Century* (London: British Museum Press, 2003).

3. Edmund Burke, *A Philosophical Enquiry into the Origin of our Ideas of the Sublime and Beautiful* (1757), ed. James T. Boulton (London: Routledge and Kegan Paul, 1958).

4. Immanuel Kant, *Critique of Judgement* (1790).

5. John Ruskin, *Modern Painters*, II, Part iii, Section 1, Chapter 3, paragraph 16.

6. Raymond Williams, *Culture and Society 1780-1950* (1958; Harmondsworth, Middlesex: Penguin, 1961), 145-6.

7. Kandinsky's note to his 1911 translation into Russian of Schoenberg's 'On Parallel Octaves and Fifths' in the exhibition catalogue *Salon 2*, reprinted in Kandinsky, *Complete Writings on Art*, ed. Kenneth C. Lindsay and Peter Vergo (Boston: GK Hall and Co, 1982), quoted in Lynn Gamwell (see note 8).

8. Lynn Gamwell, *Exploring the Invisible: Art, Science and the Spiritual* (Princeton: Princeton University Press, 2002), 265.

9. Robert Hughes, *The Shock of the New: Art and the Century of Change* (rev. edn., London: Thames and Hudson, 1996), 318-23.

10. Ibid. 409-10.

11. Samuel Beckett, *Waiting for Godot* (1955), Act 1. I have invented the artworks mentioned.

12. Gamwell, *Exploring the Invisible*, 282.

13. Ibid. 295. Gamwell is referring to the Frankfurt School and Theodor Adorno.

14. Line in W. H. Auden's poem, 'September 1939'. There was a revived interest in the poem's doom-laden sentiments after the twin towers disaster in New York on 11 September 2001.

Chapter 3: From the Future to the Past

1. Michael Donaghy, 'Touch' (1988), from *Dances Learned Last Night* (London: Macmillan, 1988). Reproduced with permission from the author and publishers.

2. Steven Mithen, *The Prehistory of the Mind: A Search for the Origins of Art, Religion and Science* (London: Thames and Hudson, 1996).

3. Ibid.

4. Ibid. 184.

5. Ibid. 181.

6. Pascal Boyer, *The Naturalness of Religious Ideas: A Cognitive Theory of Religion* (Berkeley: University of California Press, 1994).

7. See Jared Diamond, *Guns Germs and Steel* (London: Vintage, 1998).

8. Martin Kemp's insights into 'structural intuition' will be further discussed in Chapter 7.

9. William Shakespeare, *Hamlet* (1601), Act 3, scene 1.

10. The title of Damien Hirst's well-known 1991 artwork of a vivid-looking but very dead tiger-shark in a tank of formaldehyde.

Chapter 4: New Mythologies

1. Richard Dawkins, *The Blind Watchmaker* (London: Longman, 1986).

2. See also Susan Blackmore, *The Meme Machine* (Oxford: Oxford University Press, 1999).

3. Daniel Dennett, *Darwin's Dangerous Idea* (London: Penguin Books, 1995), 342.

4. Roland Barthes, 'The Death of the Author', from *Image, Music, Text*, trans. Stephen Heath (London: Fontana, 1977).

5. Mary Midgley, 'Memes and Other Unusual Life-Forms', in *Science and Poetry* (New York: Routledge, 2001).

6. Roger Scruton, review of David Hurst's book *On Westernism: An Ideology's Bid for World Dominion*, in *Times Literary Supplement*, 23 January 2004, 8.

7. Richard Dawkins, *The Selfish Gene* (Oxford, Oxford University Press, 1976), 214.

8. Charles Darwin, *The Expression of the Emotions in Man and Animals* (1872; 3rd edn. reprint, London: HarperCollins,1998).

9. William Shakespeare, *The Merchant of Venice* (1596–1598), Act 3, scene 1.

10. Donald Brown, *Human Universals* (1991), quoted in Steven Pinker, *The Blank Slate* (London: Allen Lane, 2002).

11. J. Tooby and L. Cosmides, 'The Psychological Foundations of Culture', in J. H. Barkow, L. Cosmides and J. Tooby (eds.), *The Adapted Mind* (New York: Oxford University Press, 1992), 113.

12. See the provocative series of books under the imprimatur *Darwinism Today*, edited by Helena Cronin and Oliver Curry (LSE Books).

13. See Kevin N. Laland and Gillian R. Brown, *Sense and Nonsense: Evolutionary Perspectives on Human Behaviour* (Oxford: Oxford University Press, 2002), a book which usefully informs some of this chapter.

14. Franz de Waal, *Chimpanzee Politics: Power and Sex among Apes* (London: Jonathan Cape, 1982), quoted in Steven Mithen, *The Prehistory of Mind* (London: Thames and Hudson, 1996).

15. Steven Pinker, *The Blank Slate: The Modern Denial of Human Nature* (London: Allen Lane, 2002).

16. Matthew Arnold, *Culture and Anarchy* (1869), Chapter 1.

17. According to the linguist Laura Wright (in correspondence with the author).
18. Malcolm Ross, 'Knowing Face to Face: Towards Mature Aesthetic Encountering', in Malcolm Ross (ed.), *The Development of Aesthetic Experience* (Curriculum Issues in Arts Education, 3, Oxford: Pergamon Press, 1982), 81.
19. Iris Murdoch, *The Sovereignty of Good* (London: Routledge, 1970).
20. See Hilary and Steven Rose (eds.), *Alas, Poor Darwin! Arguments against Evolutionary Psychology* (New York: Harmony Books, 2000).
21. Steven Pinker, *The Language Instinct* (New York: HarperCollins, 1994).

Chapter 5: Universal Studios

1. Peter Atkins, from 'Sweet Scent of a Symmetrical Man', a review of I. Hargittai and T. C. Laurent, *Symmetry 2000*, in *The Times Higher*, 2 August 2002.
2. J. A. Goguen (ed.), *Journal of Consciousness Studies* (Thorverton, Essex: Imprint Academic); Roger F. Malina (executive ed.), *Leonardo: Journal of the International Society for the Arts, Sciences and Technology* (San Francisco: MIT Press Journals).
3. 'Occam's Razor' derives from the fourteenth-century theologian and philosopher William of Ockham (or Occam), whose form of nominalist philosophy saw things as provable only by experience or by – un-provable – scriptural authority.
4. Steven Pinker, *How the Mind Works* (London: Allen Lane/Penguin, 1997), 524.
5. V. S. Ramachandran and William Hirstein, 'The Science of Art: A Neurological Theory of Aesthetic Experience', in *Journal of Consciousness Studies: Art and the Brain*, vol. 6, 18.
6. Interview with Cristina Carrillo de Albornoz, *The Art Newspaper*, no. 125, May 2002.
7. John Berger, *Ways of Seeing* (London: BBC and Penguin Books, 1972), 64.
8. John Berger, *Ways of Seeing*, 47.
9. See Steven Pinker, *The Blank Slate: The Modern Denial of Human Nature* (London: Allen Lane, 2002), on research by artists Vitaly Komar and Alexander Melamid, 407–8.
10. BBC Radio 4 financial programme presented by Peter Day, December 2002. Review by Judith Bumpus, *The Art Newspaper*, no. 133, February 2003.
11. Birkhoff, 1928, 1933; quoted by J. A. Goguen (ed.), *Journal of Consciousness Studies: Art and the Brain*, vol. 6, nos. 6–7, June/July 1999 (Thorverton, Essex: Imprint Academic), 6.
12. See Andrea Duncan in 'Inside – Outside – Permutation – Science and the Body in Contemporary Art', in Siân Ede (ed.), *Strange and Charmed: Science and the Contemporary Visual Arts* (London: Calouste Gulbenkian Foundation, 2000).
13. See Ramachandran and Hirstein, 'The Science of Art'; and Vilaynur Ramachandran, *The Emerging Mind: The BBC Reith Lectures* (2003).
14. The Ramachandran and Hirstein paper in *Journal of Consciousness Studies*, vol. 6, was accompanied by peer commentary by a range of authors, most of whom had objections to the general thesis of the paper. For arguments explaining that such rules are commonplace in design studies, see Jaron Lanier's paper, 'What Information Is Given by a Veil?', 65–8.

15. Jason W. Brown, 'On Aesthetic Perception', *Journal of Consciousness Studies*, vol. 6.

16. See the work of Dr David Bear of the Vanderbilt School in 'What Goes on in an Artist's Brain?', report of symposium, www.fhonline.org/pubs/conference-calls.

17. Ibid.

18. Oliver Sacks, *The Man Who Mistook His Wife For a Hat* (London: Picador, 1986).

19. John Tchalenko, 'The Painter's Eye Revisited', in Ken Arnold and Giles Newton (eds.), *Science and Art: Seeing Both Sides* (London: The Wellcome Trust, 2002). In their most recent experiments, Tchalenko and Ocean have looked at a surgeon's hand-eye activity.

20. Ernst Gombrich, *Art and Illusion* (London: Phaidon Press, 1960; 6th edn. with new preface, 2002).

21. Sven Braeutigam et al., *Neural Correlates of Everyday Purchasing Decisions: A Magnetoencephalographic Study* (Milton Keynes: The Open University, 2003); Tim Ambler et al., 'Salience and Choice: Neural Correlates of Shopping Decisions', *Psychology and Marketing*, 21 (2003), 247–61; and Braeutigam et al., 'The Distributed Neuronal Systems Supporting Choice-Making in Real-Life Situations: Difference between Men and Women when Choosing Groceries Detected Using Magnetoencephalography', *Eur. J. Neurosci*, 20 (2004), 293–302. The link with speech processing might bear out Mithen and Humphreys' views on language as an important internal cognitive linking process.

22. Margaret Boden, *The Creative Mind: Myths and Mechanisms* (2nd edn., London: Routledge, 2003).

23. Mike Page, 'Creativity and the Making of Contemporary Art', in Siân Ede (ed.), *Strange and Charmed* (2000).

24. Ibid. 109.

25. See Vladimir M. Petrov, 'The Evolution of Art: An Investigation of Cycles of Left-and Right-Hemispherical Creativity in Art', in *Leonardo: Journal of the International Society for the Arts, Sciences and Technology*, vol. 31, no. 3 (San Francisco: MIT Press Journals, 1998), 219–23.

26. Robert Hughes, *The Shock of the New* (London: Thames and Hudson, 1991), 425.

27. Petrov, 'The Evolution of Art', 224, n11, re a study by Maslov, who compared oscillations in the style of architecture with changes in social life.

28. H. J. Eysenck, 'Visual Aesthetic Sensibility', in Malcolm Ross (ed.), *The Arts: A Way of Knowing* (Exeter: University of Exeter and Oxford: Pergamon Press, 1983).

29. I. C. McManus, B. Cheena and J. Stoker, 'The Aesthetics of Composition: A Study of Mondrian', *Empirical Studies of the Arts*, 11.2 (1993), 83–94; see also Chris McManus, *Right Hand, Left Hand: The Origins of Symmetry* (London: Weidenfeld and Nicolson, 2003).

30. Arthur I. Miller, *Einstein, Picasso: Space, Time and the Beauty that Causes Havoc* (New York: Basic Books, 2002). Art historian Lynn Gamwell does not believe there is sufficient evidence for Miller's theory and says rather that cubism was more directly influenced by scientific revolutions in physiology, psychology and visual theory. Gamwell, *Exploring the Invisible: Art, Science and the Spiritual* (Princeton: Princeton University Press, 2002), 138.

31. Richard P. Taylor, Adam P. Micolich, David Jonas, 'Using Science to Investigate Jackson Pollock's Drip Paintings', in J. A. Goguen and Eric Myin (eds.), *Journal of Consciousness Studies, Arts and the Brain*, vol. 7, no. 8/9 (2000).

32. Martin Kemp, introductory essay in *Susan Derges Liquid Form 1985–99* (London: Michael Hue-Williams Fine Art,1999), 8–9.

33. Martin Kemp, *Art Journal*, vol. 55, no. 1 (College Art Association, USA, 1996), 29.

34. Peter Randall-Page, in Hamilton and Warner (eds.), *Peter Randall-Page*, 8–19, quoted in Kemp, *Art Journal* (1996).

35. Julian Maynard Smith in correspondence with the author, April 2003.

36. Richard Deacon in conversation with Pier Luigi Tazzi in *Richard Deacon* (London: Phaidon, 1995; rev. edn., 2000).

37. Richard Deacon, in correspondence with the author.

Chapter 6: Sculpted by the World

1. Jo Shapcott, 'In the Bath' (1992), from Jo Shapcott, *Her Book: Poems 1988–1998* (London: Faber and Faber, 1999). Reproduced with permission from the author and publisher.

2. Andrew Carnie's *Magic Forest*, first shown at *Head On: Art with the Brain in Mind*, a Wellcome Trust exhibition at the Science Museum, London, 2002, curated by Caterina Albano, Ken Arnold and Marina Wallace.

3. See Semir Zeki, *Inner Vision* (Oxford: Oxford University Press, 1999); Richard Gregory, *Eye and Brain* (1966; 5th revised edition, 1998); Richard Gregory (ed.), *The Oxford Companion to the Mind* (new edition, Oxford: Oxford University Press, 2003). Gregory's *Eye and Brain* has been a standard art-school text since 1966.

4. Stephen Kuusisto, *The Planet of the Blind* (London: Faber and Faber, 1998).

5. Zeki, *Inner Vision*, 31.

6. Mike Page, 'Creativity and the Making of Contemporary Art', in Siân Ede (ed.), *Strange and Charmed: Science and the Contemporary Visual Arts* (London: Calouste Gulbenkian Foundation, 2000), 109; Zeki, *Inner Vision*, Chapter 5, 'The Neurology of the Platonic Ideal'.

7. Bobb-Merrill, 'The Influence of Visual Perception' (1966).

8. Richard Gregory, 'Flagging the Present with Qualia', in Steven Rose (ed.), *From Brains to Consciousness* (London: Allen Lane, 1998), 207.

9. From George McGavin's essay in *Dead or Alive – Natural History Painting – Mark Fairington* (London: Black Dog Publishing, 2002).

10. Richard Gregory, 'Flagging the Present with Qualia', 205.

11. Nicholson Baker, *A Box of Matches* (London: Chatto and Windus, 2003), 127.

12. Quoted by Michael Duncan, 'In Plato's Electronic Cave', *Art in America*, 6, vol. 83 (June 1995), 68.

13. Wellcome Trust 'sci-art' report, September 1997; Wellcome News Supplement, *Science and Art*, 2002; also conversations with the artist.

...

14. V. S. Ramachandran and Sandra Blakeslee, *Phantoms in the Brain* (London: Fourth Estate, 1998), 46–50.

15. Antonio Damasio, *Descartes' Error: Emotion, Reason and the Human Brain* (New York: Putnam, 1994); Damasio, *The Feeling of What Happens: Body and Emotion in the Making of Consciousness* (London: William Heinemann, 1999).

16. Damasio, *Looking for Spinoza: Joy, Sorrow and the Feeling Brain* (London: William Heinemann, 2003), 80.

17. Chris Ofili's show *The Upper Room*, shown at the Victoria Miro Gallery, London in June 2002.

18. John Searle, 'Solving the Hard problem – Naturally', in Rita Carter (ed.), *Consciousness* (London: Weidenfeld and Nicolson, 2002), 70–2; other views are informed by Carter (as above); Steven Rose (ed.), *From Brain to Consciousness* (London: Allen Lane/Penguin, 1998); Joseph A. Goguen (ed.), *Journal of Consciousness Studies: Controversies in Science and the Humanities*, vol. 6, nos. 6–7 (Thorverton, Essex: Imprint Academic, 1999); and Joseph A. Goguen and Erik Myin (eds.), *Journal of Consciousness Studies: Investigations Into the Science of Art*, vol. 7, nos. 8–9 (2000), and other books in the bibliography, besides many conversations with Professor Richard Gregory and Dr Mark Lythgoe.

19. Daniel Dennett, *Consciousness Explained* (New York: Little, Brown, 1991).

20. William James (1835–1911), 'The Stream of Consciousness', first published in *Psychology* (Cleveland and New York: 1892), Chapter XI. See also David Lodge, *Consciousness and the Novel* (London: Secker and Warburg, 2002).

21. *Stefan Gec: The Outside World*, Yorkshire Sculpture Park, 2002, curator Clare Lilley, catalogue author Andrew Patrizio.

22. William Gibson, *Neuromancer* (London: Gollancz, 1984). Cyberspace is 'the consensual hallucination, the graphic representation of data abstracted from the banks of every computer in the human system'.

23. David Perrett, Department of Psychology, University of St Andrews, 'Cellular Mechanism for Deciphering the Behaviour and Intentions of Others', Institute of Cognitive Neurology, 28 July 2001, quoted in Carter, *Consciousness*.

24. On motor function and language, see Giacomo Rizalatti, 'Resonance Behaviours and Mirror Neurons', *Archives of Italian Biology*, 137, 85–100; re Broca's area, see also Marco Iacoboni, 'Cortical Mechanisms of Human Imitation', *Science*, 286 (1999), 2526–8, quoted in Carter, *Consciousness*.

25. Informed by Carter, *Consciousness*, 297.

26. Thomas Nagel, 'What Is It Like To Be a Bat?', *Philosophical Review*, LXXXIII, 4, October 1974, 435–51.

27. Tracey Warr, 'Being Something', essay in *Marcus Coates* catalogue (Ambleside, Cumbria: Grizedale Books, 2001).

28. Charles Hartshorne, in *Born to Sing: An Interpretation and World Survey of Bird Song* (Bloomington, Indiana: Indiana University Press, 1973).

29. *Adaptation*, screenplay by Charlie Kaufman and Donald Kaufman, directed by Spike Jonze (2002).

30. Daniel Dennett, *Freedom Evolves* (London: Allen Lane/Penguin, 2003).

31. Turing set the test in 1950 and so far the Levner Prize for passing it remains unclaimed.

32. See www.cyberlife-research.com; and Steve Grand, *Creation: Life and How to Make It* (Cambridge, Mass.: Harvard University Press, 2001).

33. George Poste, 'Revealing Reality Within a Body of Imaginary Things', in the catalogue for Damien Hirst's exhibition, *Theories, Models, Methods, Approaches, Assumptions, Results and Findings* (New York: Gagosian Gallery, 2000).

Chapter 7: New Bodies for Old

1. See Andrea Dunbar, 'Inside – Outside – Permutation: Science and the Body in Contemporary Art', in Siân Ede (ed.), *Strange and Charmed: Science and the Contemporary Visual Arts* (London: Calouste Gulbenkian Foundation, 2000).

2. Sarah Kent, 'Corporeal Punishment', *Time Out*, 20–27 March 2002.

3. Catalogue by Martin Kemp and Marina Wallace, *Spectacular Bodies: The Art and Science of the Human Body from Leonardo to Now* (London: Hayward Gallery and University of California Press, 2000).

4. fMRI (functional Magnetic Resonance Imaging) and TMS (transcranial magnetic stimulation) track oxygen bursts relating to neural activity; PET (Positron Emission Technology) shows neurotransmitter activity; EEG (electro-encephalogram) records the brain's electrical signals; MEG (magnetic encephalograph) picks up the magnetic pulse from neuronal activity.

5. Madeleine Strindberg's works in catalogue for *The New Anatomists*, Two10 Gallery (London: The Wellcome Trust, 1999), 39.

6. *Head On: Art with the Brain in Mind*, catalogue for Wellcome Trust exhibition at the Science Museum, curated by Caterina Albano, Ken Arnold and Marina Wallace (London: The Wellcome Trust, 2002), 38. Dr Mark Lythgoe assisted by suggesting ways of using the technology; Dr Steve Smith provided the fMRI scans, 3D Systems and the Rapid Prototyping, Hobarts the encapsulation of the models.

7. From © George Poste, 'Revealing Reality Within a Body of Imaginary Things', in the catalogue to Damien Hirst, *Theories, Models, Methods, Approaches, Assumptions, Results and Findings* (New York: Gagosian Gallery, 2000), 102.

8. Raymond Tallis, *The Hand: A Philosophical Enquiry into Human Being* (Edinburgh: Edinburgh University Press, 2003).

9. Kevin Fong's diary, from Jon Turney (ed.), *Science, Not Art: Ten Scientists' Diaries* (London: Calouste Gulbenkian Foundation, 2003).

10. T. Greenhalgh and B. Hurwitz (eds.), *Narrative Based Medicine* (London: British Medical Journal Books, 1998); and B. Hurwitz, 'Narrative and the Practice of Medicine', *The Lancet* (2000).

11. *Mapping Peception*, film, installation, book and CD-ROM by film-maker Andrew Kotting, neurophysiologist Mark Lythgoe and Giles Lane of Proboscis.mappingperception.org.uk.

12. *It's Inside*. Shopfront275@hotmail.com.

13. Quoted by © George Poste, in the catalogue to Damien Hirst, *Theories, Models, Methods, Approaches, Assumptions, Results and Findings*.

14. Andrea Duncan, in correspondence with the author.

15. See Suzanne Anker and Dorothy Nelkin, *The Molecular Gaze: Art in the Genetic Age* (New York: Cold Spring Harbor Laboratory Press, 2004).

16. Originally exhibited at the O.K. Center for Contemporary Art, Linz. See www.ekac.org/transgenicindex.html.

17. 'Pig Wings', in *Converge: Where Art and Science Meet*, catalogue of the 2002 Adelaide Biennial of Australian Art, Art Gallery of South Australia, 30.

18. Eduardo Kac, 'Transgenic Art', *Leonardo Electronic Almanac*, vol. 6N, 11 December 1998.

19. See Robin Held, 'Curating Biological Art in an Age of Bioterrorism', in *Clean Rooms* (London: The Arts Catalyst, 2002).

20. Discussed by doctors, medical historians, ethicists, lawyers and artists at a 2002 conference, *The Business of the Flesh*, held in Oxford, see info@fleshbiz.fsnet.co.uk. See also Ruth Richardson, *Death, Dissection and the Destitute* (London: Phoenix Press, 1988), new edition.

21. Peter Singer, *Writings on an Ethical Life* (London: Fourth Estate, 2002); and John Gray, *Straw Dogs: Thoughts on Humans and Other Animals* (London: Granta, 2002).

22. Margaret Atwood, *Oryx and Crake* (London: Doubleday, 2003).

23. Fay Weldon, 'Welcome, Whoever You Are', *New Statesman*, 13 January 2003; Weldon, *The Cloning of Joanna May* (London: Fontana, 1990).

Chapter 8: It's All Over, Johnny

1. Naomi Klein, *No Logo* (London: Flamingo, 2001).

2. See Michael Boulter, *Extinction: Evolution and the End of Man* (London: Fourth Estate, 2002). The term 'biodiversity' originated with the National Forum on BioDiversity, organised by the US Academy of Sciences in 1986 and its decline was a major concern of the 1992 Rio Congress.

3. Report of the symposium, Laurie Short (ed.), *think?global*, produced by Cumbria College of Art and Design and WWW-UK, 2001. Reproduction of the Dion excerpt courtesy of Cumbria College of Art and Design.

4. James Lovelock, *Gaia: A New Look at Life on Earth* (Oxford: Oxford University Press, 2000); new preface, viii.

5. Alexis Rockman, interview with Randy Gladman in *artext*, Spring 2002, 24–5. I am grateful to the artist in person, to his agents Gorney, Bravin and Lee, New York and to Jenni Lomax, Director Camden Art Centre, London.

6. See catalogue for the exhibition at the Museum of Natural History, Oxford, 2000, facilitated by the Ruskin School of Drawing and Fine Art, Oxford; *Dead or Alive* (London: Black Dog Publishing, 2000). I am grateful to the artist Mark Fairnington, Dr George McGavin and Chris O'Toole of the Hope Entomological Section at the MNH, Oxford. See also exhibition catalogue for *Fabulous Beast: Mark Fairnington and Giles Revell* at the Natural History Museum, London, 2004.
7. Discussion with Mark Fairnington at the Wellcome Trust, 2000.
8. See *Elective Affinities, Susan Derges, Garry Fabian Miller*, introduction by Mark Haworth-Booth (London: Michael Hue-Williams Fine Art, 1996); *Susan Derges River Taw*, essay by Richard Bright (London: Michael Hue-Williams Fine Art, 1997); *Susan Derges Liquid Form 1985–99*, essay by Martin Kemp (London: Michael Hue-Williams Fine Art, 1999); *Susan Derges Kingswood* (Kent: Stour Valley Arts/Photoworks, 2000); with thanks to Susan Derges and Michael Hue-Williams.
9. *River Taw* (1997–1998), *Woman Thinking River* (1999) and *Shoreline* (1997–1999).
10. Quoted in the essay 'Nature Revealing Herself' by Richard Bright in *Susan Derges River Taw*.
11. James Turrell in catalogue, *Occluded Front* (Los Angeles: Museum of Contemporary Art, 1985).
12. Lynette Wallworth, *Hold Vessels #1 & #2* (2001), commissioned by the Australia Centre for the Moving Image, Melbourne; also shown in *Space Odysseys: Sensation and Immersion* (2001) at the Art Gallery of New South Wales, Sydney; Victoria Lynn (ed.), *Space Odysseys* catalogue (Art Gallery of New South Wales, Sydney, 2001). Also many thanks to Lynette Wallworth. The images listed were taken by: Anya Salih from the Key Centre for Microscopy and Micro Analysis at Sydney University; Greg Rouse from Sydney University's School of Biological Sciences; Simon Carroll courtesy of Rolf de Heer. Other scientists involved in Wallworth's artworks are David Malin (formerly of the Anglo Australian Observatory), the NASA Gallery, Oxford Scientific Imaging, David Hannan's adaptation of medical imaging techniques for filming extreme macro underwater images on the Great Barrier Reef; George Evatt's macro-films of marine life; and night sky footage on a specialised motion control unit by Tony Clark for the film *Epsilon*.

Chapter 9: Reconnections

1. Nicholson Baker, *A Box of Matches* (London: Chatto and Windus, 2003), 175.
2. See the catalogue *Richard Wentworth*, introduction by Marina Warner (London: Thames and Hudson, in association with the Serpentine Gallery, 1993); photographs in *Richard Wentworth/Eugène Atget: Faux Amis* (London: Photographers' Gallery and Lisson Gallery, 2001).
3. Richard Wentworth in correspondence with the author.
4. In her address at the conference, 'Words and Pictures: Explaining Science Through Art and Writing', at Cumbria Institute for the Arts, spring 2003.

5. Quoted in the discussion between the artist and critic Peter Gidal in *Thérèse Oulton, Clair Obscur: Recent Paintings and Watercolours* (London: Marlborough Fine Art, 2003).

6. The Catherine Yass/William James project was called 'Visualizing Complementary Shapes: A Photographic Exploration of Molecular Recognition', reported in *Sci-art 2000* (London: The Wellcome Trust, 2000).

7. Felice Frankel, *Envisioning Science: The Design and Craft of the Science Image* (Cambridge, Massachusetts: MIT Press, 2002). Quotations from publishers' interview. See also Felice Frankel and George M. Whitesides, *On the Surface of Things: Images of the Extraordinary in Science* (San Francisco: Chronicle Books, 1997).

8. Bruce Gilchrist and Jo Joelson, *Polaria*, and its companion-piece *Gastarbyter* (London: London Fieldworks/Black Dog Publishing, 2002).

9. David Malin, *The Invisible Universe* (New York: Callaway Editions, 1999); www.aao.gov. au/images/general/about-dfm.html, with personal thanks to David Malin.

10. William Shakespeare, *Love's Labour's Lost* (1593/4).

11. Martin Rees, *Our Final Century: Will the Human Race Survive the Twenty-First Century?* (London: William Heinemann, 2003).

12. Edward O. Wilson, *Consilience: The Unity of Knowledge* (London: Little, Brown, 1998); Stephen Jay Gould, *The Hedgehog, The Fox and the Magister's Pox: Mending and Minding the Misconceived Gap Between Science and the Humanities* (London: Jonathan Cape, 2003).

13. Susan Greenfield, 'How Might the Brain Generate Consciousness?', in Steven Rose (ed.), *From Brains to Consciousness: Essays on the New Sciences of the Mind* (London: Allen Lane/Penguin, 1998), 226.

14. Iris Murdoch, *Under the Net* (London: Chatto and Windus, 1954).

Select Bibliography

Anker, Suzanne, and Dorothy Nelkin, *The Molecular Gaze: Art in the Genetic Age* (New York: Cold Spring Harbor Laboratory Press, 2004)

Arends, Bergit, and Davina Thakhara, *Experiment: Conversations in Art and Science* (London: Wellcome Trust, 2003)

Barkow, J. H., L. Cosmides and J. Tooby (eds.), *The Adapted Mind* (New York: Oxford University Press, 1992)

Blackmore, Susan, *The Meme Machine* (Oxford: Oxford University Press, 1999)

Boden, Margaret, *The Creative Mind: Myths and Mechanisms* (2nd edn., London: Routledge, 2003)

Boulter, Michael, *Extinction: Evolution and the End of Man* (London: Fourth Estate, 2002)

Buck, Louisa, *Moving Targets: A User's Guide to British Art Now* (London: Tate Gallery Publishing, 1997)

Carter, Rita, *Consciousness* (London: Weidenfeld and Nicolson, 2002)

Damasio, Antonio, *Descartes' Error: Emotion, Reason and the Human Brain* (New York: Putnam, 1994)

Damasio, Antonio, *The Feeling of What Happens: Body and Emotion in the Making of Consciousness* (London: William Heinemann, 1999)

Damasio, Antonio, *Looking for Spinoza: Joy, Sorrow and the Feeling Brain* (London: William Heinemann, 2003)

Dawkins, Richard, *The Selfish Gene* (Oxford: Oxford University Press, 1976)

Dawkins, Richard, *The Blind Watchmaker* (London: Longman, 1986)

Dennett, Daniel, *Consciousness Explained* (New York: Little, Brown and Company, 1991)

Dennett, Daniel, *Darwin's Dangerous Idea* (London: Penguin, 1995)

Dennett, Daniel, *Freedom Evolves* (London: Allen Lane/Penguin, 2003)

Diamond, Jared, *Guns, Germs and Steel* (London: Vintage, 1998)

du Sautoy, Marcus, *The Music of the Primes* (London: Fourth Estate, 2003)

Ede, Siân (ed.), *Strange and Charmed: Science and the Contemporary Visual Arts* (London: Calouste Gulbenkian Foundation, 2000)

Farmelo, Graham (ed.), *It Must Be Beautiful: An Anthology of the Great Equations of Modern Science* (London: Granta Books, 2002)

Frankel, Felice, and George M. Whitesides, *On the Surface of Things: Images of the Extraordinary in Science* (San Francisco: Chronicle Books, 1997)

Frankel, Felice, *Envisioning Science: The Design and Craft of the Science Image* (Cambridge, Mass.: MIT Press, 2002)

Gamwell, Lynn, *Exploring the Invisible: Art, Science and the Spiritual* (Princeton: Princeton University Press, 2002)

Goguen Joseph A. (ed.), *Journal of Consciousness Studies: Controversies in Science and the Humanities*, Vol. 6, Nos. 6–7 (Thorverton, Essex: Imprint Academic, 1999)

Goguen, Joseph A., and Myin Erik (eds.), *Journal of Consciousness Studies: Investigations into the Science of Art*, Vol. 7, No. 8/9 (2000)

Gombrich, Ernst, *Art and Illusion: A Study in the Psychology of Pictorial Representation* (London: Phaidon Press, 1960; 6th edn. with new preface, 2002)

Grand, Steve, *Creation: Life and How to Make It* (Cambridge, Mass.: Harvard University Press, 2001)

Gray, John, *Straw Dogs: Thoughts on Humans and Other Animals* (London: Granta Publications, 2002)

Gregory, Richard, *Eye and Brain* (5th revised edition, 1998)

Gregory, Richard, *Oxford Companion to the Mind* (new edn., Oxford: Oxford University Press, 2003)

Hughes, Robert, *The Shock of the New: Art and the Century of Change* (London: Thames and Hudson, 1991)

Kemp, Martin, and Marina Wallace, *Spectacular Bodies: The Art and Science of the Human Body, from Leonardo to Now* (London: Hayward Gallery, University of California Press, 2000)

Laland, Kevin N., and Gillian R. Brown, *Sense and Nonsense: Evolutionary Perspectives on Human Behaviour* (Oxford: Oxford University Press, 2002)

Levin, Janna, *How the Universe Got Its Spots* (London: Weidenfeld and Nicholson, 2002)

Lodge, David, *Consciousness and the Novel* (London: Secker and Warburg, 2002)

Lovelock, James, *Gaia: A New Look at Life on Earth* (new edn., Oxford: Oxford University Press, 2000)

Malin, David, *The Invisible Universe* (New York: Callaway Editions, 1999)

Mankiewicz, Richard, *The Story of Mathematics* (London: Cassell and Co, 2000)

McManus, Chris, *Right Hand, Left Hand: The Origins of Symmetry* (London: Weidenfeld and Nicolson, 2003)

Midgley, Mary, *Science and Poetry* (New York: Routledge, 2001)

Miller, Arthur I., *Einstein, Picasso: Space, Time and the Beauty that Causes Havoc* (New York: Basic Books, 2002)

Mithen, Steven, *The Prehistory of the Mind: A Search for the Origins of Art, Religion and Science* (London: Thames and Hudson, 1996)

Pinker, Steven, *The Language Instinct* (New Yorsk: HarperCollins, 1994)

Pinker, Steven, *How the Mind Works* (London: Allen Lane, Penguin, 1997)

Pinker, Steven, *The Blank Slate* (London: Allen Lane, 2002)

Ramachandran, V. S., and Sandra Blakeslee, *Phantoms in the Brain* (London: Fourth Estate, 1998)

Ramachandran, Vilaynur, *The Emerging Mind: The BBC Reith Lectures* (2003)

Richardson, Ruth, *Death, Dissection and the Destitute* (new edition, London: Phoenix Press, 1988)

Ridley, Matt, *Nature Via Nurture: Genes, Experience, and What Makes us Human* (London: Fourth Estate, 2003)

Rose, Steven (ed.), *From Brain to Consciousness* (London: Allen Lane, Penguin, 1998)

Sacks, Oliver, *The Man Who Mistook His Wife For a Hat* (London: Picador, 1986)

Singer, Peter, *Writings on an Ethical Life* (London: Fourth Estate, 2001)

Sokal, Alan, and Jean Bricmont, *Intellectual Impostures* (first published in French, Paris: Editions Odile Jacob, 1997; in English, London: Profile Books, 1998)

Sorell, Tom, *Scientism: Philosophy and the Infatuation with Science* (London: Routledge, 1994)

Turney, Jon (ed.), *Science, Not Art: Ten Scientists' Diaries* (London: Calouste Gulbenkian Foundation, 2003)

Wilson, A. N., *God's Funeral* (London: John Murray, 1999)

Zeki, Semir, *Inner Vision* (Oxford: Oxford University Press, 1999)

Index